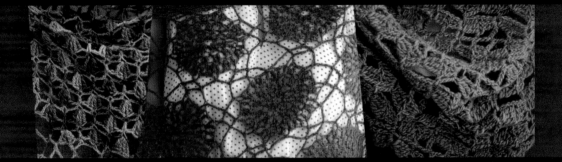

CROCHET
so lovely

21 carefree lace designs

KRISTIN OMDAHL

INTERWEAVE.
interweave.com

A special thank-you to my SharkHunter:
my sweet, talented, and good-natured
son. The seeds of my wonderful career
began while you were still growing in
my belly. Now, some twelve years later,
I watch with ever-increasing pride
as you blossom into the man you will
become. You continue to inspire me
beyond words; I feel truly blessed and
love you so much.

editor Erica Smith
technical editor Karen Manthey
photographer Joe Hancock
hair and makeup Kathy MacKay
stylist Allie Liebgott
art director Charlene Tiedemann
cover and interior design Karla Baker
production designer Kerry Jackson

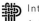

Interweave
A division of F+W Media, Inc.
4868 Innovation Drive
Fort Collins, CO 80525

interweave.com
Manufactured in China by RR Donnelley Shenzhen

Library of Congress Cataloging-in-Publication Data
Omdahl, Kristin.
Crochet so lovely : 21 carefree lace designs /
Kristin Omdahl.
 pages cm
ISBN 978-1-62033-689-2
1. Crocheting--Patterns. 2. Dress accessories.
3. Lace and lace
making. I. Title.
TT825.O4383 2014
746.43'4--dc23
 2014028612

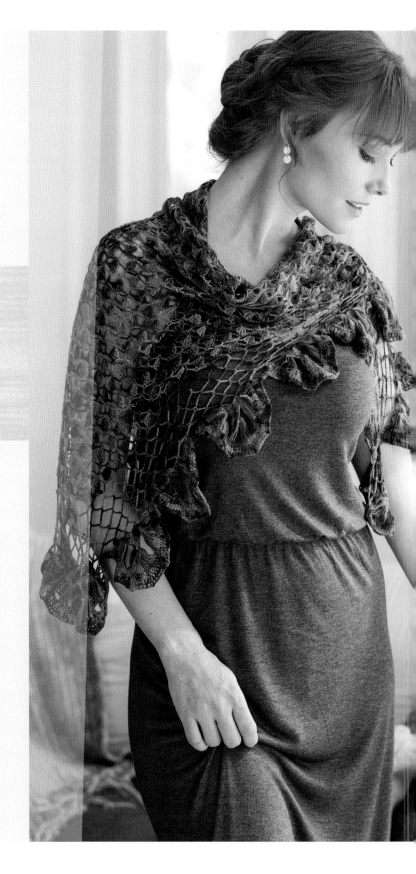

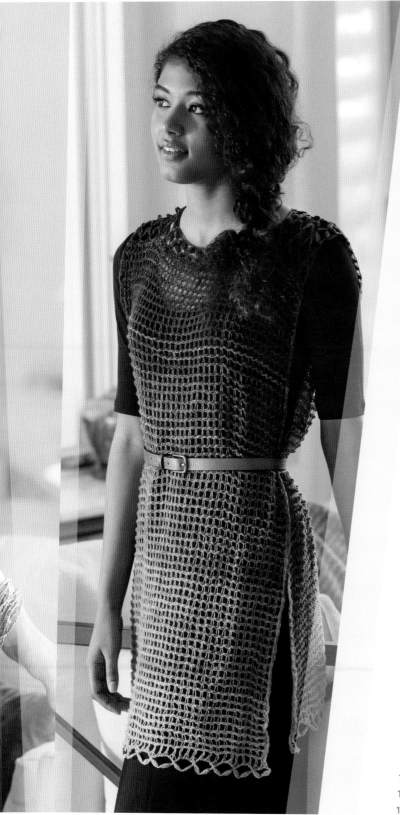

contents

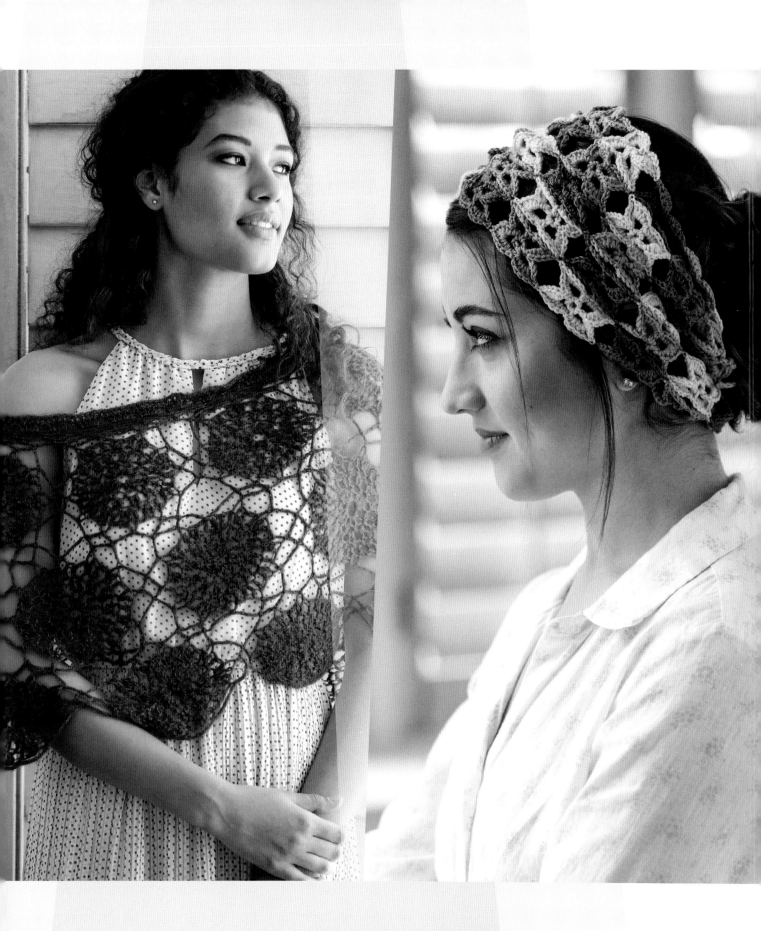

introduction

This collection is truly dear to my heart. As a math fanatic who often gets really focused on the construction and technical aspect of design, but also loves fashion and dressing up, I thought I'd challenge myself to design a collection of romantic, feminine, and girlie wearables after my own heart. Before I began this book, I promised myself I would ask this question for each piece: If money were no object and I was going on a very special date with Prince Charming, would I still wear this? If I couldn't say yes, it didn't make the cut. I thought of the kind of outings and the types of looks I would want to wear, and this book is the result of it.

These designs are wearable and versatile for all of your adventures — from sunset beach picnic, to afternoon art festival, to live and local acoustic concert, to weekend getaway, and beyond. I poured my heart into this collection and enjoyed the process very much. I have many favorites and couldn't possibly choose one. The felted bag makes me squeal with delight. The trapeze tank top looks good worn so many ways, the hairpin lace motifs (in two projects) are gorgeous and mesmerizing, and my love of floral inspiration is quite strong throughout the collection. And, the technical side of me was able to squeeze in a few crazy techniques (wouldn't you be disappointed if I didn't?).

I'm so excited to share this book with you.
I hope you enjoy making (and wearing)
these pieces as much as I do!

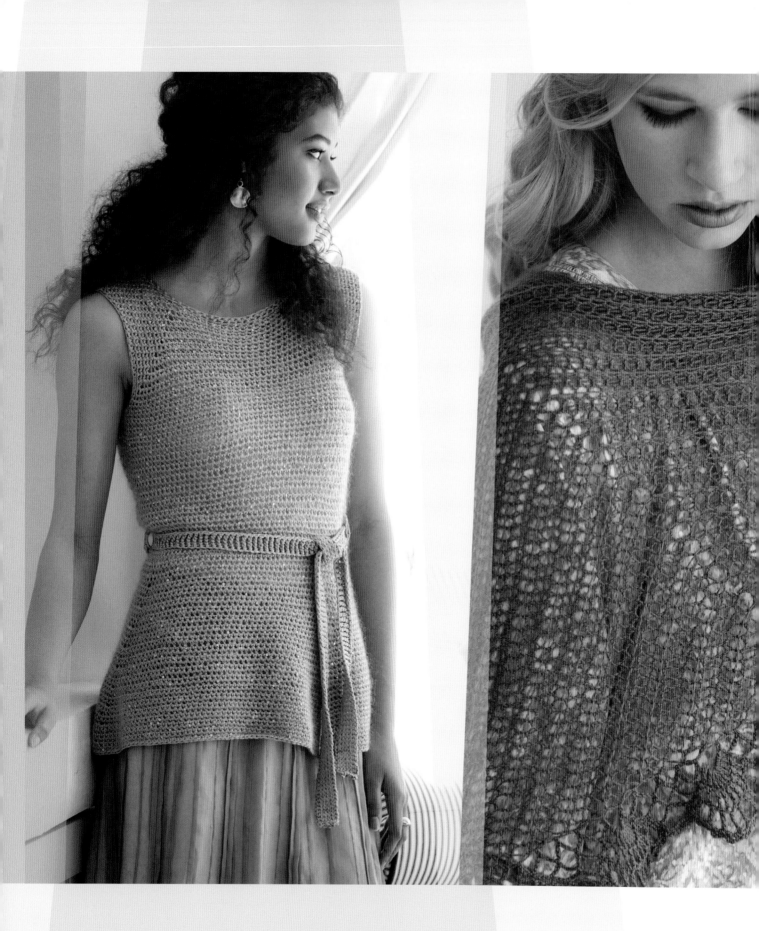

CHAPTER ONE *Lace by Gauge*

What is lace? To me, it is a pattern composed of the negative space and geometric structuring of a network of crossed paths of string. This can be accomplished in so many ways, from very simple to supercomplicated. This chapter is an exploration of the truly simple: playing with gauge.

Gauge is always critical when making lace. Blocking is mandatory; whether intentional or accidental, it will relax your gauge. Using oversized hooks for the weight of your yarn will accentuate the relaxing of your gauge in the blocking. Using simple stitches and oversized hooks gives you a remarkable lace structure after blocking, and often it makes it difficult to recognize otherwise common stitches!

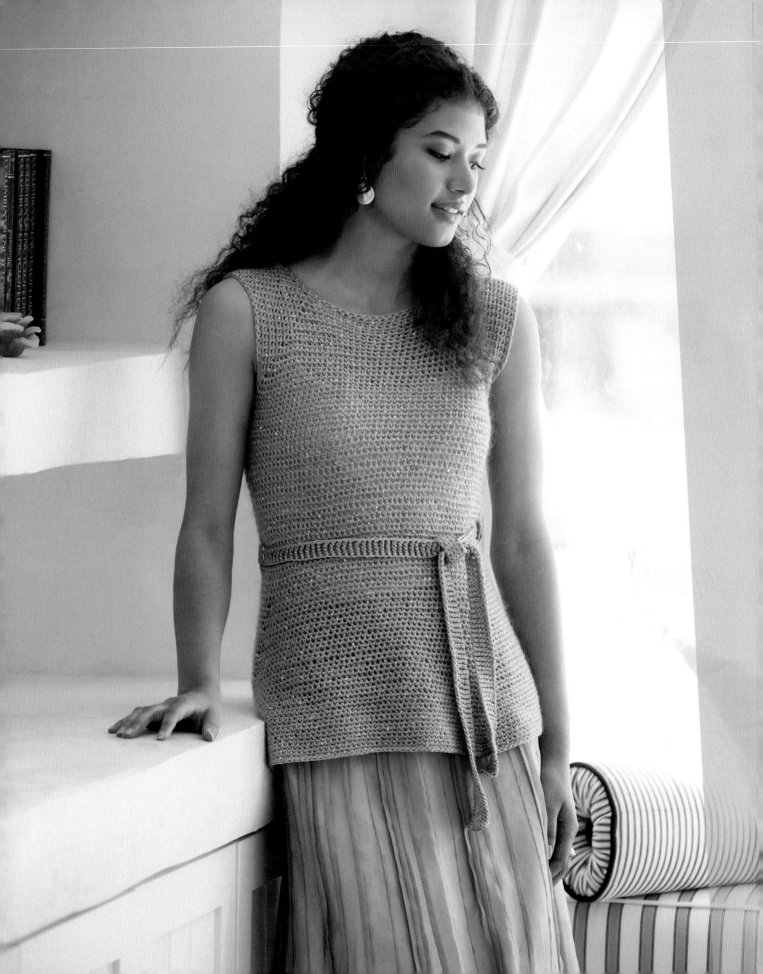

Worsted weight (#4 Medium).

SHOWN HERE: Tahki Stacy Charles S. Collezione Stella (74% silk/26% lurex metallic; 76.5 yd [70 m]/0.88 oz [25 g]): #10 Northern Lights (A), 6 (7, 8, 10, 11) balls.

Tahki Stacy Charles S. Collezione Luna (71% super kid mohair/20% silk/9% Lurex; 232 yd [212.5 m]/0.88 oz [25 g]): #09 Northern Lights (B), 2 (3, 3, 4, 4) balls.

Tahki Stacy Charles S. Collezione Crystal (85% polyester/15% cotton; 144 yd [131 m]/0.88 oz [25 g]): #12 Northern Lights (C), 3 (4, 4, 5, 6) balls.

HOOK

H/8 (5 mm) or size needed to obtain gauge.

NOTIONS

Yarn needle; stitch markers.

GAUGE

14 sts and 16 rows = 4" (10 cm) in sc in pattern, blocked.

FINISHED SIZE

Directions are given for size S. Changes for M, L, XL, and 2X are in parentheses.

FINISHED BUST: 35 (39, 43, 47, 51)" (89 [99, 109, 119.5, 129.5] cm).

CIRCUMFERENCE AT BOTTOM EDGE: 46 (50, 54, 58, 62)" (117 [127, 137, 147.5, 157.5] cm).

LENGTH: 23½ (24½, 25½, 26½, 27½)" (59.5 [62, 65, 67.5, 70] cm).

Simply Sparkly
TUNIC

Alternating rows of proper gauge with very loose gauge in simple single crochet is an interesting way to create a lacy pattern and drape. You could achieve this by switching hook size with the same yarn, or as I did in this sweater, alternating weights of yarn with the same sized hook.

The thicker (ribbon) yarn uses the proper sized hook (H/8), and I used a laceweight mohair held together with a carryalong (thinner than laceweight) sequined yarn for the alternating row, but I continued with the same hook. The finished fabric, after blocking, has lots of negative space and really opens up the pattern. It looks like a stitch pattern rather than rows of easy-peasy single crochet. And the added sparkle of sequined yarn is just plain fun!

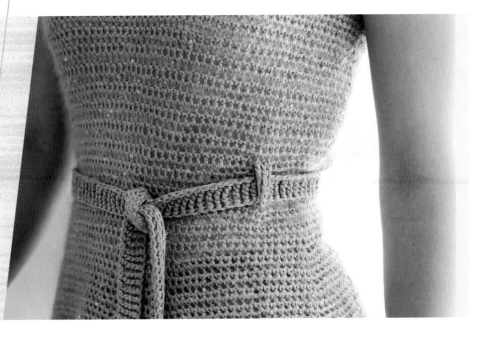

COLOR SEQUENCE

Pattern is worked in the following color sequence: *1 rnd A, 1 rnd B and C held together for one; rep from * throughout.

STITCH GUIDE

Foundation sc (Fsc): Start with a slipknot, ch 2, insert hook in 2nd ch from hook, draw up a lp, yo, draw through 1 lp, yo and draw through 2 lps—1 sc with its own ch at bottom. Work next st under lps of that ch. *Insert hook under 2 lps at bottom of the previous st, draw up a lp, yo and draw through 1 lp, yo and draw through 2 lps, rep from * for length of foundation.

Front post double treble crochet (FPdtr): Yo (3 times), insert hook from front to back to front again around the post of next st, yo, draw yarn through st, [yo, draw yarn through 2 lps on hook] 4 times.

NOTES

- This is a seamless, top-down construction pullover with cap sleeves and a longer, tunic length. Added stitches are worked into the lower body rounds for great hip ease. The belt loops are added as you go with long post stitches! This is a clever trick you can use on any belted sweater you make going forward.

- You could easily modify this sweater to add a collar, or longer sleeves, or even shorten the body. It has a streamline fit with minimal ease in the bust.

- You can easily alternate yarns every other rnd without cutting yarn at the end of every rnd. Just make sure to untwist every few rnds if they begin to twist up on themselves.

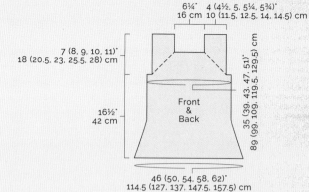

6¼" 4 (4½, 5, 5¼, 5¾)"
16 cm 10 (11.5, 12.5, 14, 14.5) cm

7 (8, 9, 10, 11)"
18 (20.5, 23, 25.5, 28) cm

35 (39, 43, 47, 51)"
89 (99, 109, 119.5, 129.5) cm

Front
&
Back

16½"
42 cm

46 (50, 54, 58, 62)"
114.5 (127, 137, 147.5, 157.5) cm

Yoke

With A, work 70 (78, 86, 94, 102) Fsc, without twisting foundation, join with sl st in first st to form a ring. Drop A to WS to be picked up later.

Rnd 1: Holding 1 strand each of B and C together as one, join B and C with sl st in first st, ch 1, *sc in each of next 6 sts, 3 sc in next st (place marker in center of 3 sc), sc in each of next 22 sts, 3 sc in next st (place marker in center of 3 sc), sc in each of next 5 sts; rep from * once, join with sl st in first sc—78 (86, 94, 102, 110) sts. Drop B and C to WS to be picked up later, pick up A.

Note: All odd-numbered rnds are worked with B and C held together as one, all even-numbered rnds are worked with A.

Rnd 2: With A, ch 1, *sc in each st across to first st marker, 3 sc in marked st, (move marker up to center of these 3 sc); rep from * around, sc in each rem st to beg, join with sl st in first sc—86 (94, 102, 110, 118) sc. Drop A, pick up B and C.

Rnd 3: With B and C, ch 1, *sc in each st across to first st marker, 3 sc in marked st, (move marker up to center of these 3 sc); rep from * around, sc in each rem st to beg, join with sl st in first sc—94 (102, 110, 118, 126) sc. Drop B and C, pick up A.

Rnds 4–17 (19, 21, 22, 24): Rep Rnds 2 and 3, ending with Rnd 3 (3, 3, 2, 2)—206 (230, 254, 270, 294) sc.

Rnd 18 (20, 22, 23, 25): With appropriate color, ch 1, sc in each st around. Fasten off.

Body

Separate into front, back, and sleeves to begin working body in rnds:

Maintain color sequence as established throughout.

Rnd 1: With next color in sequence, join yarn with sl st in marked sc in center of next 3-sc group (working toward front), ch 1, sc in each of next 58 (64, 70, 74, 80) sts, ch 3 (4, 5, 8, 9), skip next 45 (51, 57, 61, 67) sts, sc in each of next 58 (64, 70, 74, 80) sts, ch 3, join with sl st in first sc—122 (136, 150, 164, 178) sc.

Rnd 2: With next color in sequence, ch 1, sc in each st around, join with sl st in first sc—122 (136, 150, 164, 178) sts.

Rnds 3–24: Maintaining color sequence as established, rep Rnd 2 until piece measures 8" (20.5 cm) from underarms, ending with an odd-numbered B and C rnd.

Note: Belt loop rnd should be a rnd worked with A.

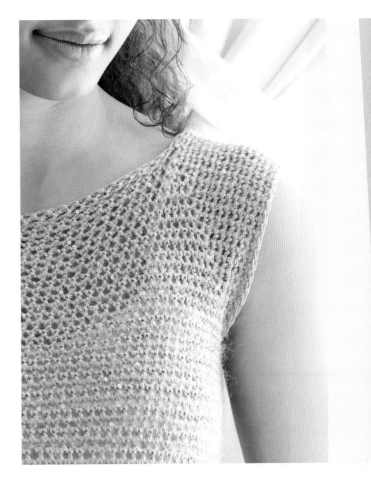

Rnd 25 (belt loop round): With A, ch 1, sc in each of next first 58 (65, 72, 79, 86) sts, FPdtr in each of next 3 sts, 4 rnds below, sc in each of next 58 (65, 72, 79, 86) sts, FPdtr in each of next 3 sts, 4 rnds below, join with sl st to first sc—122 (136, 150, 164, 178) sts.

Note: The belt loops should line up with the center of the underarm sts.

Rnd 26: With next color in sequence, ch 1, sc in each st around.

Rnds 27–39: Rep Rnd 26.

HIP INCREASES

Rnd 1: With next color in sequence, ch 1, *sc in each of next 5 sts, 3 sc in next st, sc in each of next 49 (56, 63, 70, 77) sts, 3 sc in next st, sc in each of next 5 sts; rep from * once, join with sl st in first sc—130 (144, 158, 172, 186) sts. Place a stitch marker in center of each 3-sc inc. Move marker up as work progresses.

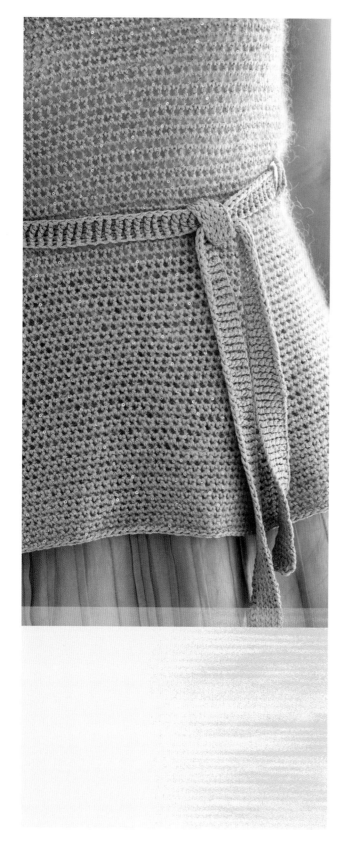

Rnds 2–6: With next color in sequence, ch 1, sc in each st around, join with sl st in first sc.

Rnd 7: With next color in sequence, ch 1, *sc in each st around to next marker, 3 sc in marked st; rep from * around, sc in each rem st from beg to end, join with sl st in first sc—138 (152, 166, 180, 194) sc.

Rnds 8–25: Rep Rnds 2–7 (3 times)—162 (176, 190, 204, 218) sc at end of last rnd.

Rnds 26–30: With next color in sequence, rep Rnds 2–6. Fasten off.

Belt

Belt is crocheted using Tunisian knit stitch (Tks) but because of the narrow rows, you don't need a special afghan hook for this. A regular crochet hook in the proper size will work just fine.

With A, ch 6.

Row 1: Fwd: Insert hook in 2nd ch from hook and draw up a lp, *insert hook in next ch and draw up a lp; rep from * across—6 lps on hook. Rtn: Yo, draw through 1 lp on hook, *yo, draw through 2 lps on hook; rep from * across, 1 lp rem and counts as first st of next row.

Row 2: Fwd: Sk first vertical bar, (loop on hook counts as first st), insert hook from front to back through next 2 vertical bars, yo, draw up a lp; rep from * across—6 lps on hook. Rtn: Rep Row 1 Rtn row.

Rep Row 2 until belt measures 50 (54, 58, 62, 66)" (127 [137, 147.5, 157.5, 168] cm) from beg.

Last Row: Sk first st, inserting hook as for Tks, sl st in each st across. Fasten off.

Finishing

Weave in ends. Wash, block to finished measurements, and let dry.

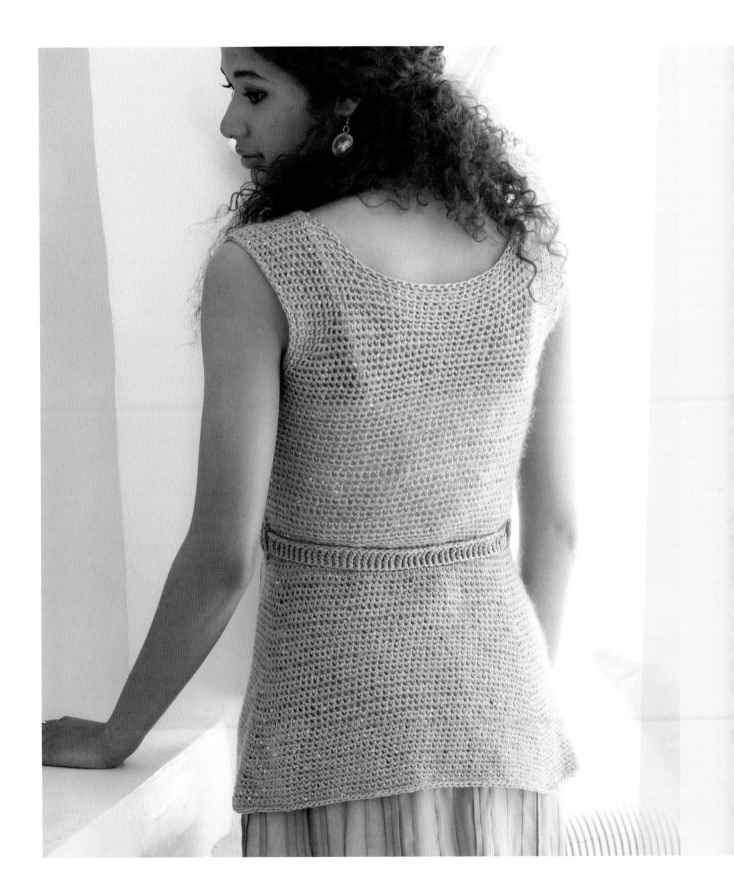

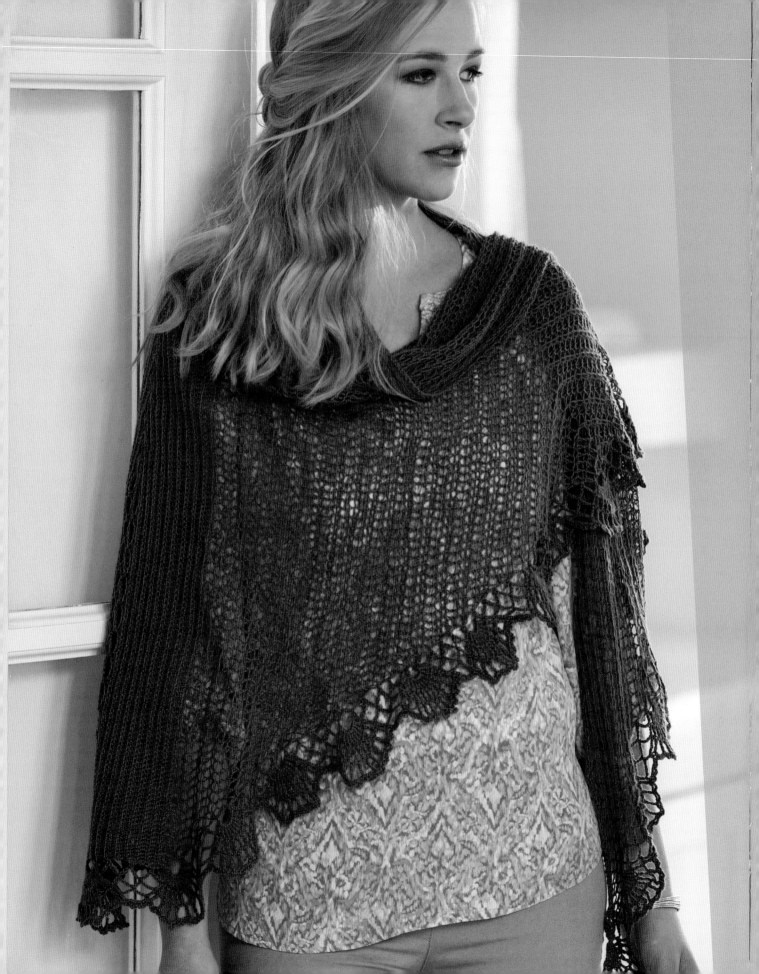

YARN

Lace weight (#1 Super Fine).

SHOWN HERE: Lotus Mimi (100% mink; 330 yd [302 m]/1.75 oz [50 g]): #27 Orchid, 3 skeins.

HOOKS

D/3 (3.25 mm) and I/10 (6 mm) or sizes needed to obtain gauges.

NOTIONS

Yarn needle; stitch marker.

GAUGE

With larger hook, 12 sts and 12 rows = 4" (10 cm) in sc-tbl pattern, blocked.

With smaller hook, 26 sts and 16 rows = 4" (10 cm) in sc-tbl pattern, blocked.

Orchid Faroese
SHAWL

The juxtaposition of loose- to firm-gauge crochet is quite interesting in this shawl. Using a 2:1 ratio of gauge, the stitch count simply doubles by going from the large to the small. This would apply to whatever sized 2:1 ratio hooks you experiment with at home. I love the texture of the very loose gauge in an otherwise tight stitch. However, when you want a lot of detailed stitchwork, like this beautiful floral edging, you need the crisp stitch definition of a finer hook size.

FINISHED SIZE

80" (203 cm) wide × 34" (86.5 cm) deep.

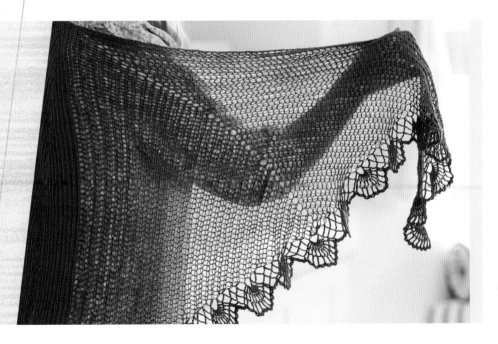

STITCH GUIDE

Single crochet through back loop only (sc-tbl):
Sc through back lp only of next st.

Single crochet 10 together (sc10tog): [Insert hook in next st, yo, draw yarn through st] 10 times, yo, draw yarn through 11 lps on hook.

Single crochet 11 together in back loop only (sc11tog-tbl): [Insert hook in back lp only of next st, yo, draw yarn through st] 11 times, yo, draw yarn through 12 lps on hook.

Triangle *(make 2)*

Row 1 (RS): With larger hook, ch 2, 5 sc in 2nd ch from hook—5 sc.

Row 2: Ch 1, 2 sc-tbl in first st, sc-tbl in next st, 3 sc-tbl in next st, sc-tbl in next st, 2 sc-tbl in last st—9 sc.

Row 3: Ch 1, 2 sc-tbl in first st, sc-tbl in each of next 3 sts, 3 sc-tbl in next st, sc-tbl in each of next 3 sts, 2 sc-tbl in last st—13 sc. Place st marker in center sc of 3-sc group and move marker up to center sc as work progresses.

Rows 4–43: Ch 1, 2 sc-tbl in first st, sc-tbl in each st across to marked st, 3 sc-tbl in marked st, sc-tbl in each st across to last st, 2 sc-tbl in last st—173 sc.

Gusset

Join triangles together while crocheting gusset as follows:

Row 1: With RS facing and smaller hook, join yarn with sl st in first st of last row of First Triangle (see diagram), ch 1, 2 sc in each st across to center marked st, working in Second Triangle, work 2 sc in marked center st of last row, working across left side of last row of Second Triangle, work 2 sc in each st across to end of row, turn—348 sc.

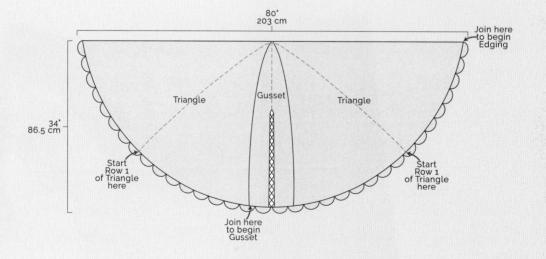

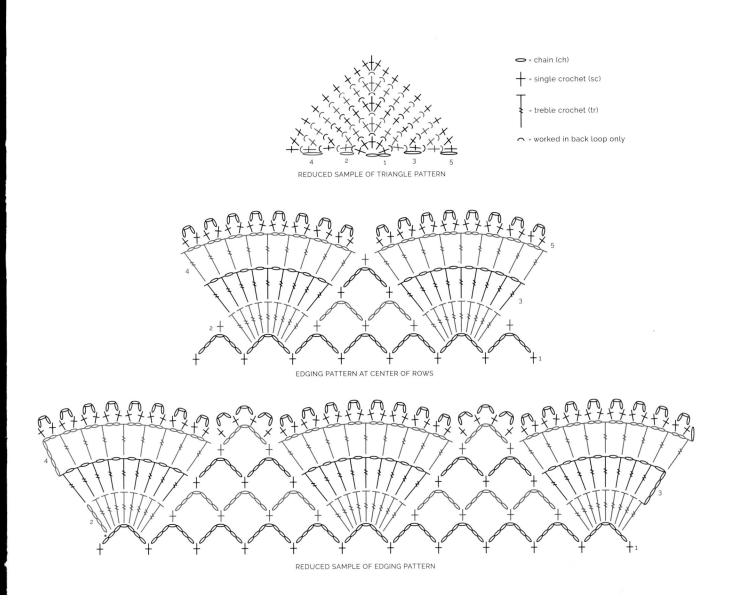

= chain (ch)

+ = single crochet (sc)

⌡ = treble crochet (tr)

⌒ = worked in back loop only

REDUCED SAMPLE OF TRIANGLE PATTERN

EDGING PATTERN AT CENTER OF ROWS

REDUCED SAMPLE OF EDGING PATTERN

Row 2: Ch 1, sc-tbl in each st across to 5 sts before center, sc10tog, sc-tbl in each st across, turn—339 sts.

Row 3: Ch 1, sc-tbl in each st across to 6 sts before center, sc11tog-tbl, sc-tbl each st across, turn—329 sts.

Rows 4–21: Rep Row 3—149 sts at end of last row.

Note: Gusset will be joined together on next row. Work chain mesh up one half of row, and join to first half of row while working 2nd half of row so that at the end of this row the gusset is seamed.

Row 22 (joining row): Ch 1, sc in same st, *ch 7, skip next 4 sts, sc in next st; rep from * 14 times, ending at center of row, working on 2nd half of row to join to first half of row as follows: *ch 3, sl st in next corresponding ch-7 sp, ch 3, skip next 4 sts on Row 21, sc in next st; rep from * across, ending with sc in last st. Fasten off.

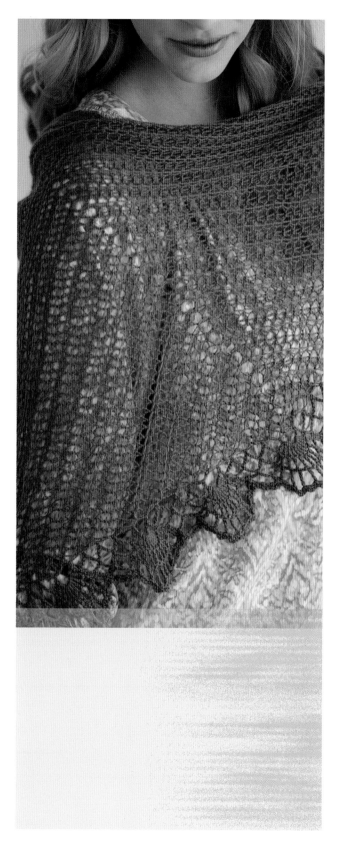

Edging

Rnd 1 of Edging is worked around entire shawl. Then work is turned and the remainder of edging is worked back and forth in rows across the lower V only.

Rnd 1: With RS facing, join yarn with sl st in top right-hand corner, and working along top edge, ch 1, 2 sc in each st across to gusset, sc in center gusset point, 2 sc in each st across, working across lower V edge of shawl, *ch 7, sc in next st*; rep from * to * across to center gusset, [ch 7, skip next 2 rows, sc in next row-end st] 7 times, ch 7, sk center joining lps, sc in next st, [ch 7, skip next 2 rows, sc in next row-end st] 7 times; rep from * to * across to top right-hand corner, join with sl st in first sc, turn—345 sc across top edge of shawl; 186 ch-7 sps across lower V of shawl.

Row 2: Sl st in first ch-7 sp, ch 4 (counts as tr), 8 tr in same sp, sc in next ch-7 sp, *(ch 7, sc) in each of next 3 ch-7 sps, 9 tr in next ch-7 sp; rep from * across top left-hand corner of V, turn, leaving top edge unworked—37 shells.

Row 3: Ch 5 (counts as tr, ch 1), (tr, ch 1) in each of next 7 tr, tr in next st, sc in next ch-7 sp, *(ch 7, sc) in each of next 2 ch-7 sps, (tr, ch 1) in each of next 8 tr, tr in next st; rep from * across, turn—37 scallops.

Row 4: Ch 6 (counts as tr, ch 2), (tr, ch 2) in each of next 7 tr, tr in next st, sc in next ch-7 sp, *ch 7, sc in next ch-7 sp, (tr, ch 2) in each of next 8 tr, tr in next st; rep from * across, turn—37 scallops.

Row 5: Sl st in first ch-2 sp, ch 1, (sc, ch 3, sc) in each of first 8 ch-2 sps, *(sc, ch 3, sc, ch 3, sc, ch 3, sc) in next ch-7 sp, (sc, ch 3, sc) in each of next 8 ch-2 sps; rep from * to across. Fasten off.

Finishing

Weave in ends. Wash, block to finished measurements, and let dry.

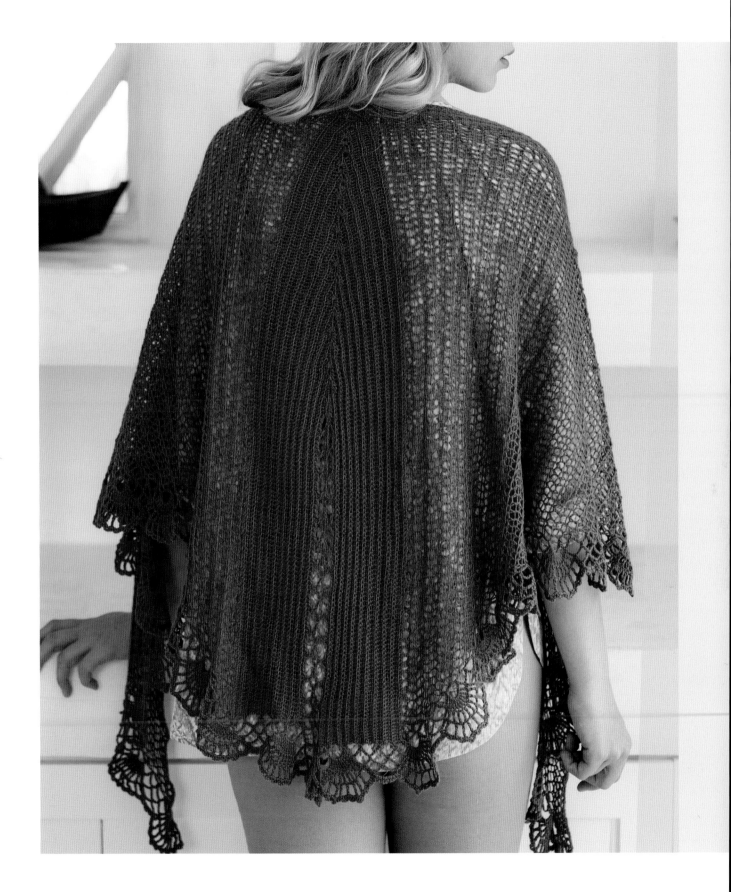

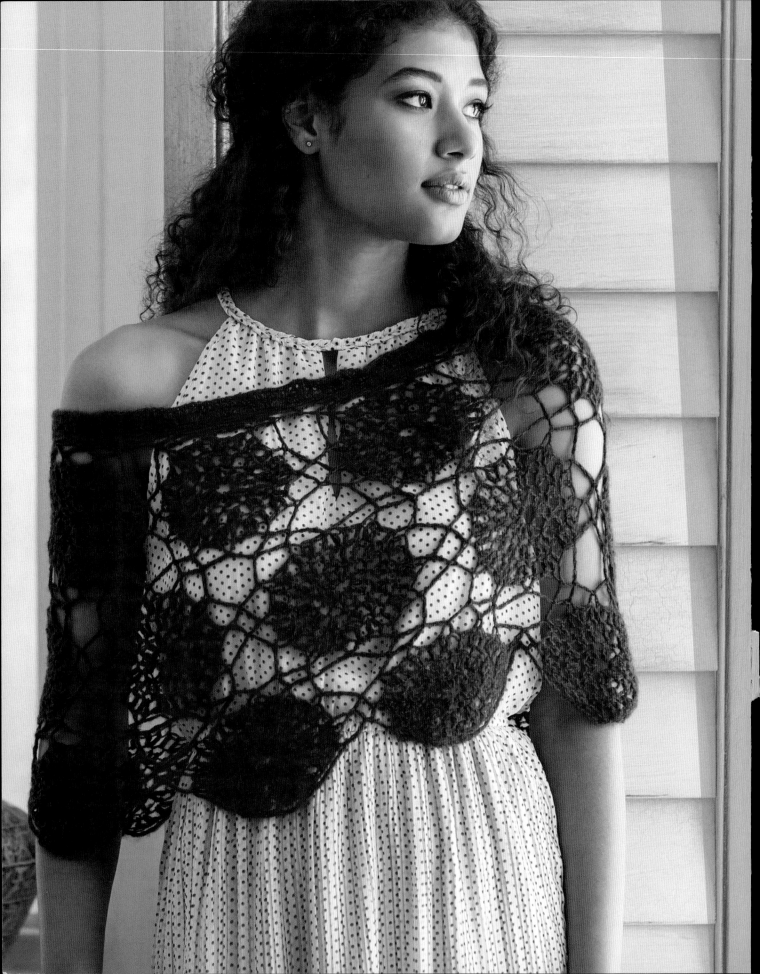

Lace weight (#1 Super Fine).

SHOWN HERE: Tahki Stacy Charles Filatura Di Crosa Superior (70% cashmere/30% silk; 330 yd [300 m]/0.88 oz [25 g]): #75 Dark Copper (A), 1 ball.

Tahki Stacy Charles Filatura Di Crosa Nirvana (100% extrafine superwash merino wool; 372 yd [340 m]/0.88 oz [25 g]): #49 Deep Copper (B), 1 ball.

HOOKS

H/8 (5 mm) and M/13 (8 mm) or sizes needed to obtain gauges.

NOTIONS

Yarn needle.

GAUGE

With larger hook and A and B held together as one, motif = 6" (15 cm) in diameter, blocked.

Rustica
CAPELET

A tube of lace motifs, this project can be blocked and worn/styled as a cowl. But by adding a narrower yoke, it can be worn as a capelet. I think it would also be a very pretty layering piece over a skirt or jeans as a lacy skirt accent, with a belt woven through the lace holes and cinched at the hips.

FINISHED SIZE

Cowl measures 33" (84 cm) in circumference at narrower neck opening; 42" (106.5 cm) in circumference at bottom edge; 17" (43 cm) long.

NOTE

- Project is worked with A and B held together as one throughout. Each motif has 12 ch-7 spaces, but they are joined as hexagons. Each of the 6 "sides" is joined at 2 ch-7 sps.

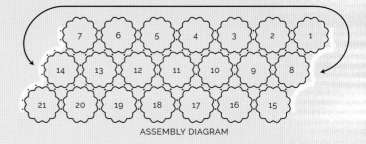

ASSEMBLY DIAGRAM

First Motif *(no joining)*

Ch 4, sl st in first ch to join into a ring.

Rnd 1: Ch 3 (counts as dc here and throughout), 11 dc in ring, join with sl st to top of beg ch-3—12 dc.

Rnd 2: Ch 3, dc in same st, 2 dc in each st around, join with sl st to top of beg ch-3—24 dc.

Rnd 3: Ch 3, dc in same st, dc in next st, *2 dc in next st, dc in next st; rep from * around, join with sl st to top of beg ch-3—36 dc.

Rnd 4: Ch 1, sc in same st, *ch 7, skip next 2 sts**, sc in next st; rep from * around, ending last rep at **, join with sl st to top of beg ch-3—12 ch-7 sps. Fasten off.

Second and Successive Motifs
(joined on one side)

Work same as First Motif through Rnd 3.

Rnd 4: Ch 1, sc in same st, [ch 3, sl st to next ch-7 sp on previous motif, ch 3, skip next 2 sts, sc in next st on current motif] twice on same motif, *ch 7, skip next 2 sts**, sc in next st; rep from * around, ending last rep at **, join with sl st to top of beg ch-3—10 ch-7 sps; 2 joined sps. Fasten off.

Successive Motifs
(joined on two sides)

Work same as First Motif through Rnd 3.

Rnd 4: Ch 1, sc in same st, [ch 3, sl st to next ch-7 sp on previous motif, ch 3, skip next 2 sts, sc in next st on current motif] twice on same motif, [ch 3, sl st to next ch-7 sp on next motif, ch 3, skip next 2 sts, sc in next st on current motif] twice on same motif, *ch 7, skip next 2 sts**, sc in next st; rep from * around, ending last rep at **, join with sl st to top of beg ch-3—8 ch-7 sps; 4 joined sps. Fasten off.

Successive Motifs
(joined on three sides)

Work same as First Motif through Rnd 3.

Rnd 4: Ch 1, sc in same st, [ch 3, sl st to next ch-7 sp on previous motif, ch 3, skip next 2 sts, sc in next st on current motif] twice on same motif, *[ch 3, sl st to next ch-7 sp on next motif, ch 3, skip next 2 sts, sc in next st on current motif] twice on same motif; rep from * once, **ch 7, skip next 2 sts***, sc in next st; rep from ** around, ending last rep at ***, join with sl st to top of beg ch-3—6 ch-7 sps; 6 joined sps. Fasten off.

Successive Motifs
(joined on four sides)

Work same as First Motif through Rnd 3.

Rnd 4: Ch 1, sc in same st, [ch 3, sl st to next ch-7 sp on previous motif, ch 3, skip next 2 sts, sc in next st on current motif] twice on same motif, *[ch 3, sl st to next ch-7 sp on next motif, ch 3, skip next 2 sts, sc in next st on current motif] twice on same motif; rep from * twice, **ch 7, skip next 2 sts***, sc in next st; rep from ** around, ending last rep at ***, join with sl st to top of beg ch-3—4 ch-7 sps; 8 joined sps. Fasten off.

Follow diagram for determining which type is required for each motif.

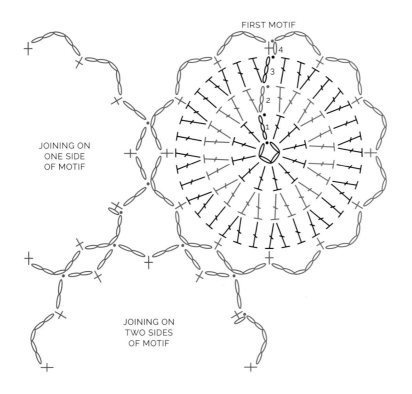

JOINING ON
ONE SIDE
OF MOTIF

JOINING ON
TWO SIDES
OF MOTIF

◯ = chain (ch)

• = slip st (sl st)

+ = single crochet (sc)

T = double crochet (dc)

Yoke

Rnd 1: With smaller hook, join yarn with sl st to any ch-7 sp on top edge of tube, ch 1, sc in same sp, *ch 5, sc in next ch-7 sp; rep from * around, ending with ch 2, dc in first sc at beg of rnd to join instead of last ch-5 sp—28 ch-7 sps.

Rnds 2–4: Rep Rnd 1.

Rnd 5: Ch 3, 4 dc in same sp, 5 dc in each ch-5 sp around, join with sl st to top of beg ch-3—140 dc.

Rnd 6: Ch 3, dc in each st around, join with sl st to top of beg ch-3—140 dc. Fasten off.

Finishing

Weave in ends. Wash, block to finished measurements, and let dry.

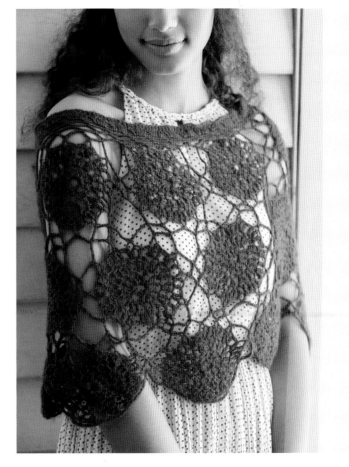

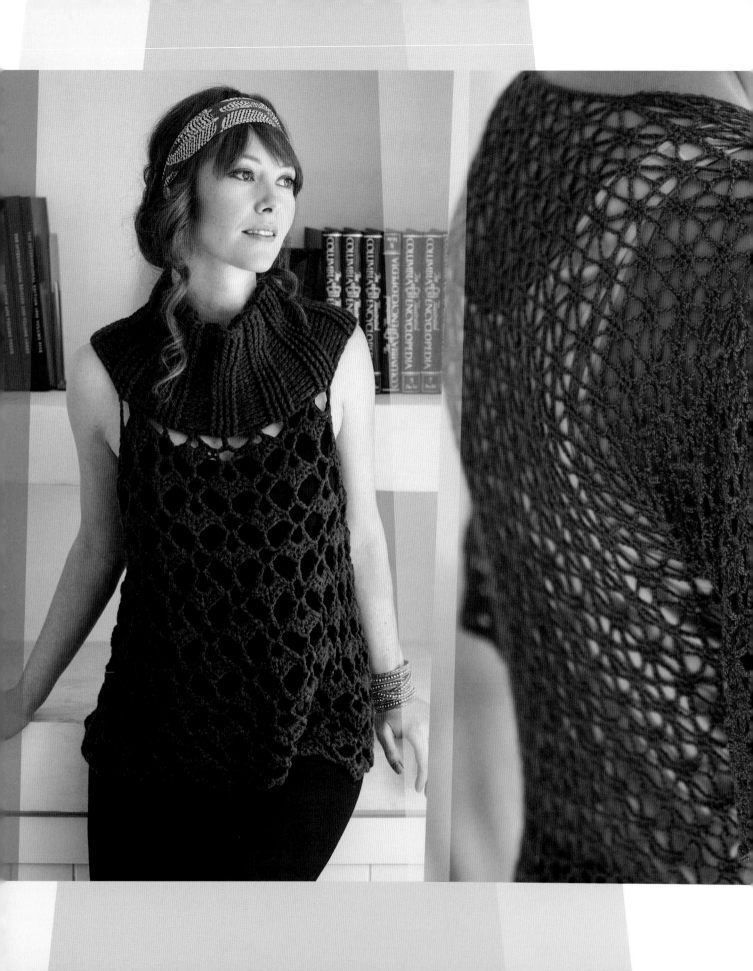

CHAPTER TWO *Allover Lace*

Watching lace stitch patterns blossom after blocking is one of the greatest pleasures a crafter knows. This chapter is dedicated to creating garments from allover lace patterns and manipulating them in a variety of ways to create shaping. As novice crocheters, we venture into the world of lace with a scarf or rectangular wrap. This chapter is the next step when you want a fitted garment showcasing your lacy stitchwork.

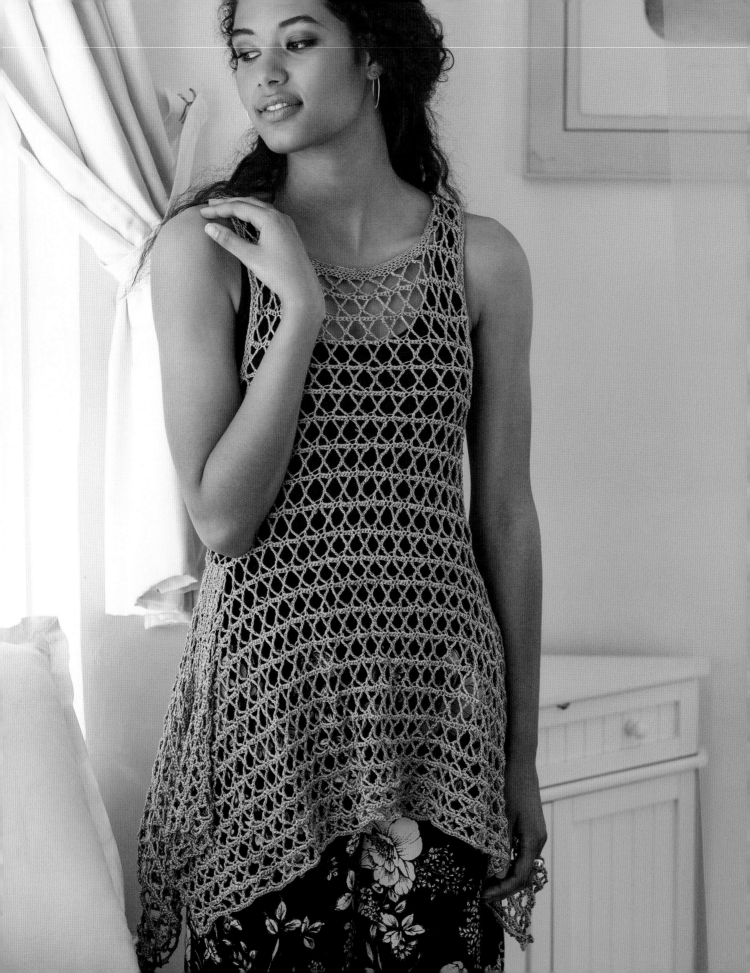

YARN

Sport weight (#2 Fine).

SHOWN HERE: Alchemy Yarns Silken Straw
(100% silk; 236 yd [216 m]/1.4 oz [40 g]):
#143W Vinca, 3 (5, 5, 6, 6) skeins.

HOOK

C2 (2.75 mm) or size needed to obtain
gauge.

NOTIONS

Yarn needle.

GAUGE

22 sts and 8 rows = 4" (10 cm) in pattern,
blocked.

Trapeze
TANK

This is a great summer tank. It can be worn loose and drapey
over shorts or chinos with cute wedge sandals. For a more
fitted look, cinch it with a belt over leggings. The handkerchief-
style hem is interesting, and working the fabric in such a tiny,
delicate gauge makes a very fine fabric that is flattering on most
body types. You could extend the length of this top to make a
summer dress or beach cover-up, too.

FINISHED SIZE

Directions are given for size S.
Changes for M, L, XL, and 2X are
in parentheses.

FINISHED BUST: 35 (38½, 42,
45½, 51)" (89 [98, 106.5, 115.5,
129.5] cm).

FINISHED LENGTH
(WITHOUT DRAPE ON
SIDES): 25½ (25½, 25½,
26½, 27½)" (65 [65, 65, 67.5,
70] cm).

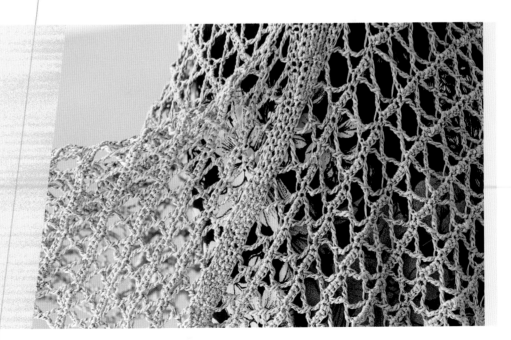

STITCH GUIDE

Foundation sc (Fsc): Start with a slipknot, ch 2, insert hook in 2nd ch from hook, draw up a loop, yo, draw through 1 lp, yo and draw through 2 lps—1 sc with its own ch at bottom. Work next st under lps of that ch. *Insert hook under 2 loops at bottom of the previous st, draw up a loop, yo and draw through 1 lp, yo and draw through 2 lps; rep from * for length of foundation.

Beginning X-stitch (Beg X-st): Ch 4 (counts as first leg of beg X-st), sk next 3 sts, tr in next st (counts as 2nd leg of beg X-st), ch 7 (counts as top right leg of X-st, ch 3), tr in top of first 2 legs of beg X-st.

X-stitch (X-st): Yo (4 times), insert hook in next st, [yo, draw through 2 lps on hook] twice, yo (twice), sk next 3 sts, insert hook in next st, [yo, draw through 2 lps on hook] 4 times (counts as 2nd leg and top right leg of X-st), ch 3, yo (twice), insert hook in top of first 2 legs of X-st, [yo, draw through 2 lps on hook] 3 times.

Beg Increase X-Stitch (Beg inc X-st): Ch 4 (counts as first leg of beg X-st), tr in same st (counts as 2nd leg of beg X-st), ch 7 (counts as top right leg of X-st, ch 3), tr in top of first 2 legs of beg X-st.

Increase X-stitch (X-st): Yo (4 times), insert hook in same st as 2nd leg of last X-st, [yo, draw through 2 lps on hook] twice, yo (twice), insert hook in next st, [yo, draw through 2 lps on hook] 4 times (counts as 2nd leg and top right leg of X-st), ch 3, yo (twice), insert hook in top of first 2 legs of X-st, [yo, draw through 2 lps on hook] 3 times.

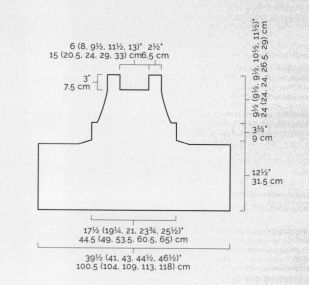

6 (8, 9½, 11½, 13)" 2½"
15 (20.5, 24, 29, 33) cm 6.5 cm

3"
7.5 cm

9½ (9½, 9½, 10½, 11½)"
24 (24, 24, 26.5, 29) cm

3½"
9 cm

12½"
31.5 cm

17½ (19¼, 21, 23¾, 25½)"
44.5 (49, 53.5, 60.5, 65) cm

39½ (41, 43, 44½, 46½)"
100.5 (104, 109, 113, 118) cm

Back

BACK RIGHT STRAP

Row 1: Work 15 Fsc.

Row 2 (RS): Beg X-st over first 5 sts, *X-st over next 5 sts; rep from * across, turn—3 X-sts.

Row 3 (WS): Ch 1, starting in first st, *sc in next sc, 3 sc in next ch-3 sp, sc in next sc; rep from * across, turn—15 sc.

Rows 4–6: Rep Rows 2 and 3 once; then rep Row 2 once more. Fasten off.

BACK LEFT STRAP

Work same as Back Right Strap through Row 6.

Yoke

Join Straps to work across Back Yoke.

Row 7: Ch 1, starting in first st, *sc in next st, 3 sc in next ch-3 sp, sc in next st*; rep from * to * across Left Strap, Work 35 (45, 55, 65, 75) Fsc, working across Row 6 of Back Right Strap; rep from * to * across, turn—65 (75, 85, 95, 105) sc.

Rows 8–15: Rep Rows 2 and 3 (4 times).

Row 16: Beg Inc X-st in first st, starting in same st, X-st over next 5 sts, Inc X-st worked in same st and next st, starting in same st, work 11 (13, 15, 17, 19) X-sts across to last 5 sts, Inc X-st in same st and next st, starting in same st, X-st over next 5 sts, Inc X-st in last st already holding last leg of last X-st—17 (19, 21, 23, 25) X-sts.

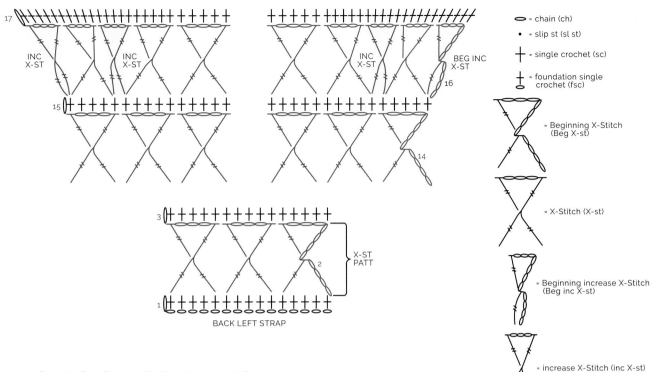

= chain (ch)

• = slip st (sl st)

+ = single crochet (sc)

= foundation single crochet (fsc)

= Beginning X-Stitch (Beg X-st)

= X-Stitch (X-st)

= Beginning increase X-Stitch (Beg inc X-st)

= increase X-Stitch (inc X-st)

BACK LEFT STRAP

X-ST PATT

Row 17: Rep Row 3—85 (95, 105, 115, 125) sc.

Row 18: Beg Inc X-st in first st, starting in same st, work 17 (19, 21, 23, 25) X-sts across, Inc X-st in last st already holding last leg of last X-st—19 (21, 23, 25, 27) X-sts—95 (105, 115, 125, 135) sts.

Sizes XL and 2X only

Rows 19 and 20 (22): Rep Rows 2 and 3 (1 [2] times). Fasten off.

Front

FRONT LEFT STRAP

Row 1: Work 15 Fsc.

Note: Alternatively, begin with Row 2 of Front Straps, working in free loops of foundation row of Back Straps for a seamless project!

Rows 2–6: Work same as Rows 2–6 of Back Right Strap. Fasten off.

FRONT RIGHT STRAP

Work same as Front Left Strap through Row 6.

FRONT YOKE

Join Straps to work across Front Yoke.

Rows 7–18 (18, 18, 20, 22): Rep Rows 7–18 (18, 18, 20, 22) of Back.

Body

Joining Fronts to Backs across underarms: Begin working in joined rnds, turning at the end of each rnd.

Rnd 19 (WS): Ch 1, starting in first st, *sc in next st, 3 sc in next ch-3 sp, sc in next sc*; rep from * to * across front, work 5 (5, 5, 5, 10) Fsc for underarm; rep from * to * across back, work 5 (5, 5, 5, 10) Fsc for underarm, join with sl st in first sc, turn—200 (220, 240, 260, 290) sts. Place a st marker in first and last Fsc of each underarm. Move markers up as work progresses.

Rnd 20 (RS): Beg X-st in first 5 sts, *X-st over next 5 sts; rep from * around, join with sl st in 4th ch of ch-7 of Beg X-st, turn—40 (44, 48, 52, 58) X-sts.

Rnd 21: Ch 1, starting in first st, *sc in next st, 3 sc in ch-3 sp, sc in next st; rep from * around, join with sl st in first sc, turn—200 (220, 240, 260, 290) sc.

Rnd 22: Rep Rnd 20.

Rnds 23–26: Rep Rnds 21 and 22 (twice). Fasten off.

Lower Back

Work now progresses in rows across Back only.

Row 1: Work 65 Fsc, starting in first st to the left of under-arm marker; rep Row 3 of Back across center 95 (105, 115, 125, 135) Back sts, ending in st before next marker, work 65 Fsc, turn, leaving rem sts unworked—225 (235, 245, 255, 265) sc.

Row 2: Beg X-st in first 5 sts, *X-st over next 5 sts; rep from * across, turn—225 (235, 245, 255, 265) sts.

Row 3: Rep Row 3 of Back.

Rows 4–25: Rep Rows 2 and 3 of Back (11 times). Fasten off.

Right Side Wedge

Row 1 (short-rows): With WS facing, join yarn with sl st in base of first Fsc of Row 1 of right side of Lower Back, ch 1, sc in each of first 65 sts, [ch 1, turn, sc in ea of next 5 sts] twice, [ch 1, turn, sc in ea of next 10 sts] twice, [ch 1, turn, sc in ea of next 15 sts] twice, [ch 1, turn, sc in ea of next 10 sts] twice, [ch 1, turn, sc in ea of next 5 sts] twice, ch 1, turn, sc in ea of next 65 sts. Fasten off.

Left Side Wedge

Row 1 (short-rows): With RS facing, join yarn with sl st in base of first Fsc of Row 1 of other side of Lower Back, ch 1, sc in each of first 65 sts, [ch 1, turn, sc in ea of next 5 sts] twice, [ch 1, turn, sc in ea of next 10 sts] twice, [ch 1, turn, sc in ea of next 15 sts] twice, [ch 1, turn, sc in ea of next 10 sts] twice, [ch 1, turn, sc in ea of next 5 sts] twice, ch 1, turn, sc in ea of next 65 sts. Do not fasten off.

Lower Front

Note: Lower Front is picked up and worked from one Lower Back Side Wedge and across Upper Front, then continued across other Lower Back Side Wedge.

Row 1: With WS facing, join yarn in first sc in Right Side Wedge, ch 1, sc in ea st across—225 (235, 245, 255, 265) sts.

Row 2: Beg X-st in first 5 sts, *X-st over next 5 sts; rep from * across, turn—225 (235, 245, 255, 265) sts.

Row 3: Rep Row 3 of Back.

Rows 4–25: Rep Rows 2 and 3 of Back (11 times). Fasten off.

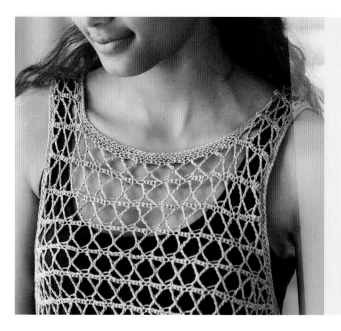

Armhole Edging

Rnd 1: With RS facing, join yarn with sl st in first st of one underarm, sc in ea st across underarm, 3 sc in ea leg of ea X-st around armhole opening, join with sl st in first sc—149 (149, 149, 149, 154) sc.

Rnds 2 and 3: Ch 1, sc in ea st around, join with sl st in first sc. Fasten off.

Rep Armhole Edging around other armhole.

Neck Band

Rnd 1: With RS facing, join yarn with sl st in first st of Back neck edge, ch 1, sc in ea st across Back neck edge, working across row-end sts of Straps, work 3 sc in each leg of each X-st across to Front neck edge, sc in ea st across Front neck edge, work 3 sc in each leg of each X-st across to Back neck edge, join with sl st in first sc.

Rnds 2 and 3: Ch 1, sc in ea st around, join with sl st in first sc. Fasten off.

Finishing

Sew ends of Side Wedges to skipped sts in Row 25 of Body. Weave in ends. Wash, block to finished measurements, and let dry.

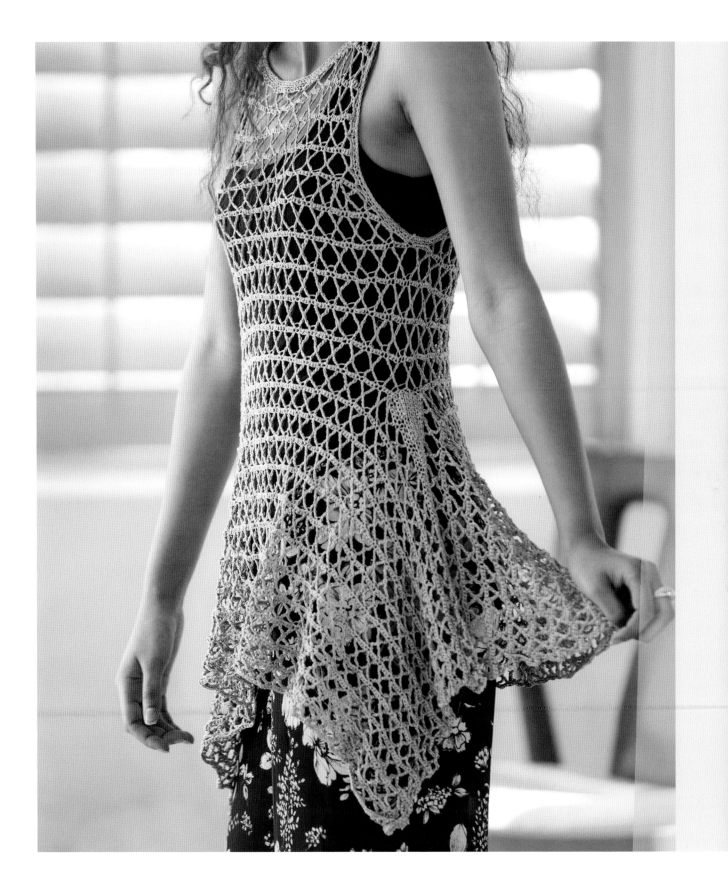

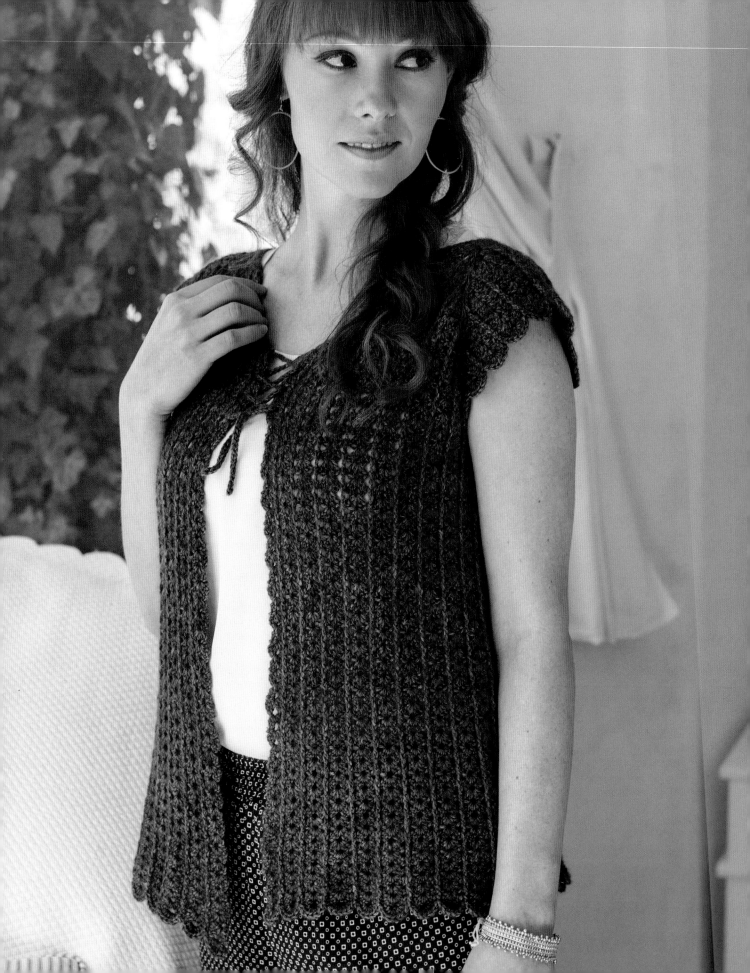

YARN

Sport weight (#2 Fine).

SHOWN HERE: The Fibre Co. Road to China Light (65% baby alpaca/15% silk/10% camel/10% cashmere; 159 yd [145 m]/ 1.75 oz [50 g]): Hematite, 7 (9, 10, 11, 12) skeins.

HOOK

G/6 (4 mm) or size needed to obtain gauge.

NOTIONS

Yarn needle.

GAUGE

[Shell, post st] 4 times in pattern = 4" (10 cm); 8 rows in pattern = 3" (7.5 cm).

Corset-Tied
CARDI

The key to working clean, perfect post stitches is making sure you don't have them placed near the beginning or end of a row or round. I specifically designed this cardigan so the shells are at the beginning and end of the rows so I didn't need to fuss with chains at or around the post stitches.

The closure for this sweater is a set of simple chain ties. You could always add buttons—the holes in the lace fabric would work for buttonholes if you shop for just the right size. But the beauty of the chains is simplicity. I like how simple and sweet the ties look in a bow, but I love how it looks if you lace it up a few inches.

FINISHED SIZE

Directions are given for size S. Changes for M, L, XL, and 2X are in parentheses.

FINISHED BUST: 36 (40, 44, 48, 52)" (91.5 [101.5, 112, 122, 132] cm).

FINISHED LENGTH: 20½ (22, 23½, 25, 26½)" (52 [56, 59.5, 63.5, 67.5] cm).

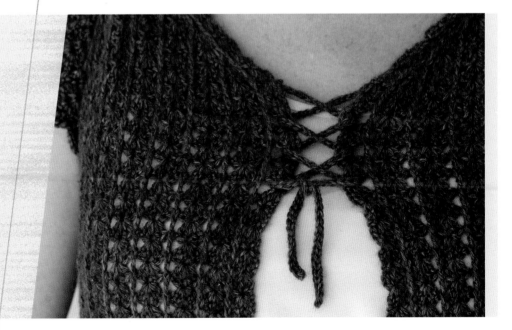

STITCH GUIDE

Foundation sc (Fsc): Start with a slipknot, ch 2, insert hook in 2nd ch from hook, draw up a loop, yo, draw through 1 lp, yo and draw through 2 lps—1 sc with its own ch at bottom. Work next st under lps of that ch. *Insert hook under 2 loops at bottom of the previous st, draw up a loop, yo and draw through 1 lp, yo and draw through 2 lps; rep from * for length of foundation.

Beginning shell (beg shell): Ch 3, (dc, ch 3, 2 dc) in same st or sp.

Shell: (2 dc, ch 3, 2 dc) in same st or sp.

Front post double crochet (FPdc): Yo, insert hook from front to back to front again around the post of next st, yo, draw yarn through st, [yo, draw yarn through 2 lps on hook] twice.

Back post double crochet (BPdc): Yo, insert hook from back to front to back again around the post of next st, yo, draw yarn through st, [yo, draw yarn through 2 lps on hook] twice.

NOTE

* The armhole opening is worked in a perfect multiple of the stitch pattern, so if you wanted to continue to make longer sleeves, just pick up where you left off at the end of the yoke and continue until desired length.

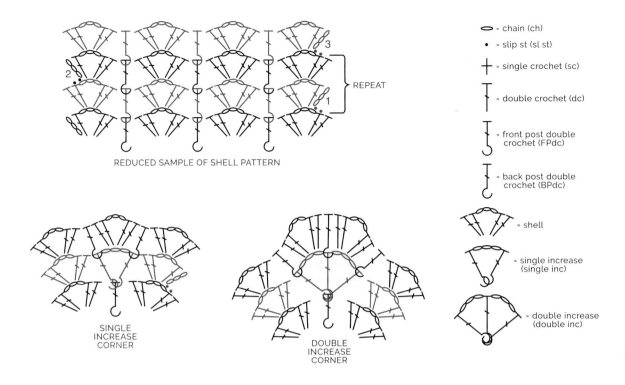

REDUCED SAMPLE OF SHELL PATTERN

SINGLE
INCREASE
CORNER

DOUBLE
INCREASE
CORNER

REPEAT

⬭ = chain (ch)

• = slip st (sl st)

✝ = single crochet (sc)

🇹 = double crochet (dc)

🇹 = front post double
crochet (FPdc)

🇹 = back post double
crochet (BPdc)

= shell

= single increase
(single inc)

= double increase
(double inc)

Yoke

Foundation Row: Work 95 Fsc, turn.

Row 1: Working in sc side of foundation, sk first 2 sts, shell in next st, *sk next 2 sts, FPdc around the post of next sc, sk 2 sts, shell in next st; rep from * across, ending with shell in last sc—16 shells.

Row 2: Sl st to first ch-3 sp, beg shell in same sp, *BPdc around the post of next FPdc, shell in next ch-3 sp; rep from * across—16 shells.

Row 3: Sl st to first ch-3 sp, beg shell in same sp, (FPdc, ch 3, FPdc) around the post of next BPdc (single inc made), shell in next ch-3 sp, (FPdc, ch-3, FPdc, ch-3, FPdc) around the post of next BPdc (double inc made), shell in next ch-3 sp, FPdc around the post of next BPdc, shell in next ch-3 sp, (FPdc, ch-3, FPdc, ch-3, FPdc) around the post of next BPdc, [shell in next ch-3 sp, FPdc around the post of next BPdc] 7 times, shell in next ch-3 sp, (FPdc, ch-3, FPdc, ch-3, FPdc) around the post of next BPdc, shell in next ch-3 sp, FPdc around the post of next BPdc, shell in next ch-3 sp, (FPdc, ch-3, FPdc, ch-3, FPdc) around the post of next BPdc, shell in next ch-3 sp, (FPdc, ch-3, FPdc) around the post of next BPdc, shell in last ch-3 sp—26 ch-3 sps.

Row 4: Rep Row 2—26 shells.

Row 5: Sl st to first ch-3 sp, beg shell in same sp, *(FPdc, ch 3, FPdc) around the post of next BPdc, shell in next ch-3 sp, FPdc around the post of next BPdc, shell in next ch-3 sp, (FPdc, ch 3, FPdc, ch 3, FPdc) around the post of next BPdc, [shell in next ch-3 sp, FPdc around the post of next BPdc] 3 times, shell in next ch-3 sp, (FPdc, ch 3, FPdc, ch 3, FPdc) around the post of next BPdc, [shell in next ch-3 sp, FPdc around the post of next BPdc] 9 times, shell in next ch-3 sp, (FPdc, ch 3, FPdc, ch 3, FPdc) around the post of next BPdc, [shell in next ch-3 sp, FPdc around the post of next BPdc] 3 times, shell in next ch-3 sp, (FPdc, ch 3, FPdc, ch 3, FPdc) around the post of next BPdc, [shell in next ch-3 sp, FPdc around the post of next BPdc] twice, shell in next ch-3 sp, (FPdc, ch 3, FPdc) around the post of next BPdc, shell in last ch-3 sp, turn—35 ch-3 sps.

Row 6: Rep Row 2—35 shells.

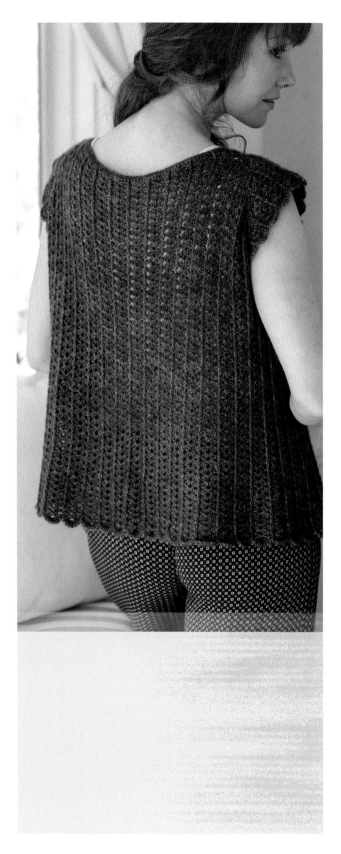

Row 7: Sl st to first ch-3 sp, beg shell in same sp, *(FPdc, ch 3, FPdc) around the post of next BPdc, [shell in next ch-3 sp, FPdc around the post of next BPdc] 4 times, shell in next ch-3 sp, (FPdc, ch 3, FPdc, ch 3, FPdc) around the post of next BPdc, [shell in next ch-3 sp, FPdc around the post of next BPdc] 5 times, shell in next ch-3 sp, (FPdc, ch 3, FPdc, ch 3, FPdc) around the post of next BPdc, [shell in next ch-3 sp, FPdc around the post of next BPdc] 11 times, shell in next ch-3 sp, (FPdc, ch 3, FPdc, ch 3, FPdc) around the post of next BPdc, [shell in next ch-3 sp, FPdc around the post of next BPdc] 5 times, shell in next ch-3 sp, (FPdc, ch 3, FPdc, ch 3, FPdc) around the post of next BPdc, [shell in next ch-3 sp, FPdc around the post of next BPdc] 4 times, shell in next ch-3 sp, (FPdc, ch 3, FPdc) around the post of next BPdc, shell in last ch-3 sp, turn—36 (40, 44, 48, 52) ch-3 sps—45 ch-3 sps.

Row 8: Rep Row 2—45 shells.

Note: At this point we are omitting the front single increases. You will continue to work the double increases at the 4 raglan corners (8 increases per odd-numbered row).

Row 9: Sl st to first ch-3 sp, beg shell in same sp, [FPdc around the post of next BPdc, shell in next ch-3 sp] 7 times, (FPdc, ch 3, FPdc, ch 3, FPdc) around the post of next BPdc, [shell in next ch-3 sp, FPdc around the post of next BPdc] 7 times, shell in next ch-3 sp, (FPdc, ch 3, FPdc, ch 3, FPdc) around the post of next BPdc, [shell in next ch-3 sp, FPdc around the post of next BPdc] 13 times, shell in next ch-3 sp, (FPdc, ch 3, FPdc, ch 3, FPdc) around the post of next BPdc, [shell in next ch-3 sp, FPdc around the post of next BPdc] 7 times, shell in next ch-3 sp, (FPdc, ch 3, FPdc, ch 3, FPdc) around the post of next BPdc, [shell in next ch-3 sp, FPdc around the post of next BPdc] 7 times, shell in last ch-3 sp—53 ch-3 sps.

Row 10: Rep Row 2—53 shells.

Sizes M, L, XL, and 2X only

Row 11: Sl st to first ch-3 sp, beg shell in same sp, [FPdc around the post of next BPdc, shell in next ch-3 sp] 8 times, (FPdc, ch 3, FPdc, ch 3, FPdc) around the post of next BPdc, [shell in next ch-3 sp, FPdc around the post of next BPdc] 9 times, shell in next ch-3 sp, (FPdc, ch 3, FPdc, ch 3, FPdc) around the post of next BPdc, [shell in next ch-3 sp, FPdc around the post of next BPdc] 15 times, shell in next ch-3 sp, (FPdc, ch 3, FPdc, ch 3, FPdc) around the post of next BPdc, [shell in next ch-3 sp, FPdc around the post of next BPdc] 9 times, shell in next ch-3 sp, (FPdc, ch 3, FPdc, ch 3, FPdc) around the post of next BPdc, [shell in next ch-3 sp, FPdc around the post of next BPdc] 8 times, shell in last ch-3 sp—61 ch-3 sps.

Row 12: Rep Row 2—61 shells.

Sizes L, XL, and 2X only

Row 13: Sl st to first ch-3 sp, beg shell in same sp, [FPdc around the post of next BPdc, shell in next ch-3 sp] 9 times, (FPdc, ch 3, FPdc, ch 3, FPdc) around the post of next BPdc, [shell in next ch-3 sp, FPdc around the post of next BPdc] 11 times, shell in next ch-3 sp, (FPdc, ch 3, FPdc, ch 3, FPdc) around the post of next BPdc, [shell in next ch-3 sp, FPdc around the post of next BPdc] 17 times, shell in next ch-3 sp, (FPdc, ch 3, FPdc, ch 3, FPdc) around the post of next BPdc, [shell in next ch-3 sp, FPdc around the post of next BPdc] 11 times, shell in next ch-3 sp, (FPdc, ch 3, FPdc, ch 3, FPdc) around the post of next BPdc, [shell in next ch-3 sp, FPdc around the post of next BPdc] 9 times, shell in last ch-3 sp—69 ch-3 sps.

Row 14: Rep Row 2—69 shells.

Sizes XL and 2X only

Row 15: Sl st to first ch-3 sp, beg shell in same sp, [FPdc around the post of next BPdc, shell in next ch-3 sp] 10 times, (FPdc, ch 3, FPdc, ch 3, FPdc) around the post of next BPdc, [shell in next ch-3 sp, FPdc around the post of next BPdc] 13 times, shell in next ch-3 sp, (FPdc, ch 3, FPdc, ch 3, FPdc) around the post of next BPdc, [shell in next ch-3 sp, FPdc around the post of next BPdc] 19 times, shell in next ch-3 sp, (FPdc, ch 3, FPdc, ch 3, FPdc) around the post of next BPdc, [shell in next ch-3 sp, FPdc around the post of next BPdc] 13 times, shell in next ch-3 sp, (FPdc, ch 3, FPdc, ch 3, FPdc) around the post of next BPdc, [shell in next ch-3 sp, FPdc around the post of next BPdc] 10 times, shell in last ch-3 sp—77 ch-3 sps.

Row 16: Rep Row 2—77 shells.

Size 2X only

Row 17: Sl st to first ch-3 sp, beg shell in same sp, [FPdc around the post of next BPdc, shell in next ch-3 sp] 11 times, (FPdc, ch 3, FPdc, ch 3, FPdc) around the post of next BPdc, [shell in next ch-3 sp, FPdc around the post of next BPdc] 15 times, shell in next ch-3 sp, (FPdc, ch 3, FPdc, ch 3, FPdc) around the post of next BPdc, [shell in next ch-3 sp, FPdc around the post of next BPdc] 21 times, shell in next ch-3 sp, (FPdc, ch 3, FPdc, ch 3, FPdc) around the post of next BPdc, [shell in next ch-3 sp, FPdc around the post of next BPdc] 15 times, shell in next ch-3 sp, (FPdc, ch 3, FPdc, ch 3, FPdc) around the post of next BPdc, [shell in next ch-3 sp, FPdc around the post of next BPdc] 11 times, shell in last ch-3 sp—85 ch-3 sps.

Row 18: Rep Row 2—85 shells.

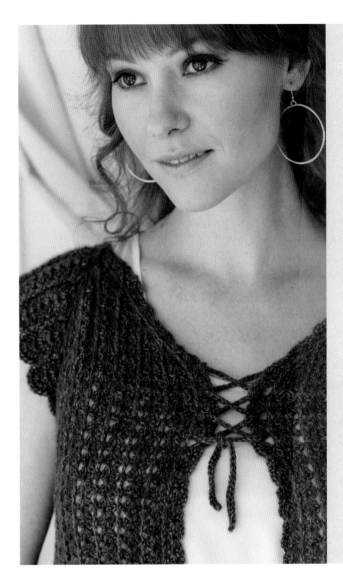

Body

Divide into Fronts and Back and add underarm ch sts.

Row 1: Sl st to first ch-3 sp, beg shell in same sp, FPdc around the post of next BPdc, [shell in next ch-3 sp, FPdc around the post of next BPdc] 8 (9, 10, 11, 12) times, ch 5 for underarm, sk next 9 (11, 13, 13, 15) BPdc, FPdc around the post of next BPdc, [shell in next ch-3 sp, FPdc around the post of next BPdc] 16 (18, 20, 22, 24) times, ch 5 for underarm, sk next 9 (11, 13, 13, 15) BPdc, FPdc around the post of next BPdc, [shell in next ch-3 sp, FPdc around the post of next BPdc] 8 (9, 10, 11, 12) times, shell in last ch-3 sp, turn—34 (38, 42, 46, 50) shells; 2 ch-5 sps.

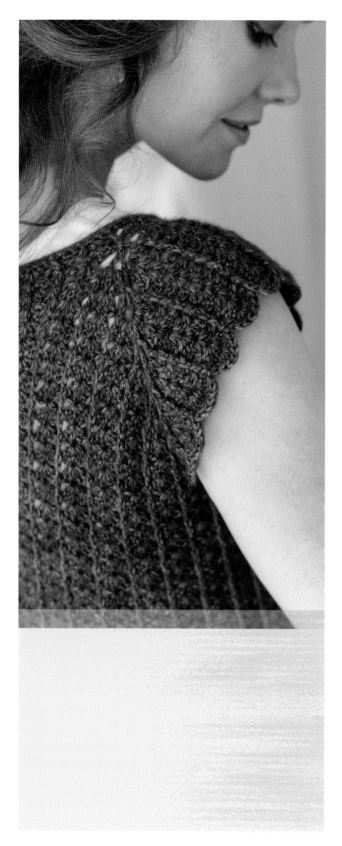

Row 2: Rep Row 2 of Yoke, working shell in 3rd ch of ch-5 sp at each underarm—36 (40, 44, 48, 52) shells.

Row 3: Sl st to first ch-3 sp, beg shell in same sp, *FPdc around the post of next BPdc, shell in next ch-3 sp, rep from * across, turn.

Row 4: Sl st to first ch-3 sp, beg shell in same sp, *BPdc around the post of next FPdc, shell in next ch-3 sp; rep from * across, turn.

Rep Rows 3 and 4 until Body measures 14 (14½, 15, 15½, 16)" (35.5 [37, 38, 39.5, 40.5] cm) from underarm, ending with a WS row. Fasten off.

Body Edging

Last Row: Sl st to first ch-3 sp, ch 3, 6 dc in same sp, *FPsc around the post of next BPdc, 7 dc in next ch-3 sp; rep from * across. Fasten off.

Sleeve Edging

With RS facing, join yarn with sl st in ch-3 sp of first skipped shell of sleeve opening, ch 3, 6 dc in same sp, FPdc around the post of next BPdc, 7 dc in next ch-3 sp; rep from * across all skipped ch-3 sps of sleeve opening. Fasten off. Note: Do not work in the underarm ch sts.

Tie *(make 2)*

With RS facing, join yarn with sl st at either end of Row 10 (12, 14, 16, 18), ch 58, sl st in 2nd ch from hook and ea ch across, sl st in same row-end st on sweater. Fasten off.

Rep Tie at other end of Row 10 (12, 14, 16, 18).

Note: If you want to make longer corset ties farther down the front of the sweater, double (ch 115) or triple (ch 172) this Tie length.

Finishing

Weave in ends. Wash, block to finished measurements, and let dry.

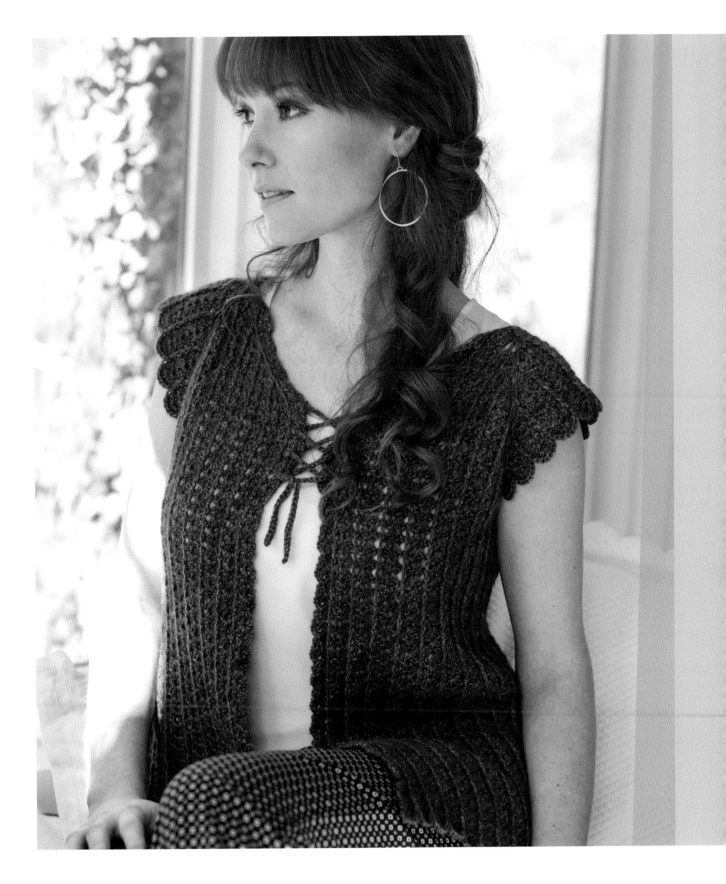

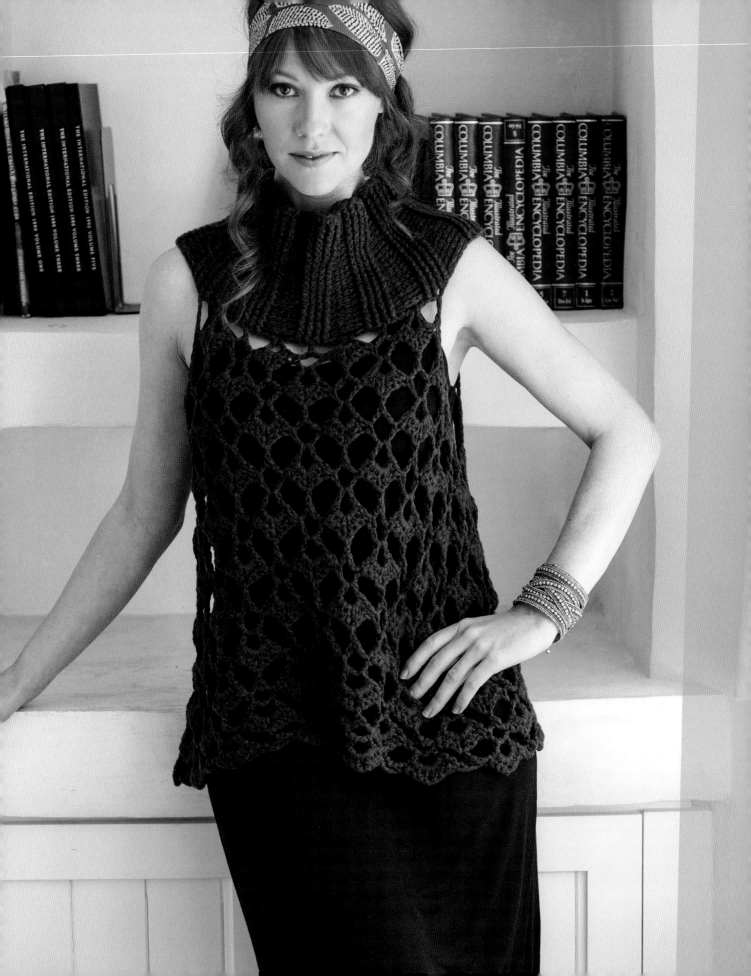

Chunky weight (#5 Bulky).

SHOWN HERE: Tahki Stacy Charles Aria (78% extrafine merino wool/22% nylon; 108 yd [100 ml]/1.75 oz [50 g]): #05 Teal, 6 (7, 8, 8, 9) balls.

HOOKS

K/10.5 (6.5 mm) and M/13 (8 mm) or sizes needed to obtain gauges.

NOTIONS

Yarn needle.

GAUGE

With smaller hook in ribbing pattern (collar), 15 sts and 11 rows = 4" (10 cm), blocked.

With larger hook in lace pattern (body), 1 pattern rep = 3" (7.5 cm); 4 rows = 4" (10 cm).

Note: The lace portion of this top has a drastic change in gauge after blocking. Make sure to block your swatch before measuring to ensure the best fit.

Lapis
WESEK TUNIC

Inspired by the ancient Egyptian collar necklaces, this lacy tunic begins with a large, chunky cowl neckline that magically scrunches around the neck and splays open around the shoulders. You could stop here and it would be a lovely cowl, or continue with the large-scale openwork lace for an awesome layering piece.

The construction of this yarn is very interesting as well. It's a chunky-weight chainette, which gives you great loft without the weight. This is a surprisingly light piece considering it's made from bulky-weight wool!

Wear this tunic over a monochromatic long-sleeved dress and tights with boots, or a tank and jeans with a great belt.

FINISHED SIZE

Directions are given for size S. Changes for M, L, XL, and 2X are in parentheses.

FINISHED BUST: 36 (42, 48, 54, 60)" (91.5 [106.5, 122, 137, 152.5] cm).

FINISHED LENGTH: 27½" (70 cm).

STITCH GUIDE

Foundation dc (Fdc): Start with a slipknot, ch 3, yo, insert hook in 3rd ch from hook, draw up a loop, yo, draw through 1 lp, [yo, and draw through 2 lps] twice—1 dc with its own ch at bottom. Work next st under lps of that ch. *Insert hook under 2 loops at bottom of the previous st, draw up a loop, yo and draw through 1 lp, [yo and draw through 2 lps] twice; rep from * for length of foundation.

Shell: (3 dc, ch 1, 3 dc) in same sp.

Beginning shell (beg shell): Ch 3, (2 dc, ch 1, 3 dc) in same sp.

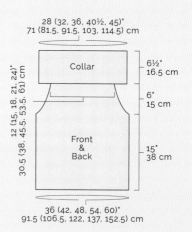

28 (32, 36, 40½, 45)"
71 (81.5, 91.5, 103, 114.5) cm

Collar

6½"
16.5 cm

6"
15 cm

12 (15, 18, 21, 24)"
30.5 (38, 45.5, 53.5, 61) cm

Front
&
Back

15"
38 cm

36 (42, 48, 54, 60)"
91.5 (106.5, 122, 137, 152.5) cm

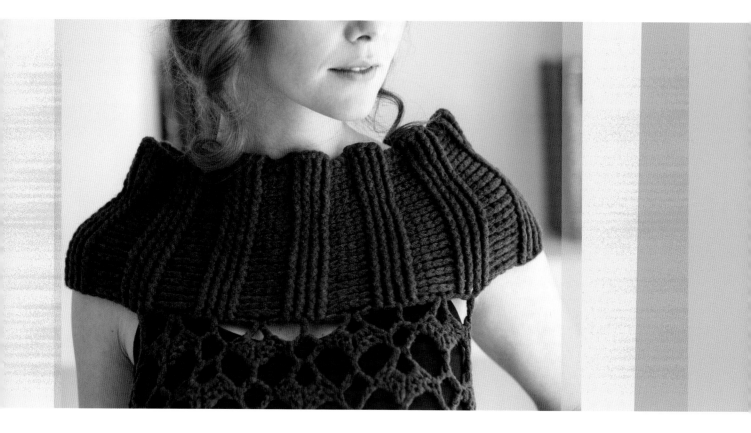

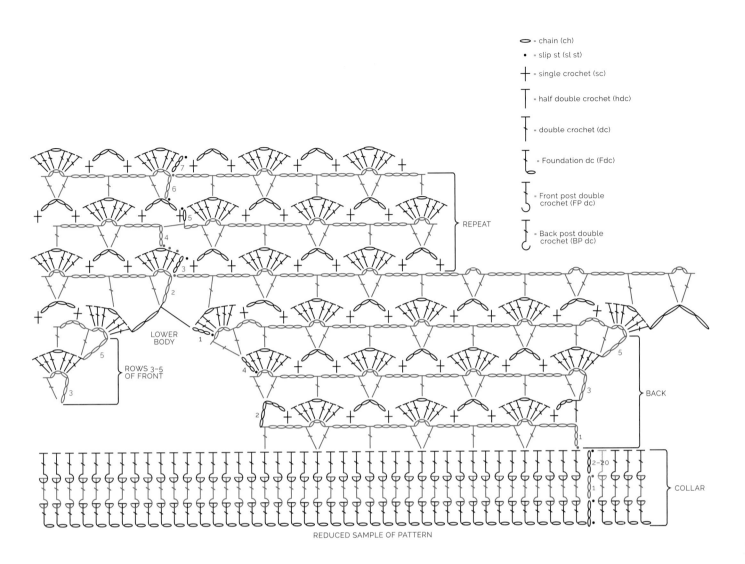

Key:

⬭ = chain (ch)

• = slip st (sl st)

+ = single crochet (sc)

T = half double crochet (hdc)

T = double crochet (dc)

= Foundation dc (Fdc)

= Front post double crochet (FP dc)

= Back post double crochet (BP dc)

REPEAT

LOWER BODY

ROWS 3–5 OF FRONT

BACK

COLLAR

REDUCED SAMPLE OF PATTERN

Collar

With smaller hook, leaving a 6" (15 cm) sewing length, work 104 (120, 136, 152, 168) Fdc, without twisting foundation, join with sl st in first st to form a ring.

Rnd 1: Ch 3 (counts as first FPdc), FPdc around the post of each of next 3 sts, *BPdc around the post of each of next 4 sts**, FPdc around the post of each of next 4 sts, rep from * around—104 (120, 136, 152, 168) post sts.

Rnds 2–20: Rep Rnd 1. Fasten off. With sewing length, sew base of foundation together.

Front Bodice

Work now progresses in rows.

Row 1: With RS facing and larger hook, join yarn with sl st in 2nd FPdc of any 4-FPdc group, ch 7 (counts as dc, ch 4),

sk next 3 sts, *(dc, ch 3, dc) in next st, ch 4, sk next 3 sts, dc in next st, ch 4, sk next 3 sts; rep from * 3 (4, 5, 6, 7) times, turn—4 (5, 6, 7, 8) ch-3 sps.

Row 2: Ch 6 (counts as dc, ch 3 here and throughout), sc in next ch-4 sp, *shell in next ch-3 sp, sc in next ch-4 sp**, ch 4, sc in next ch-4 sp, rep from * across, ending last rep at **, ch 3, dc in 3rd ch of ch-7 turning ch, turn—4 (5, 6, 7, 8) shells.

Row 3: Ch 6 (counts as dc, ch 3), dc in first st, *ch 4, dc in next ch-1 sp, ch 4, (dc, ch 3, dc) in next ch-4 sp; rep from * across, ending with last (dc, ch 3, dc) in 3rd ch of ch-6 turning ch, turn—5 (6, 7, 8, 9) ch-3 sps.

Row 4: Sl st in next ch-3 sp, beg shell in same sp, *sc in next ch-4 sp, ch 4, sc in next ch-4 sp, shell in next ch-3 sp; rep from * across, turn—5 (6, 7, 8, 9) shells.

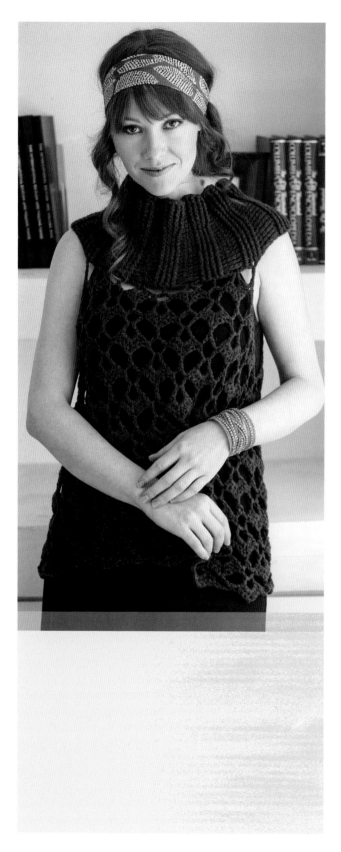

Row 5: Ch 6 (counts as dc, ch 3), dc in first st, ch 4, dc in next ch-1 sp, ch 4, (dc, ch 3, dc) in next ch-4 sp; rep from * across, ending with last (dc, ch 3, dc) in top of ch-3 turning ch, turn—6 (7, 8, 9, 10) ch-3 sps. Fasten off.

Back Bodice

With RS facing, sk next 19 sts, join yarn in next st. Work same as Front Bodice through Row 5. Do not fasten off.

Lower Body

Join Front to Back at underarms and work remainder of Body in joined rnds.

Rnd 1 (WS): Sl st in next ch-3 sp, beg shell in same sp, *sc in next ch-4 sp, ch 4, sc in next ch-4 sp, shell in next ch-3 sp; rep from * 5 (6, 7, 8, 9) times, ch 4, with RS for Front facing, shell in first ch-3 sp, sc in next ch-4 sp, ch 4, sc in next ch-4 sp, shell in next ch-3 sp, rep from * 5 (6, 7, 8, 9) times, ch 4, ch 2, hdc in top of ch-3 turning ch at beg of rnd instead of last ch-4 sp, turn—12 (14, 16, 18, 20) ch-3 sps.

Rnd 2 (RS): Ch 6, dc in same sp, *ch 4, dc in next ch-1 sp, ch 4**, (dc, ch 3, dc) in next ch-4 sp; rep from * around, ending last rep at **, join with sl st in 3rd ch of beg ch-6—12 (14, 16, 18, 20) shells.

Rnd 3: Sl st in first ch-3 sp, beg shell in first ch-3 sp, *sc in next ch-4 sp, ch 4, sc in next ch-4 sp**, shell in next ch-3 sp; rep from * around, ending last rep at **, join with sl st in top of beg ch-3, turn.

Rnd 4: Sl st in each of next 2 dc, sl st in next ch-1 sp, ch 7 (counts as dc, ch 4), *(dc, ch 3, dc) in next ch-4 sp**, ch 4, dc in next ch-1 sp, ch 4, rep from * around, ending last rep at **, ch 2, hdc in 3rd ch of beg ch-7 instead of last ch-4 sp.

Rnd 5: Ch 1, sc in same sp, *ch 4, sc in next ch-4 sp, shell in next ch-3 sp**, sc in next ch-4 sp; rep from * around, ending last rep at **, join with sl st in first sc.

Rnd 6: Sl st in next ch-4 sp, ch 6, dc in same sp, *ch 4, dc in next ch-1 sp, ch 4**, (dc, ch 3, dc) in next ch-4 sp; rep from * around, ending last rep at **, join with sl st in 3rd ch of beg ch-6.

Rep Rnds 3–6 until Lower Body measures 15" (38 cm) from underarm, ending with Rnd 2 or 5 of pattern. Fasten off.

Finishing

Weave in ends. Wash, block to finished measurements, and let dry.

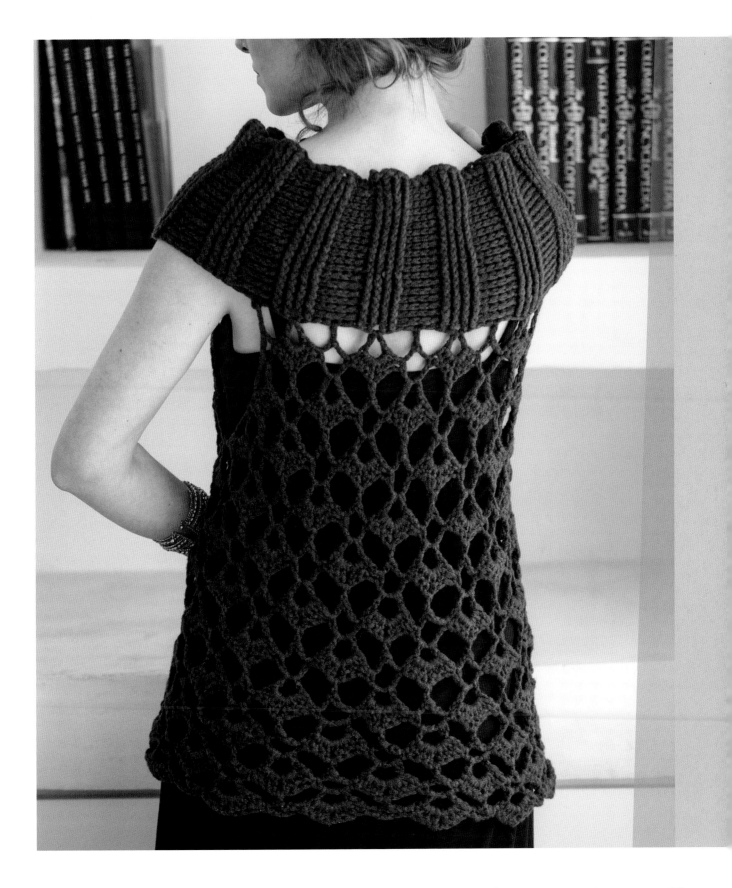

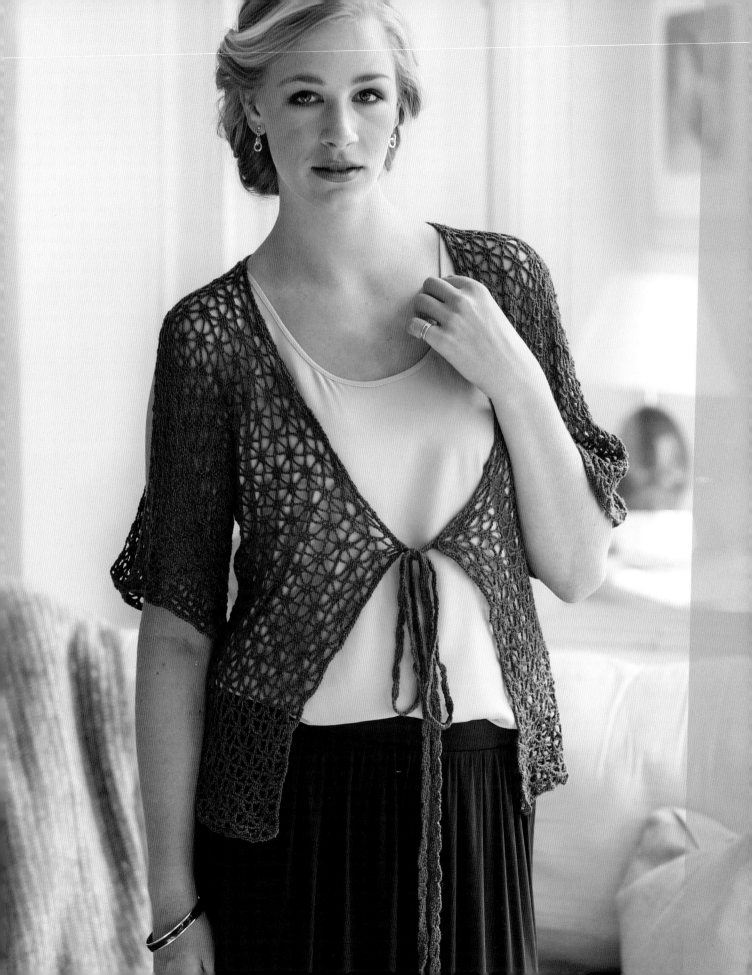

YARN

Lace weight (#1 Super Fine).

SHOWN HERE: Cascade Yarns Forest Hills (51% silk/49% merino wool; 785 yd [718 m]/3.5 oz [100 g]): #15 Hyacinth Violet, 1 (2, 2, 2, 2) balls.

HOOK

E/4 (3.5 mm) or size needed to obtain gauge.

NOTIONS

Yarn needle.

GAUGE

2 pattern reps = 3" (7.5 cm); 8 rows = 3" (7.5 cm) in pattern, blocked.

Rosetta
WRAP SWEATER

This delicate lace sweater is seamless in construction. The lace stitch pattern is a 4-row repeat that is easy to memorize.

The waist ties hit just above the natural waistline and tie in the back. The sleeves have large cutouts, exposing the upper arm and shoulder, which has a subtle sensuous quality without being overtly sexy. The lower body cuts away below the wrap (not with decreases, but rather by working the stitches straight).

FINISHED SIZE

Directions are given for size S. Changes for M, L, XL, and 2X are in parentheses.

FINISHED BUST: 34½ (37½, 42, 45½, 49½)" (87.5 [95, 106.5, 115.5, 125.5] cm).

FINISHED LENGTH: 25½" (65 cm).

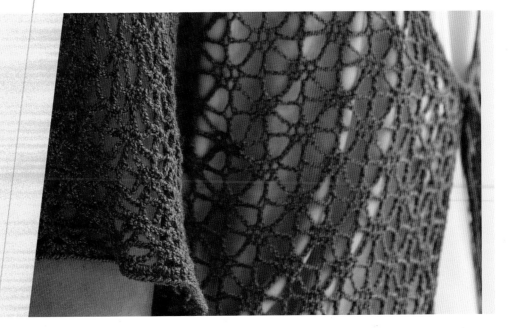

NOTES

- Sweater is worked from the top down, beginning with the back.

- The fronts are crocheted onto the opposite sides of the back's foundation chain for a seamless construction.

- This stitch grows a lot in the blocking process. Block your gauge swatch to ensure a good fit.

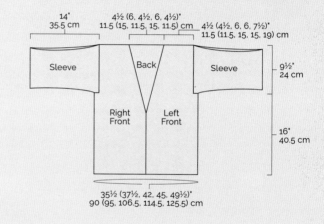

14"
35.5 cm

4½ (6, 4½, 6, 4½)"
11.5 (15, 11.5, 15, 11.5) cm

4½ (4½, 6, 6, 7½)"
11.5 (11.5, 15, 15, 19) cm

Sleeve Back Sleeve

9½"
24 cm

Right
Front Left
Front

16"
40.5 cm

35½ (37½, 42, 45, 49½)"
90 (95, 106.5, 114.5, 125.5) cm

Back

With MC, starting at neck edge, ch 91 (101, 111, 121, 131).

Row 1: Sc in 2nd ch from hook, sc in next ch, ch 4, sk next 3 ch, dc in next ch, ch 4, sk next 3 ch, sc in next ch, *sc in ea of next 2 ch, ch 4, sk next 3 ch, dc in next ch, ch 4, sk next 3 ch, sc in next ch; rep from * across, turn—9 (10, 11, 12, 13) reps.

Row 2: Ch 6 (counts as dc, ch 3 here and throughout), *sc in next ch-4 sp, sc in next dc, sc in next ch-4 sp, ch 3, sk next sc, dc in next sc**, ch 3; rep from * across, ending last rep at **, turn.

Row 3: Ch 7 (counts as dc, ch 4 here and throughout), sk next ch-4 sp, *sc in ea of next 3 sc, ch 4, sk next ch-4 sp**, dc in next dc, ch 4, sk next ch-4 sp; rep from * across, ending last rep at **, dc in 3rd ch of ch-6 turning ch, turn.

Row 4: Ch 1, sc in first dc, *ch 3, sk next sc, dc in next sc, ch 3, sc in next ch-4 sp**, sc in next dc, sc in next ch-4 sp; rep from * across, ending last rep at **, sc in 3rd ch of ch-7 turning ch, turn.

Row 5: Ch 1, sc in ea of first 2 sc, *ch 4, sk next ch-4 sp, dc in next dc, ch 4, sk next ch-4 sp**, sc in each of next 3 sc; rep from * across, ending last rep at **, sc in last sc, turn.

Rep Rows 2–5 for pattern.

Rows 6–25: Rep Rows 2–5 (5 times). Fasten off.

Note: Begin Right and Left Fronts from corresponding free loops on top edge of back. Alternatively, you could work them separately and sew the shoulder seams at the end.

Left Front

Note: Increases are worked on odd-numbered rows for Left Front and even-numbered rows for Right Front.

Ch 31 (31, 41, 41, 51).

Note: Alternatively, join yarn in first ch on opposite side of foundation ch of Back, ch 1, then begin Row 1 of Left Front, working in free loops of foundation row of Back Straps for a seamless project!

Row 1: Sc in 2nd ch from hook, sc in next ch, ch 4, sk next 3 ch, dc in next ch, ch 4, sk next 3 ch, sc in next ch, *sc in ea of next 2 ch, ch 4, sk 3 ch, dc in next ch sp, ch 4 sk next 3 ch, sc in next ch; rep from * 1 (1, 2, 2, 3) times, turn—3 (3, 4, 4, 5) reps.

Rows 6–9: Rep Rows 2–5 of Back (twice).

Row 10: Ch 6, sc in next ch-4 sp, sc in next dc, sc in next ch-4 sp, ch 3, sk next sc, dc in next sc, *ch 3, sc in next ch-4 sp, sc in next dc, sc in next ch-4 sp, ch 3, sk next sc, dc in next sc; rep from * across, ch 5, turn.

Row 11: Ch 1, sc in 2nd ch from hook, sc in next ch, ch 4, sk next 3 ch, dc in next dc, *ch 4, sc in ea of next 3 sc, ch 4, dc in next dc; rep from * across, ending with last dc in 3rd ch of turning ch, turn.

Row 12: Ch 1, sc in first dc, *sc in next ch-4 sp, ch 3, sk next sc, dc in next sc**, ch 3, sc in next ch-4 sp, sc in next dc, rep from * across, ending last rep at **, turn.

Row 13: Ch 7, sk next ch-3 sp, *sc in ea of next 3 sc, ch 4, sk next ch-3 sp, dc in next dc, ch 4, sk next ch-3 sp; rep from * across, ending last rep at **, sc in each of last 2 sc, turn.

Row 14: Ch 6, sc in next ch-4 sp, sc in next dc, *sc in next ch-4 sp, ch 3, sk next sc, dc in next sc, ch 3, sc in next ch-4 sp, sc in next dc; rep from * across, ending with last sc in 3rd ch of ch-7 turning ch, ch 5, turn.

Row 15: Ch 7, sc in 12th ch from hook, sc in ea of next 2 sc, *ch 4, sk next ch-3 sp, dc in next dc, *ch 4, sk next ch-3 sp, sc in ea of next 3 sc; rep from * across, ch 4, sk next ch-3 sp, dc in 3rd ch of ch-6 turning ch, turn.

Row 16: Ch 1, sc in first dc, *sc in next ch-4 sp, ch 3, sk next sc, dc in next sc, ch 3, sc in next ch-4 sp, sc in next dc; rep from * across, ending with last dc in 3rd ch of ch-7 turning ch, turn—4 (4, 5, 5, 6) reps.

Row 17: Ch 1, sc in first sc, *sc in next sc, ch 4, sk next ch-3 sp, dc in next dc, ch 4, sk next ch-3 sp, sc in ea of next 2 sc; rep from * across, turn.

Rows 18–25: Rep Rows 10–17 once—5 (5, 6, 6, 7) reps at end of last row. Fasten off.

Right Front

Ch 31 (31, 41, 41, 51).

Note: Alternatively, join yarn in first ch on opposite side of foundation ch of Back, ch 1, then begin Row 1 of Left Front, working in free loops of foundation row of Back Straps for a seamless project!

Work same as Left Front through Row 9.

Row 10: Rep Row 2.

Row 11: Ch 7, sk next ch-3 sp, *sc in ea of next 3 sc, ch 4, sk next ch-3 sp**, dc in next dc, ch 4, sk next ch-3 sp; rep from * across, ending last rep from **, dc in 3rd ch of ch-7 turning ch, ch 5, turn.

Row 12: Ch 6, sc in 12th ch from hook, *sc in next dc, sc in next ch-4 sp, ch 3, sk next sc, dc in next sc, ch 3, sc in next ch-4 sp; rep from * across, sc in 3rd ch of ch-7 turning ch, turn.

Row 13: Ch 1, sc in ea of first 2 sc, *ch 4, sk next ch-3 sp, dc in next dc, ch 4, sk next ch-3 sp, sc in ea of next 3 sc; rep from * across, ch 4, dc in 3rd ch of ch-6 turning ch, turn.

Row 14: Ch 1, sc in first dc, *sc in next ch-4 sp, ch 3, sk next sc, dc in next sc**, ch 3, sc in next ch-4 sp, sc in next dc; rep from * across, ending last rep at **, turn.

Row 15: Ch 7, sk next ch-3 sp, *sc in ea of next 3 sc, ch 4, sk next ch-3 sp, dc in next dc, ch 4, sk next ch-3 sp; rep from * across, sc in last 2 sc, ch 5, turn.

Row 16: Ch 1, sc in 2nd ch from hook, sc in next ch, ch 3, sk next 3 ch, *dc in next sc, ch 3, sc next ch-4 sp**, sc in next dc, sc in next ch-4 sp, ch 3, sk next sc; rep from * across, ending last rep at **, sc in 3rd ch of ch-7 turning ch, turn—4 (4, 5, 5, 6) reps.

Row 17: Ch 1, sc in each of first 2 sc, *ch 4, sk next ch-3 sp, dc in next dc, ch 4, sk next ch-3 sp**, sc in ea of next 3 sc; rep from * across, ending last rep at **, sc in each of last 2 sc, turn.

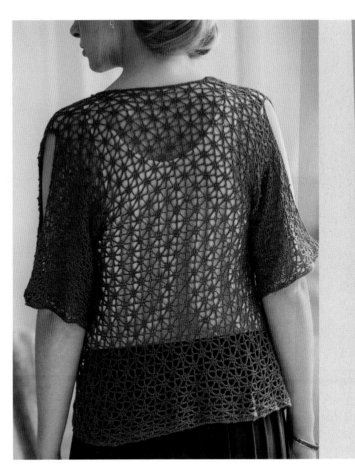

Rows 18–25: Rep Rows 10–17 once—5 (5, 6, 6, 7) reps at end of last row. Do not fasten off.

Lower Body

Note: On next row, begin working across right front, add chains for underarm, work across back, add chains for underarm, then work across left front, thus joining fronts to back.

Row 26 (WS): Ch 6, sc in next ch-4 sp, sc in next dc, sc in next ch-4 sp, ch 3, sk next sc, dc in next sc, *ch 3, sc in next ch-4 sp, sc in next dc, sc in next ch-4 sp, ch 3, sk next sc, dc in next sc*; rep from * to * 4 (4, 5, 5, 6) times, ch 10 (for underarm), with WS of back facing, dc in first sc of Back; rep from * to * 9 (10, 11, 12, 13) times across back, ch 10 (for underarm), with WS of left front facing, dc in first sc of left front; rep from * to * 4 (4, 5, 5, 6) times, ch 5, turn.

Row 27: Ch 1, sc in 2nd ch from hook, sc in next ch, ch 4, sk next 3 ch, dc in next dc, *ch 4, sk next ch-3 sp, sc in ea of next 3 sc, ch 4, sk next ch-3 sp, dc in next dc; rep from * across, ending with last dc in 3rd ch of ch-6 turning ch, ch 5, turn—22 (23, 26, 27, 30) reps.

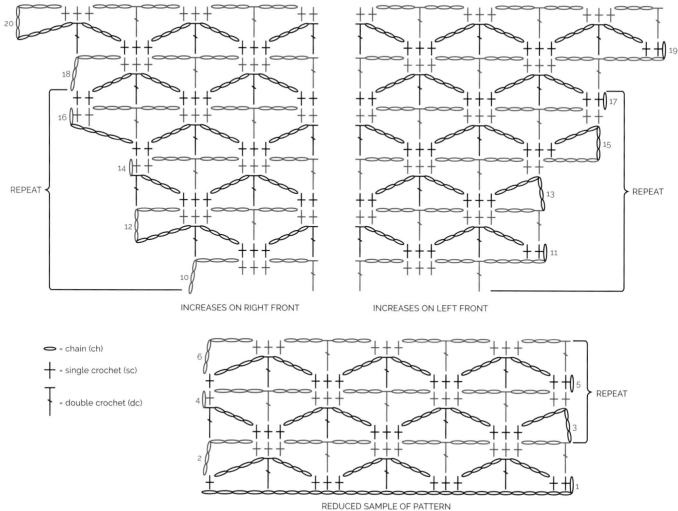

INCREASES ON RIGHT FRONT INCREASES ON LEFT FRONT

REPEAT

= chain (ch)

+ = single crochet (sc)

⊤ = double crochet (dc)

REDUCED SAMPLE OF PATTERN

Row 28: Ch 6, sc in 12th ch from hook, sc in next dc, *sc in next ch-4 sp, ch 3, sk next sc, dc in next sc**, ch 3, sc in next ch-4 sp, sc in next dc; rep from * across, ending last rep at **, turn.

Row 29: Ch 7, sk next ch-3 sp, sc in ea of next 3 sc, ch 4, sk next ch-3 sp, dc in next dc, *ch 4, sc in ea of next 3 sc, ch 4, dc in next dc; rep from * across, ending with last dc in 3rd ch of turning ch, turn.

Row 30: Ch 1, sc in first dc, *sc in next ch-4 sp, ch 3, sk next sc, dc in next sc, ch 3, sc in next ch-4 sp, sc in next dc; rep from * across, ending with last sc in 3rd ch of ch-7 turning ch, ch 5, turn.

Row 31: Ch, sc in 12th ch from hook, sc in ea of next 2 sc, *ch 4, sk next ch-3 sp, dc in next dc, ch 4, sk next ch-3 sp**, sc in each of next 3 sc; rep from * across, ending last rep at **, sc in last 2 sc, ch 5, turn—24 (25, 28, 29, 32) reps.

Row 32: Ch 1, sc in 2nd ch from hook, sc in next ch, ch 3, sk next 3 ch, *dc in next sc, ch 3, sc in next ch-4 sp**, sc in next dc, sc in next ch-4 sp, ch 3, sk next sc; rep from * across, ending last rep at **, sc in 3rd ch of ch-7 turning ch, turn.

Row 33: Ch 1, sc in ea of first 2 sc, *ch 4, sk next ch-3 sp, dc in next dc, ch 4, sk next ch-3 sp**, sc in ea of next 3 sc; rep from * across, ending last rep at **, sc in each of last 2 sc, turn—24 (25, 28, 29, 32) reps.

Sizes M and L only

Rows 34–37: Rep Rows 26–29 once—27 (30) reps.

Sizes XL and 2X only

Rows 34–41: Rep Rows 26–33 once—33 (36) reps.

Note: Place marker at beginning and end of last row for placement of ties.

All Sizes

Starting with Row 2 (4, 4, 2, 2) of pattern, work even in established pattern until Body measures 16" (40.5 cm) from this point ending with Row 2 of pattern. Fasten off.

First Sleeve

Notes: Side edge of sleeve opening is remarkably similar to top of Row 5, which allows for easy continuation of pattern, beginning with a Row 5 of pattern.

Sleeves begin and end at shoulder seam in turned rows, without joining, to allow for an opening at shoulder side of Sleeves (cold shoulder, unseamed arm). At the end of the sleeve, the cuff will be sewn together and cuff joined in a rnd.

Row 1: With RS facing, join yarn with sl st in shoulder seam on top of sleeve opening, ch 1, 2 sc in first row-end sc, *ch 4, dc in top of next row-end dc, ch 4, sk next row-end dc, sc in next row-end sc**, 2 sc in next row-end sc*; rep from * to * across to underarm, ch 4, sk next 4 ch, dc in next ch, ch 4, sk next 5 ch; rep from * to * across to shoulder seam, ending last rep at **, do not join, turn—13 reps.

Rows 2–40: Starting with Row 2 of pattern, work even ending with Row 5. At end of last row, join with sl st in first sc of row.

Sleeve Edging

Note: All dc's are skipped in this round. The pattern repeat of 10 is reduced to a pattern repeat of 9 for the sleeve edging.

Rnd 41: Ch 3 (counts as dc), dc in next sc, *3 dc next ch-4 sp, sk next dc, 3 dc in next ch-4 sp**, dc in ea of next 3 sc; rep from * around, ending last rep at **, dc in last sc, join with sl st in top of beg ch-3—117 dc. Fasten off.

Rep Sleeve around other Sleeve opening.

Sweater Edging

Rnd 1: With RS facing, join yarn with sl st in bottom right-hand corner of Right Front, sc evenly across Right Front to shoulder seam, sc evenly across back neck edge to shoulder seam, sc evenly across Left Front edge to bottom edge, sc evenly across bottom edge, join with sl st in first sc.

First Tie

With RS facing, join yarn with sl st in sc at marked corner of Right Front edge, ch 4 (counts as tr), 3 tr in same st, turn, *sl st in sp bet 2nd and 3rd tr, ch 4, 3 tr in same sp, turn; rep from * 49 (54, 59, 64, 69) times. Fasten off.

Second Tie

With RS facing, join yarn with sl st in sc at marked corner of Left Front edge; rep First Tie.

Finishing

Weave in ends. Wash, block to finished measurements, and let dry.

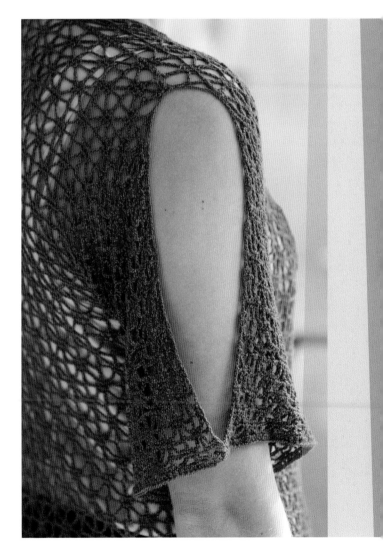

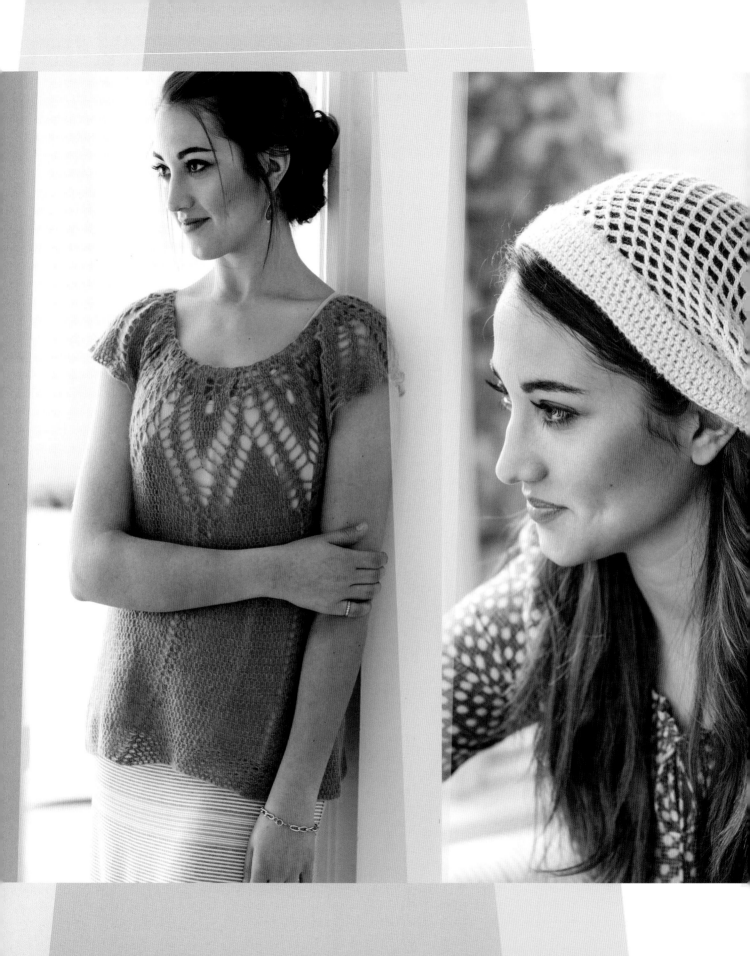

Lace as the Focal Point

CHAPTER THREE

When I fall in love with a lace motif I don't always necessarily want to repeat the design in tiled motifs. This chapter is dedicated to the times when using that motif as the focal point of a design creates drama and flair that can't be accomplished otherwise. You also can create shaping and detailing illusions by the way you contrast the lace with more simple, opaque stitch panels.

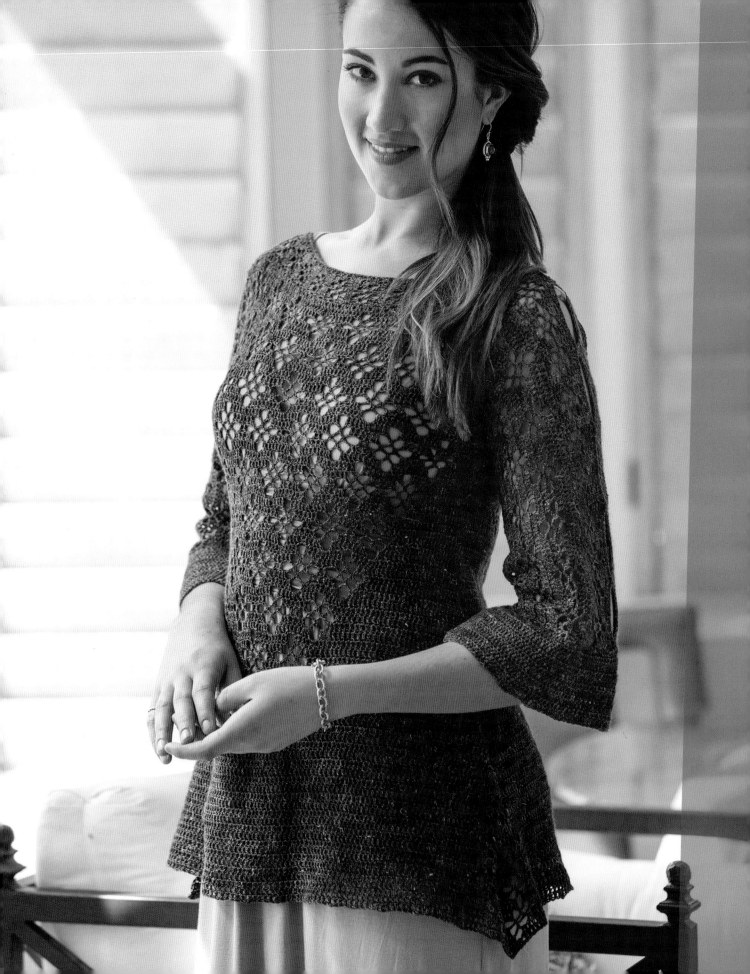

YARN

Lace weight (#1 Super Fine).

SHOWN HERE: The Fibre Co. Meadow (40% merino wool/25% baby llama/20% silk/15% linen; 545 yd [498 m]/3.5 oz [100 g]): Larkspur, 3 (3, 4, 4, 4) skeins.

HOOK

C/2 (2.75 mm) or size needed to obtain gauge.

NOTIONS

Yarn needle

Stitch markers

GAUGE

22 sts and 12 rows = 4" (10 cm) in dc, blocked.

FINISHED SIZE

Directions are given for size S. Changes for M, L, XL, and 2X are in parentheses.

FINISHED BUST: 36 (41, 45, 49½, 54)" (91.5 [104, 114.5, 125.5, 137] cm).

LENGTH: 27 (30, 30, 31½, 31½)" (68.5 [76, 76, 80, 80] cm).

Deep Sea
TUNIC

"Love grows slow, it will grow. Love grows fast, it won't last." Sometimes I repeat this to myself when I'm designing a sweater. If the yarn is bulky and the gauge is big and quick, it probably won't be a figure-flattering sweater that I will feel healthy, sexy, and fit wearing. If I spend the extra time and patience making a fine-gauge sweater that is a thin, drapey fabric, I know it will be worth the time invested because it will look good on and I'll feel great in it.

It will take a long time to make this sweater. You will need a lot of laceweight yarn. But it's going to look fabulous on you, and it will be worth it.

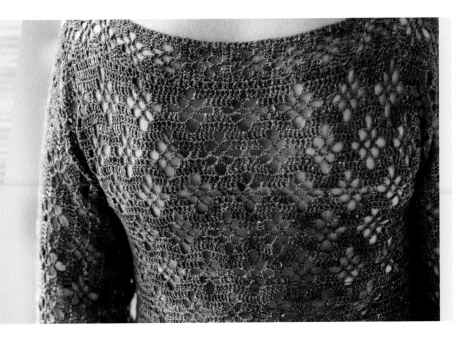

STITCH GUIDE

Dc-join: Dc in designated sp on Front, sl st in corresponding st on Back.

Front/Back *(make 2)*

SLEEVE TOP STRIP

Note: Sleeve Top Strips are worked in an Aligned Pattern with a 4-row rep.

Ch 17.

Row 1 (RS): Dc in 4th ch from hook, dc in ea of next 5 ch, ch 3, sk 2 chs, 1dc in ea of next 6 sts, turn.

Row 2: Ch 3 (counts as dc here and throughout), dc in ea of next 3 sts, ch 3, sk next 2 sts, sc in ch-3 sp, ch 3, sk next 2 sts, dc in ea of last 4 sts, turn.

Row 3: Ch 3, dc in next st, ch 3, sk next 2 sts, sc in ch-3 sp, ch 3, sc in next ch-3 sp, ch 3, sk next 2 sts, dc in ea of last 2 sts, turn.

Row 4: Ch 3, dc in next st, 2 dc in next ch-3 sp, ch 3, sc in next ch-3 sp, ch 3, 2 dc in next ch-3 sp, dc in ea of last 2 sts, turn.

Row 5: Ch 3, dc in ea of next 3 sts, 2 dc in next ch-3 sp, ch 3, 2 dc in next ch-3 sp, dc in ea of last 4 sts, turn.

Rows 6–125 (133, 141, 149, 157): Rep Rows 2–5 (30 [32, 34, 36, 38] times). Fasten off.

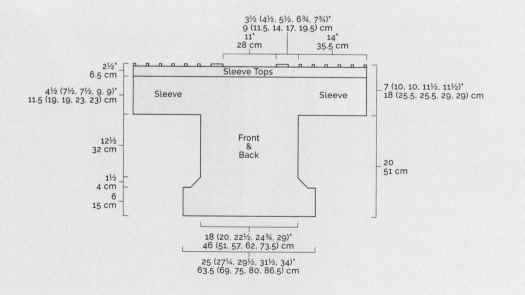

Note: Body is worked across side of rows of Sleeve Top Strips, at a rate of approximately 2 dc per row. Sleeve pattern requires a multiple of 12 plus 2 sts. In order to achieve desired number of sts, make the following adjustments to pattern: Sizes S and XL, add 4 (2) sts by working 3 dc (instead of 2 dc) in ea of 4 (2) sps; Sizes L and 2X, subtract work 4 (2) sts by working 1 dc (instead of 2 dc) in ea of 4 (2) sps.

Sleeve

Note: Remainder of sweater is worked in an Offset Pattern with a 10-row rep. Pattern requires a multiple of 12 + 1 sts.

Row 1: With RS facing, join yarn with sl st in bottom left-hand corner of one Sleeve Top Strip, ch 3, work 253 (265, 277, 289, 301) dc evenly spaced across by working 2 dc in ea row-end st across, adjusting by adding or subtracting sts as necessary (see note above) to achieve designated number of dc, turn—254 (266, 278, 290, 302) sts.

Row 2: Ch 3, *dc in ea of next 5 sts, ch 3, sk next 2 sts, dc in ea of next 5 sts; rep from * 20 (21, 22, 23, 24) times, dc in last st, turn—21 (22, 23, 24, 25) reps.

Row 3: Ch 3, *dc in ea of next 3 sts, ch 3, sk next 2 sts, sc in next ch-3 sp, ch 3, sk next 2 sts, dc in ea of next 3 sts; rep from * across, dc in last st.

Row 4: Ch 3, *dc in next st, ch 3, sk next 2 sts, (sc, ch 3) in ea of next 2 ch-3 sps, ch 3, sk next 2 sts, dc in next st; rep from * across, dc in last st, turn.

Row 5: Ch 3, *dc in next st, 2 dc in next ch-3 sp, ch 3, sc in next ch-3 sp, ch 3, 2 dc in next ch-3 sp, dc in next st; rep from * across, dc in last st, turn.

Row 6: Ch 3, *dc in ea of next 3 sts, 2 dc in next ch-3 sp, ch 3, 2 dc in next ch-3 sp, dc in next 6 sts; rep from * across, dc in last st, turn—20 (21, 22, 23, 24) reps.

Row 7: Ch 3, dc in ea of next 5 sts, 2 dc in next ch-3 sp, *dc in ea of next 4 sts, ch 3, sk next 2 sts, dc in ea of next 4 sts, 2 dc in next ch-3 sp; rep from * across to last 6 sts, dc in ea of last 6 sts, turn.

Row 8: Ch 3, dc in ea of next 9 sts, *ch 3, sk next 2 sts, sc in ch-3 sp, ch 3, sk next 2 sts, dc in ea of next 6 sts; rep from * across to last 4 sts, dc in ea of last 4 sts, turn.

Row 9: Ch 3, dc in ea of next 7 sts, *ch 3, sk next 2 sts, (sc, ch 3) in ea of next 2 ch-3 sps, sk next 2 sts, dc in each of next 2 sts; rep from * across to last 7 sts, dc in ea st to end.

Row 10: Ch 3, dc in ea of next 7 sts, *2 dc in next ch-3 sp, ch 3, sc in next ch-3 sp, ch 3, 2 dc in next ch-3 sp, dc in each of next 2 sts; rep from * across to last 6 sts, dc in ea of last 6 sts, turn.

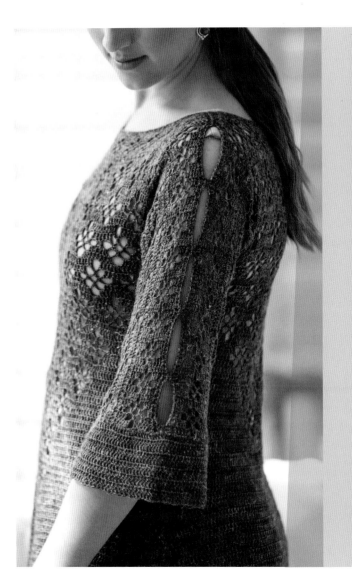

Row 11: Ch 3, dc in ea of next 9 sts, *2 dc in next ch-3 sp, ch 3, 2 dc in next ch-3 sp, dc in ea of next 6 sts; rep from * across to last 4 sts, dc in ea of last 4 sts, turn.

Row 12: Ch 3, dc in ea of next 5 sts, *ch 3, sk next 2 sts, dc in ea of next 4 sts, 2 dc in next ch-3 sp, dc in ea of next 4 sts; rep from * across to last 2 sts, dc in ea of last 2 sts, turn—21 (22, 23, 24, 25) reps.

Rep Rows 3–12 for Offset Pattern on Sleeves.

Work even in pattern for 4 (14, 14, 19, 19) rows, ending with Row 6 (6, 6, 11, 11) of pattern. Fasten off.

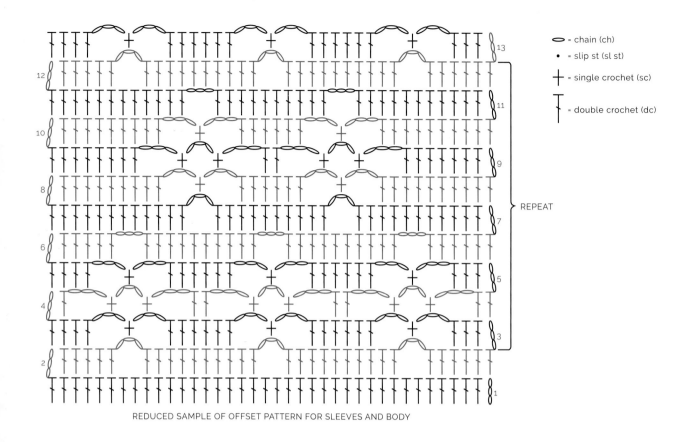

REDUCED SAMPLE OF OFFSET PATTERN FOR SLEEVES AND BODY

= chain (ch)

• = slip st (sl st)

+ = single crochet (sc)

| = double crochet (dc)

REPEAT

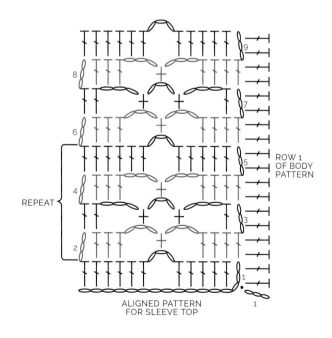

ALIGNED PATTERN
FOR SLEEVE TOP

ROW 1
OF BODY
PATTERN

REPEAT

Back Shoulder Edging

Row 1: With RS facing, join yarn with sl st in top right-hand corner of Sleeve Top Strip of Back, ch 3, work 2 dc in ea row-end st across. Fasten off.

Front Shoulder Edging

Row 1 (joining row): With RS facing, join yarn with sl st in top right-hand corner of Sleeve Top Strip of Front, ch 3, with WS of Front and Back together, sl st in corresponding dc on Back, 2 dc-joins in same row-end st, *2 dc in each of next 7 row-end sts, 2 dc-joins in next row-end st*; rep from * to * 4 (5, 5, 6, 6) times, [2 dc-joins in next row-end st] 5 (1, 5, 1, 5) times, 2 dc in each of next 33 row-end sts, [2 dc-joins in next row-end st] 5 (1, 5, 1, 5) times; rep from * to * 5 (6, 6, 7, 7) times. Fasten off.

Sleeve Cuff

Rnd 1: Working in end of rows for sleeve and tops of sts (or foundation ch) of Sleeve Top Strip, join with sl st in bottom right-hand corner of Front Sleeve, ch 3, dc in same row-end st, work 2 dc in ea row-end st across Sleeve edge to Sleeve Top Strip, dc in ea of next 6 sts of Sleeve Top Strip, 2 dc in ch-3 sp, dc in each of next 6 sts, 2 dc in ea row-end st across next 2 Shoulder Edging rows, dc in ea of next 6 sts of Sleeve Top Strip, 2 dc in ch-3 sp, dc in each of next 6 sts, work 2 dc in ea row-end st across Sleeve edge to beg, join with sl st in top of beg ch-3—100 (156, 156, 176, 176) dc.

Rnds 2–12: Ch 3, dc in ea st around, join with sl st in top of beg ch-3. Fasten off.

Lower Body

Note: Body is worked across the last row of sts of Front and Back Sleeves, joined into a rnd at this point. Continue in Off-set Pattern, decreasing 1 rep every 5 rnds until 2 reps remain, filling in with dc on either side of center pattern.

Sizes S, M, and L only

Row 1: With RS of Front facing, sk first 6 ch-3 sps, sk next 9 dc, join yarn with sl st in next st, ch 3, sk first st, *2 dc in next ch-3 sp, dc in ea of next 4 sts, ch 3, sk next 2 sts, dc in ea of next 4 sts*; rep from * to * 7 (8, 9) times, 2 dc in next ch-3 sp, dc in next dc, sk first 6 ch-3 sps on Back, sk next 9 dc, dc in next dc, rep from * to * 8 (9, 10) times across Back, 2 dc in next ch-3 sp, dc in next dc, join with sl st in top of beg ch-3 on Front—8 (9, 10) ch-3 sps on Front and Back.

Sizes XL and 2X only

Row 1: With WS of Front facing, sk first 6 ch-3 sps, sk next 3 dc, join yarn with sl st in next st, ch 3, sk first st, dc in ea of next 6 sts, *2 dc in next ch-3 sp, dc in ea of next 4 sts, ch 3, sk next 2 sts, dc in ea of next 4 sts*; rep from * to * 9 (10) times, 2 dc in next ch-3 sp, dc in ea of next 7 dc, sk first 6 ch-3 sps on Back, sk next 9 dc, dc in next dc; rep from * to * 10 (11) times across Back, 2 dc in next ch-3 sp, dc in ea of next 7 dc, join with sl st in top of beg ch-3 on Front, turn—10 (11) ch-3 sps on Front and Back.

All Sizes

Rnd 2 (WS): Ch 3, dc in ea st across to 2 sts before next ch-3 sp on Back, ch 3, sk next 2 sts, sc in next ch-3 sp, ch 3, sk next 2 sts, *dc in ea of next 6 sts, ch 3, sk next 2 sts, sc in next ch-3 sp, ch 3, sk next 2 sts*; rep from * to * across

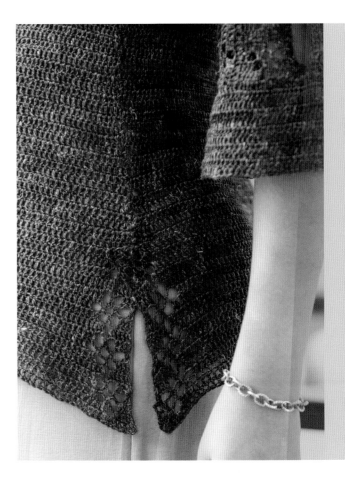

to last ch-3 sp on Back, dc in ea st across to 2 sts before next ch-3 sp on Front, ch 3, sk next 2 sts, sc in next ch-3 sp, ch 3, sk next 2 sts, rep from * to * across to last ch-3 sp on Front, dc in ea st around, join with sl st in top of beg ch-3, turn.

Rnd 3 (RS): Ch 3, dc in ea st across to 2 sts before next ch-3 sp on Front, *ch 3, sk next 2 sts, (sc, ch 3) in ea of next 2 ch-3 sps, ch 3, sk next 2 sts, dc in ea of next 2 sts*; rep from * to * across to last ch-3 sp on Front, dc in ea st across to 2 sts before next ch-3 sp on Back, rep from * to * across to 2 sts past last ch-3 sp on Back, dc in ea st around, join with sl st in top of beg ch-3, turn.

Rnd 4 (WS): Ch 3, dc in ea st across to next ch-3 sp on Back, *2 dc in next ch-3 sp, ch 3, sc in next ch-3 sp, ch 3, 2 dc in next ch-3 sp, dc in ea of next 2 sts; rep from * across to last ch-3 sp on Back, dc in each st across to next ch-3 sp on Front; rep from * to * across to last ch-3 sp on Front, dc in ea st around to beg, join with sl st in top of beg ch-3, turn.

Rnd 5 (RS): Ch 3, dc in ea st across to next ch-3 sp on Front, *2 dc in next ch-3 sp, ch 3, 2 dc in next ch-3 sp**, dc in ea of next 6 sts*; rep from * to * across to 6 sts past ch-3 sp on Front, dc in ea st across to next ch-3 sp on Back; rep from * to * across Back, ending last rep at **, dc in ea st around to beg, join with sl st in top of beg ch-3, turn.

Rnd 6 (WS) (dec rnd): Ch 3, dc in ea st across to next ch-3 sp on Back, 2 dc in next ch-3 sp, *dc in ea of next 4 sts, ch 3, sk next 2 sts, dc in ea of next 4 sts, 2 dc in next ch-3 sp*; rep from * to * across to last ch-3 sp on Back, dc in ea st across to next ch-3 sp on Front, 2 dc in next ch-3 sp, rep from * to * across to last ch-3 sp on Front, dc in ea st around to beg, join with sl st in top of beg ch-3, turn—7 (8, 9, 9, 10) ch-3 sps on Front and Back.

Rnds 7–35: Rep Rnds 2–6 (5 times), then rep Rnds 2–5 (once)—2 (3, 4, 4, 5) ch-3 sps on Front and Back.

Rnd 36: Ch 3, dc in ea st across, working 2 dc in ea ch-3 sp, join with sl st in top of beg ch-3, turn—200 (224, 248, 272, 296) dc.

Rnd 37: Ch 3 (place marker in first st), dc in first st, dc in ea of next 98 (110, 122, 134, 146) sts, 2 dc in ea of next 2 sts (place marker in 2nd and 3rd dc of last 2 increases), dc in ea of next 98 (110, 122, 134, 146) sts, 2 dc in last st (place marker in last st), join with sl st in top of beg ch-3, turn—204 (228, 252, 276, 300) dc. Move markers up as work progresses.

Rnd 38: Ch 3 (place marker in first st), dc in first st, 2 dc in next marked st, dc in ea st across to next marker 2 dc in ea of next 2 marked sts, dc in each st around to beg, join with sl st in top of beg ch-3, turn—208 (232, 256, 280, 304) dc.

Rnd 39: Ch 3 (place marker in first st), dc in first st, dc in ea st across to next marker, 2 dc in ea of next 2 marked sts, dc in each st around to last marked st, 2 dc in last marked st, join with sl st in top of beg ch-3, turn—212 (236, 260, 284, 308) dc.

Rnds 40 and 41: Rep Rnds 38 and 39—220 (244, 268, 292, 316) dc. Fasten off.

BACK FLAP

Work now progresses in rows, leaving side vents open. Decorative side vents are worked on ea side of Front and Back by beginning and ending the next row with a chain instead of increases. Then Aligned Pattern is worked on ea end of Front and Back.

Row 42 (WS): Ch 7, with WS facing, starting in last st of Rnd 41, dc in ea st across next 110 (122, 134, 146, 158) sts on Back, ch 9, turn.

Row 43: Dc in 4th ch from hook, and in ea of next 4 ch, ch 3, sk next ch and next dc, dc in ea st across to last dc, ch 3, sk next 2 sts, dc in ea of last 6 ch, turn.

Row 44: Ch 3, dc in ea of next 3 sts, ch 3, sk next 2 sts, sc in next ch-3 sp, ch 3, sk next 2 sts, dc in ea st across to 2 sts before next ch-3 sp, ch 3, sk next 2 sts, sc in next ch-3 sp, ch 3, sk next 2 sts, dc in ea of last 4 sts, turn.

Row 45: Ch 3, dc in next st, ch 3, sk next 2 sts, sc in next ch-3 sp, (sc, ch 3) in each of next 2 ch-3 sps, sk next 2 sts, dc in ea st across to 2 sts before next ch-3 sp, ch 3, sk next 2 sts, sc in next ch-3 sp, (sc, ch 3) in each of next 2 ch-3 sps, sk next 2 sts, dc in ea of last 2 sts, turn.

Row 46: Ch 3, dc in next st, 2 dc in next ch-3 sp, ch 3, sc in next ch-3 sp, ch 3, 2 dc in next ch-3 sp, dc in ea st across to next ch-3 sp, 2 dc in ch-3 sp, ch 3, sc in next ch-3 sp, ch 3, 2 dc in next ch-3 sp, dc in ea of last 2 sts, turn.

Row 47: Ch 3, dc in ea of next 3 sts, 2 dc in next ch-3 sp, ch 3, 2 dc in next ch-3 sp, dc in ea st across to next ch-3 sp, 2 dc in next ch-3 sp, ch 3, 2 dc in next ch-3 sp, dc in ea of last 4 sts, turn.

Rows 48–59: Rep Rows 44–47 (3 times).

Row 60: Ch 3, dc in ea of next 5 sts, 2 dc in next ch-3 sp, dc in ea st across to next ch-3 sp, 2 dc in next ch-3 sp, dc in ea of last 6 sts. Fasten off.

Front Flap

Row 1 (WS): Ch 7, with WS facing, first marked st to the left of last st made in Row 42 of Back Flap, dc in ea st across next 110 (122, 134, 146, 158) sts on Front, ch 9, turn.

Rows 2–18: Rep Rows 42–60 of Back Flap. Fasten off.

Finishing

With Front side vents overlapping on Back, sew foundation ch edge of ea Front side vent to Back and sew foundation ch edge of ea Back side vent to inside of Front. Weave in ends. Wash, block to finished measurements, and let dry.

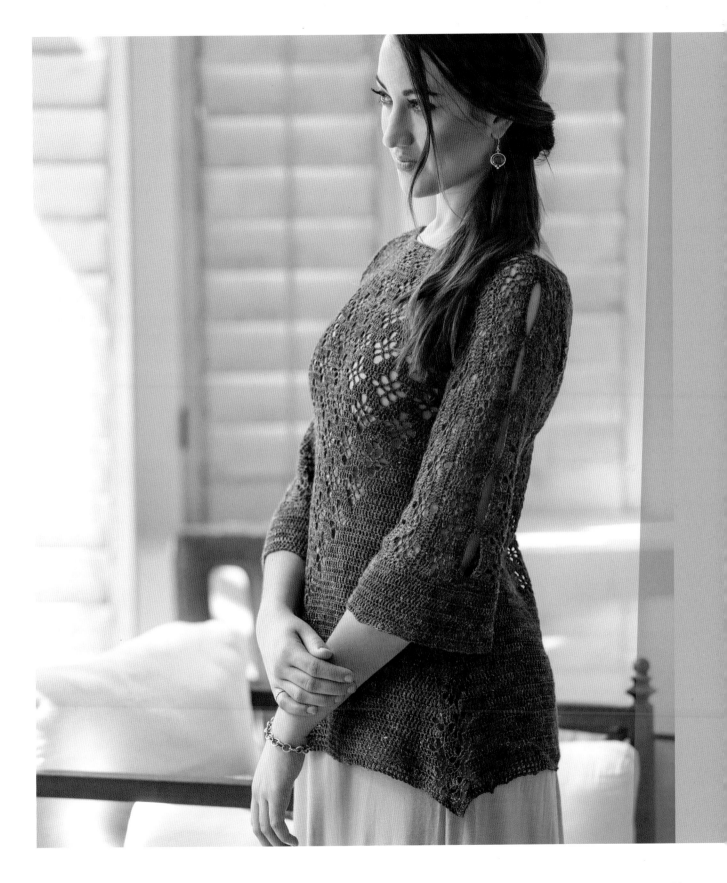

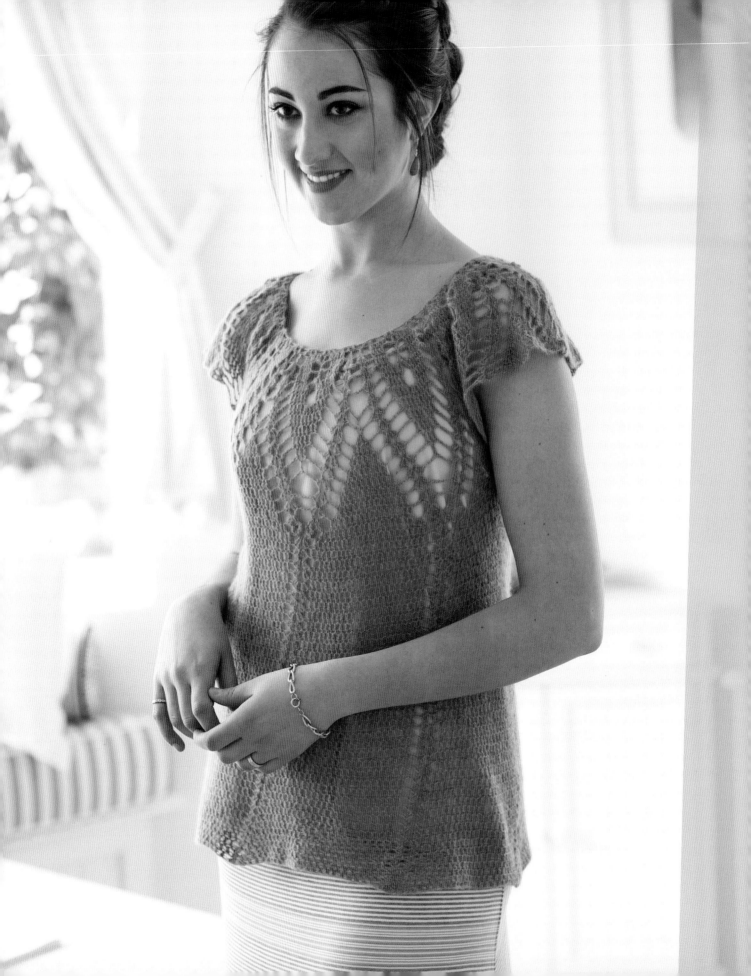

YARN

Lace weight (#1 Super Fine.

SHOWN HERE: Tahki Stacy Charles Filatura Di Crosa Superior (70% cashmere/30% silk; 328 yd [300 m]/1 oz [25 g]): #70 Mauve, 3 (3, 3, 4, 4) balls.

HOOK

E/4 (3.5 mm) or size needed to obtain gauge.

NOTIONS

Yarn needle; stitch markers.

GAUGE

18 sts and 10 rows = 4" (10 cm) in dc, blocked.

Liliana
PULLOVER

Allover lace stitch patterns are so beautiful and really fun to crochet. But when you strip them out of the allover pattern and use them for bold, graphic accents, you can elevate your designs to the next level.

This was an allover stitch pattern that is in my list of favorites. I modified it to half-scale (the flower petals used to be diamonds), and extracted the points of the flowers from the offset pattern by alternating them with a growing section of double crochets. The sleeves are created within the repeat of the stitch pattern, so you don't have to skip a beat and can continue the same stitch pattern in the round. Keep the edging minimal, as the main element of this garment is the boldly graphic yoke framing your pretty face.

FINISHED SIZE

Directions are given for size S. Changes for M, L, XL, and 2X are in parentheses.

FINISHED BUST: 36 (40, 44, 48, 52)" (91.5 [101.5, 112, 122, 132] cm).

FINISHED LENGTH: 26" (66 cm).

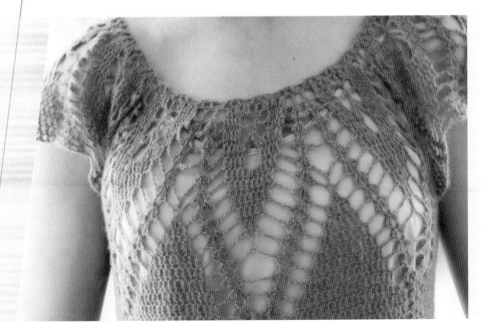

STITCH GUIDE

Beginning shell (beg shell): Ch 3, (dc, ch 2, 2 dc) in same st or sp.

Shell: (2 dc, ch 2, 2 dc) in same st or sp.

Double crochet 4 together (dc4tog): [Yo, insert hook in next sp, yo, draw yarn through sp, yo, draw yarn through 2 lps on hook] twice in same sp, [yo, insert hook in next sp, yo, draw yarn through sp, yo, draw yarn through 2 lps on hook] twice in same sp, yo, draw yarn through 5 lps on hook.

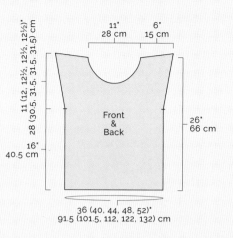

Sweater

Rnd 1: *Ch 4, dc in 4th ch from hook; rep from * 35 times, join with sl st in first ch at beg of rnd—36 dc.

Rnd 2: Ch 3 (counts as dc here and throughout), 2 dc around the post of first dc in Rnd 1, work 3 dc around the post of each dc around, join with sl st in top of beg ch-3—108 dc.

Rnd 3: Ch 6 (counts as dc, ch 3), *2 dc in each of next 3 dc, ch 2, dc in next dc, ch 2, 2 dc in each of next 3 dc, ch 3, dc in next st, ch 3**, dc in next dc; rep from * around, ending last rep at **, join with sl st in 3rd ch of beg ch-6—36 dc-3 sps; 12 ch-2 sps.

Rnd 4: Beg shell in first st, *ch 3, dc in each of next 5 dc, *ch 3, sk next dc, dc in next dc, ch 3, sk next dc, dc in each of next 5 dc, ch 3**, shell in next dc, ch 3; rep from * around, ending last rep at **, join with sl st in top of beg ch-3—24 shells.

Rnd 5: Sl st to next ch-2 sp, beg shell in same sp, *ch 3, sk next ch-3 sp, dc in each of next 5 dc, ch 4, sc in next dc, ch 4, sk next ch-3 sp, dc in each of next 5 dc, ch 3, sk next ch-3 sp, shell in next ch-2 sp, ch 3, sk next ch-3 sp**, shell in next ch-2 sp; rep from * around, ending last rep at **, join with sl st in top of beg ch-3—24 shells.

Rnd 6: Sl st to next ch-2 sp, beg shell in same sp, *ch 3, sk next ch-3 sp, sk next dc, dc in each of next 4 dc, 2 dc in next ch-4 sp, ch 3, sc in next sc, ch 3, 2 dc in next ch-4 sp, dc in each of next 4 dc, ch 3, sk next ch-3 sp, shell in next ch-2 sp, ch 5, sk next ch-3 sp**, shell in next ch-2 sp; rep from * around, ending last rep at **, join with sl st in top of beg ch-3—24 shells.

Rnd 7: Sl st to next ch-2 sp, beg shell in same sp, *ch 3, sk next ch-3 sp, sk next dc, dc in each of next 5 dc, ch 3, sk next 2 ch-4 sps, dc in each of next 5 dc, ch 3, sk next ch-3 sp, shell in next ch-2 sp, ch 7, sk next ch-5 sp**, shell in next ch-2 sp; rep from * around, ending last rep at **, join with sl st in top of beg ch-3—24 shells.

Rnd 8: Sl st to next ch-2 sp, beg shell in same sp, *ch 3, sk next ch-3 sp, sk next dc, dc in each of next 4 dc, 3 dc in ch-3 sp, dc in each of next 4 dc, ch 3, sk next ch-3 sp, shell in next ch-2 sp, ch 3, dc in 4th ch of next ch-7 sp, ch 3**, shell in next ch-2 sp; rep from * around, ending last rep at **, join with sl st in top of beg ch-3—24 shells.

Rnd 9: Sl st to next ch-2 sp, beg shell in same sp, *ch 3, sk next ch-3 sp, sk next dc, dc in each of next 9 dc, ch 3, sk next ch-3 sp, shell in next ch-2 sp, ch 3, sk next ch-3 sp, 3 dc in next dc, place a marker in 2nd dc, ch 3, sk next ch-3 sp**, shell in next ch-2 sp; rep from * around, ending last rep at **, join with sl st in top of beg ch-3—24 shells.

Rnd 10: Sl st to next ch-2 sp, beg shell in same sp, *ch 3, sk next ch-3 sp, sk next dc, dc in each of next 7 dc, ch 3, sk next ch-3 sp, shell in next ch-2 sp, ch 3, dc in next ch-3 sp, dc in each dc across to next ch-3 sp, working 1 (2, 2, 2, 2) dc in marked dc, dc in next ch-3 sp, ch 3**, shell in next ch-2 sp; rep from * around, ending last rep at **, join with sl st in top of beg ch-3—24 shells. Move marker up as work progresses.

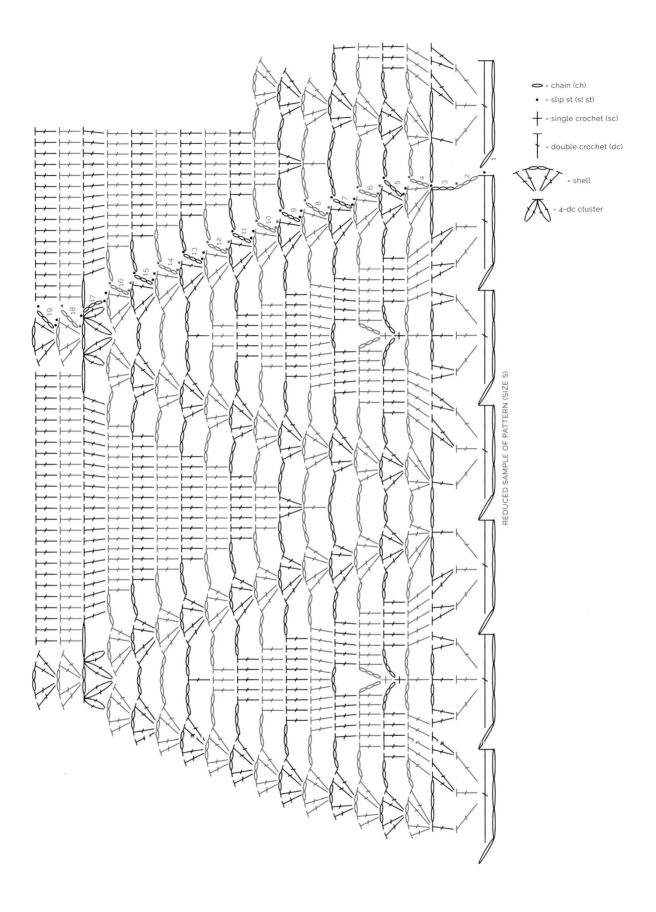

REDUCED SAMPLE OF PATTERN (SIZE S)

<table>
</table>

= chain (ch)

• = slip st (sl st)

+ = single crochet (sc)

⊤ = double crochet (dc)

= shell

= 4-dc cluster

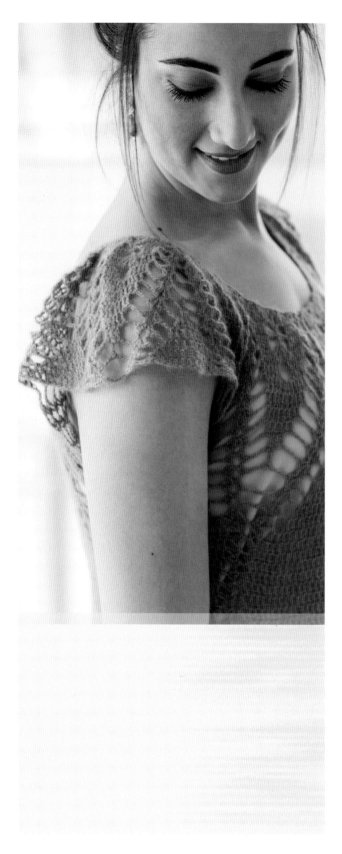

Rnd 11: Sl st to next ch-2 sp, beg shell in same sp, *ch 3, sk next ch-3 sp, sk next dc, dc in each of next 5 dc, ch 3, sk next ch-3 sp, shell in next ch-2 sp, ch 3, dc in next ch-3 sp, dc in each dc across to next ch-3 sp, working 1 (2, 2, 2, 2) dc in marked dc, dc in next ch-3 sp, ch 3**, shell in next ch-2 sp; rep from * around, ending last rep at **, join with sl st in top of beg ch-3—24 shells.

Rnd 12: Sl st to next ch-2 sp, beg shell in same sp, *ch 3, sk next ch-3 sp, sk next dc, dc in each of next 3 dc, ch 3, sk next ch-3 sp, shell in next ch-2 sp, ch 3, dc in next ch-3 sp, dc in each dc across to next ch-3 sp, working 1 (2, 2, 2, 2) dc in marked dc, dc in next ch-3 sp, ch 3**, shell in next ch-2 sp; rep from * around, ending last rep at **, join with sl st in top of beg ch-3—24 shells,

Rnd 13: Sl st to next ch-2 sp, beg shell in same sp, *ch 3, sk next ch-3 sp, sk next dc, dc in next dc, ch 3, sk next ch-3 sp, shell in next ch-2 sp, ch 3, dc in next ch-3 sp, dc in each dc across to next ch-3 sp, working 1 (1, 2, 2, 2) dc in marked dc, dc in next ch-3 sp, ch 3**, shell in next ch-2 sp; rep from * around, ending last rep at **, join with sl st in top of beg ch-3—24 shells.

Rnd 14: Sl st to next ch-2 sp, beg shell in same sp, *ch 5, sk next 2 ch-3 sps, shell in next ch-2 sp, ch 3, dc in next ch-3 sp, dc in each dc across to next ch-3 sp, working 1 (1, 2, 2, 2) dc in marked dc, dc in next ch-3 sp, ch 3**, shell in next ch-2 sp; rep from * around, dc last rep at **, join with sl st in top of beg ch-3—24 shells.

Rnd 15: Sl st to next ch-2 sp, beg shell in same sp, *ch 3, sk next ch-5 sp, shell in next ch-2 sp, ch 3, dc in next ch-3 sp, dc in each dc across to next ch-3 sp, working 1 (1, 2, 2, 2) dc in marked dc, dc in next ch-3 sp, ch 3, shell in next ch-2 sp*; rep from * to * once, **ch 3, sk next ch-5 sp, shell in next ch-2 sp, ch 3, dc in next ch-3 sp, dc in each of next 5 (7, 8, 8, 8) dc, sk next 6 shells, sk next 5 (7, 8, 8, 8) dc, dc in each of next 6 (7, 8, 8, 8) dc, dc in next ch-3 sp, ch 3**, shell in next ch-2 sp; rep from * to * twice; rep from ** to ** once, join with sl st in top of beg ch-3—12 shells.

Rnd 16: Sl st to next ch-2 sp, beg shell in same sp, sk next ch-3 sp, shell in next ch-2 sp, ch 3, dc in next ch-3 sp, dc in each dc across to next ch-3 sp, working 1 (1, 1, 2, 2) dc in marked dc, dc in next ch-3 sp, ch 3**, shell in next ch-2 sp; rep from * around, dc last rep at **, join with sl st in top of beg ch-3—12 shells.

Rnd 17: Sl st to next ch-2 sp, ch 3 (does not count as a st), *dc4tog, working first 2 legs in same sp, and next 2 legs in sp bet 2 shells, complete cluster, ch 2, dc4tog, working first 2 legs in same sp bet 2 shells, next 2 legs in next ch-2 sp, complete cluster, ch 1, 2 dc in next ch-3 sp, dc in each dc across to next ch-3 sp, working 1 (1, 1, 2, 2) dc in marked dc, 2 dc in next ch-3 sp, ch 3; rep from * around, join with sl st in top of beg ch-3—12 dc4tog clusters.

Rnd 18: Sl st to next ch-2 sp, beg shell in same sp, 2 dc in next ch-1 sp, dc in each dc across to next ch-3 sp, working 1 (1, 1, 2, 2) dc in marked dc, 2 dc in next ch-1 sp**, shell in next ch-2 sp; rep from * around, ending last rep at **, join with sl st in top of beg ch-3—6 shells.

Rnds 19–21: Sl st to next ch-2 sp, beg shell in same sp, sk next 2 dc of shell, dc in each dc across to next shell, working 1 (1, 1, 1, 2) dc in marked dc, sk next 2 dc of shell**, shell in next ch-2 sp; rep from * around, ending last rep at **, join with sl st in top of beg ch-3—6 shells.

Rnds 22–55: Sl st to next ch-2 sp, beg shell in same sp, sk next 2 dc of shell, dc in each dc across to next shell, sk next 2 dc of shell**, shell in next ch-2 sp; rep from * around, ending last rep at **, join with sl st in top of beg ch-3—6 shells; 25 (28, 31, 34, 37) dc bet shells. Fasten off.

Finishing

Weave in ends. Wash, block to finished measurements, and let dry.

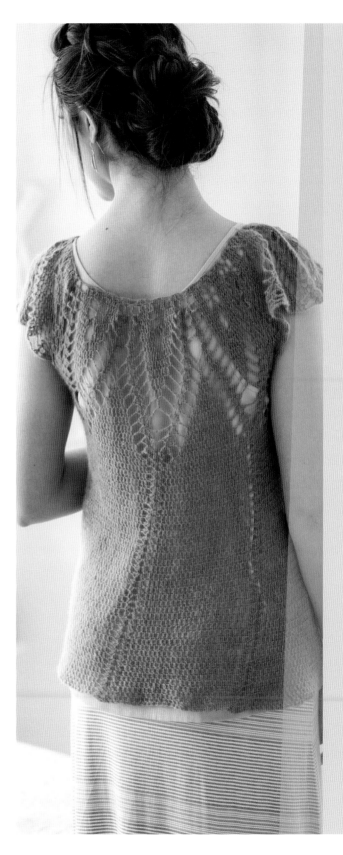

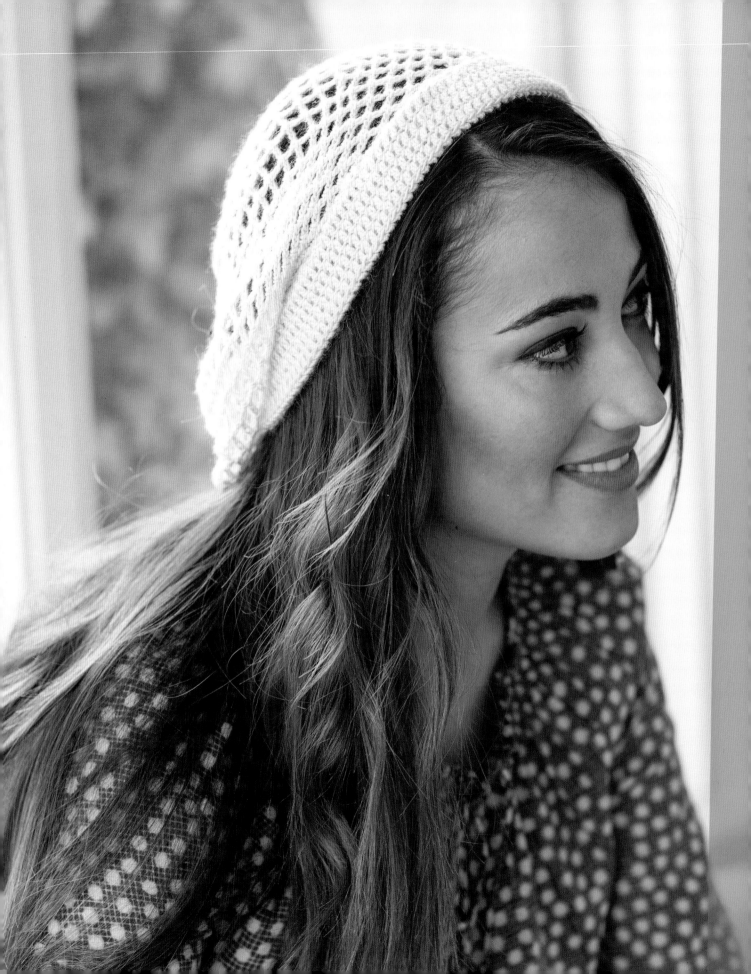

YARN

Sport weight (#2 Fine).

SHOWN HERE: Blue Sky Alpacas Metalico (50% baby alpaca/50% mulberry silk; 147 yd [134 m]/1.75 oz [50 g]): #1610 Opal, 2 skeins.

HOOK

C/3 (2.75 mm) or size needed to obtain gauge.

NOTIONS

Yarn needle.

GAUGE

22 sts = 4" (10 cm); 3 rows in dc = 1" (2.5 cm), blocked.

Queen
of the Night
BERET

The central motif of this beret mimics the delicate white flowers that bloom nightly in the summer months at my home in south Florida: night-blooming jasmine, one of the most intoxicating floral scents in the world. The flower has a long history and the mysterious nickname of Queen of the Night.

The beret begins from the center of the flower, increases out to the widest part of the hat, decreases back down to the circumference of the brim, and a thick, doubled brim is worked extra long to keep your ears snug and warm.

Using a dinner plate for blocking this type of garment is really helpful, and even more so for sewing the doubled brim!

FINISHED SIZE

22" (56 cm) in circumference at brim; 9" (23 cm) deep.

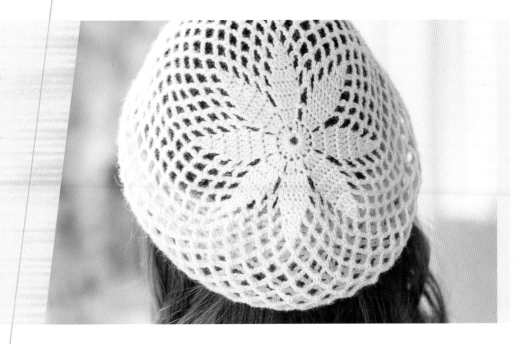

STITCH GUIDE

Double crochet 2 together (dc2tog): [Yo, insert hook in next st, yo, draw yarn through st, yo, draw yarn through 2 lps on hook] twice, yo, draw yarn through 3 lps on hook.

Dc-tbl: Dc worked through back lp only.

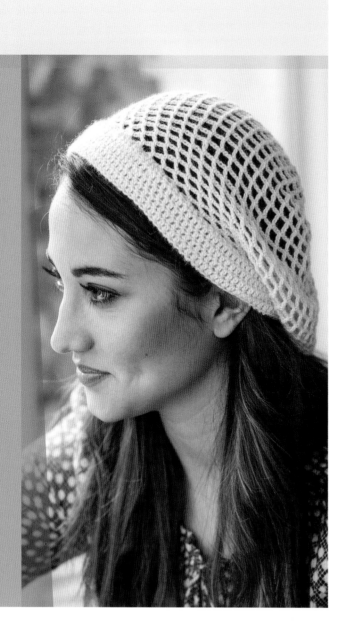

Beret

Ch 7, join with sl st in 7th ch to form ring.

Rnd 1: Ch 3 (counts as dc here and throughout), work 15 dc in ring, join with sl st to top of beg ch-3—16 dc.

Rnd 2: Ch 3, dc in first st, 2 dc in next st, ch 2, *2 dc in ea of next 2 sts, ch 2; rep from * around, join with sl st to top of beg ch-3—32 dc.

Rnd 3: Ch 3, dc in first st, dc in ea of next 2 sts, 2 dc in next st, *ch 5, 2 dc in next st, dc in ea of next 2 sts, 2 dc in next st; rep from * around, ch 2, dc in top of beg ch-3—48 dc; 8 ch-5 sps.

Rnd 4: Ch 1, sc in same sp, *ch 5, dc in ea of next 6 sts, ch 5, sc in next ch-5 sp; rep from * around, 2 dc in next st; rep from * around, ch 2, dc in top of beg ch-3—48 dc; 16 ch-5 sps.

Rnd 5: Ch 1, sc in same sp, *ch 5, sc in next ch-5 sp, ch 5, dc2tog over next 2 sts, dc in ea of next 2 sts, dc2tog over next 2 sts, [ch 5, sc in next ch-5 sp] twice; rep from * around, ch 2, dc in top of beg ch-3—32 dc; 24 ch-5 sps.

Rnd 6: Ch 1, sc in same sp, *[ch 5, sc in next ch-5 sp] twice, ch 5, dc in next st, dc2tog over next 2 sts, dc in next st, ch 5; rep from * around, ch 2, dc in top of beg ch-3—24 dc; 32 ch-5 sps.

Rnd 7: Ch 1, sc in same sp, *[ch 5, sc in next ch-5 sp] 3 times, ch 5, dc3tog over next 3 sts, ch 5; rep from * around, ch 2, dc in top of beg ch-3—8 dc3tog; 40 ch-5 sps.

Rnds 8–19: Ch 1, sc in same sp, *ch 5, sc in next ch-5 sp; rep from * around, ch 2, dc in top of beg ch-3—40 ch-5 sps.

Rnd 20: Ch 1, sc in same sp, *ch 4, sc in next ch-5 sp; rep from * around, ch 2, hdc in top of beg ch-3—40 ch-4 sps.

Rnds 21–25: Ch 1, sc in same sp, *ch 4, sc in next ch-4 sp; rep from * around, ch 2, hdc top of beg ch-3—40 ch-4 sps.

Rnd 26: Ch 1, sc in same sp, *ch 4, sc in next ch-4 sp; rep from * around, ch 4, join with sl st in first sc—40 ch-4 sps.

Rnd 27: Sl st in next ch-4 sp, ch 1, (sc, hdc, dc) in same ch-4 sp, *3 dc in next ch-4 sp; rep from * around, do not join—120 sts. Work in a spiral, marking beg of ea rnd and moving marker up as work progresses.

Rnds 28–31: Dc in ea st around—120 sts.

Rnd 32: Dc-tbl in ea st around—120 sts.

Rnds 33–35: Dc in ea st around.

Rnd 36: Dc in ea st around to last 3 sts, hdc in next st, sc in next st, sl st in next st. Fasten off, leaving a long sewing length.

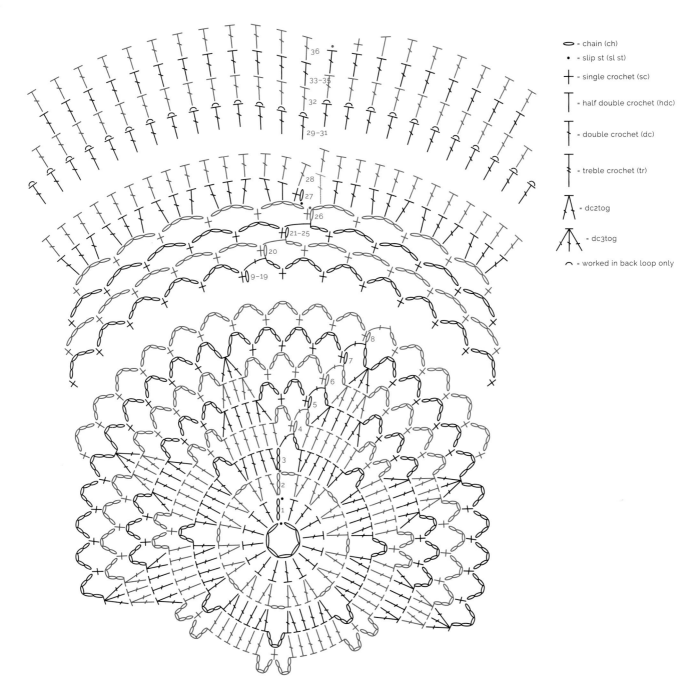

Legend:

- ⬯ = chain (ch)
- • = slip st (sl st)
- + = single crochet (sc)
- T = half double crochet (hdc)
- ╪ = double crochet (dc)
- ‡ = treble crochet (tr)
- ⋀ = dc2tog
- ⋀ = dc3tog
- ⌒ = worked in back loop only

Finishing

Wash, block to finished measurements, and let dry.

Note: Blocking a beret inside a dinner plate is best for proper shaping. Once dry, leave beret with plate inserted inside for ease in sewing brim doubled.

Fold Rnds 27–36 in half toward inside of hat, with free loops of Rnd 32 facing outward at fold line. With sewing length, sew top of Rnd 36 to bottom of Rnd 27. Weave in ends.

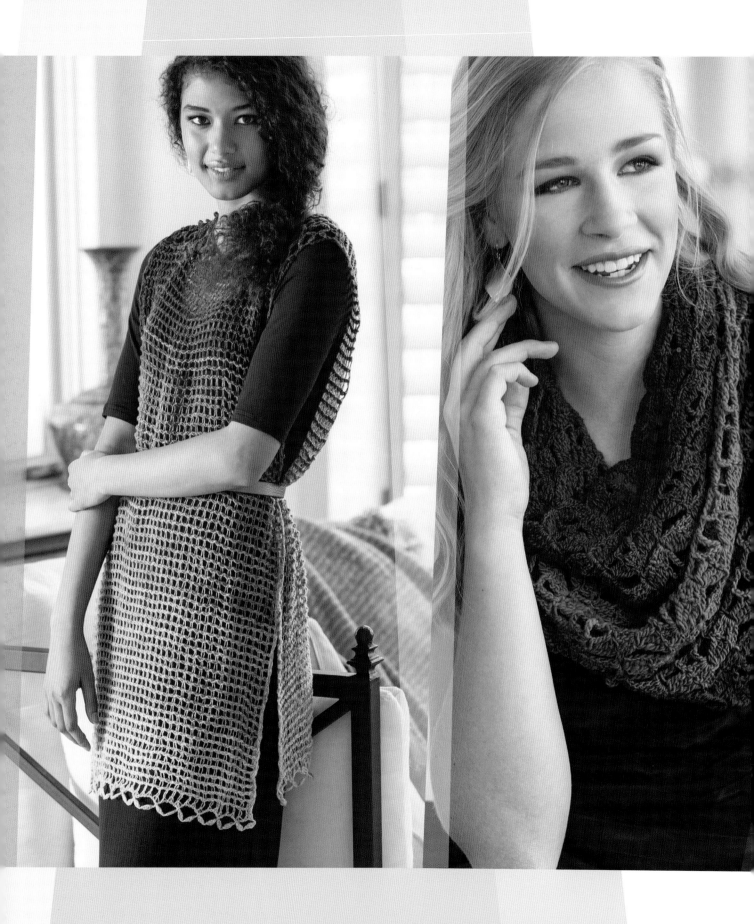

Bruges Lace &
Tunisian Crochet

CHAPTER FOUR

Bruges Lace is traditionally a two-dimensional fabric created by making meandering strips that are joined as you go. I explored this technique with a variety of stitch patterns to create three-dimensional shaped garments. The formulas for shaping are universal, the same ones used with other crochet techniques.

The beautiful, sturdy texture of Tunisian crochet is given new depth and dimension when recast as lace.

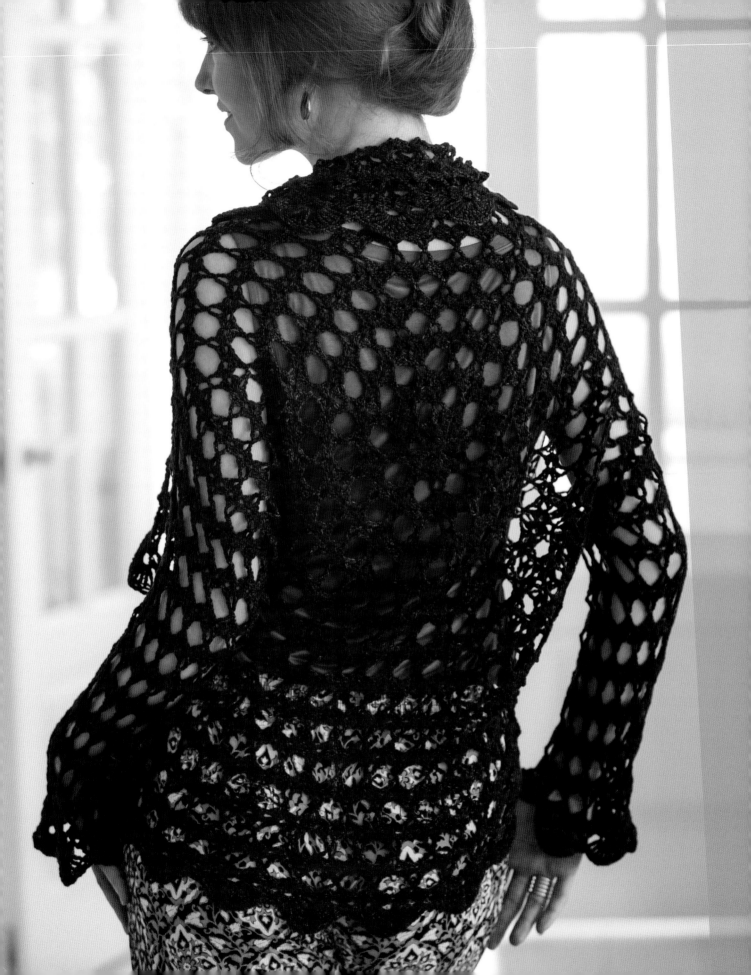

YARN

Fingering weight (#1 Super Fine).

SHOWN HERE: SweetGeorgia Yarns Merino Silk Fine (50% fine merino wool/50% silk; 380 yd [347 m]/3.5 oz [100 g]): Ultraviolet, 3 (3, 3, 4, 4) skeins.

HOOK

G/6 (4 mm) or size needed to obtain gauge.

NOTIONS

Yarn needle; stitch markers.

GAUGE

One repeat of Bruges lace strip = 1½" (3.8 cm) wide; 6 rows = 3" (7.5 cm) in pattern, blocked.

Dahlia Spiral
SHRUG

Growing fabric with Bruges lace is very similar to making a circular medallion with double crochet working in the round. The rate of increase is exactly the same, but obviously the construction technique is quite different. From this construction method, you could create a hat, pillow, cushions, or motifs for a lace shawl or afghan.

For the Dahlia shrug, crochet the circular medallion until it is the width required to accommodate shoulders and arm openings, then continue in spiral rounds (without growth) for the collar and sleeves. The garment is finished off with a simple and elegant scalloped lace border.

FINISHED SIZE

Directions are given for size S. Changes for M, L, XL, and 2X are in parentheses.

BACK WIDTH: 24 (27, 30, 33, 36)" (61 [68.5, 76, 84, 91.5] cm).

FINISHED BUST: 35 (41, 47, 53, 59)" (89 [104, 119.5, 134.5, 150] cm).

FINISHED LENGTH: 27 (30, 33, 36, 39)" (68.5 [76, 84, 91.5, 99] cm) long from 3½" (9 cm) folded collar at back neck to bottom edge of back, including edging.

SLEEVES: 12 (14, 16, 18, 20)" (30.5 [35.5, 40.5, 45.5, 51] cm) in circumference, 15" (38 cm) long including edging.

STITCH GUIDE

Shell: (2 dc, ch 2, 2 dc) in same st or sp.

NOTE

- Place a split ring stitch marker at the end of each section to help remember when the different rate of increases begins. When working in a spiral, it is hard to determine the beginning and end of each round.

Body

Set-up row: Ch 6 (counts as ch-5 center ring, and ch-1 for working sts), shell in 6th ch from hook, turn.

FIRST SECTION

Row 1: Ch 5, shell in next ch-2 sp, turn.

Row 2: Ch 2, sl st in ch-5 center ring of Set-up row, ch 2, shell in next ch-2 sp, turn.

Rows 3–16: Rep Rows 1 and 2 (7 times).

Note: First Section of spiral complete—you should have 8 ch-5 lps around perimeter of work.

SECOND SECTION

Row 17: Rep Row 1.

Row 18: Ch 2, sl st in next ch-5 sp in preceding section, ch 2, shell in next ch-2 sp, turn.

Row 19: Rep Row 1.

Row 20: Ch 2, sl st in same ch-5 sp as last sl st, ch 2, shell in next ch-2 sp, turn.

Rows 21–48: Rep Rows 17–20 (7 times).

Note: Second Section of spiral complete—you should have 16 ch-5 lps around perimeter of work.

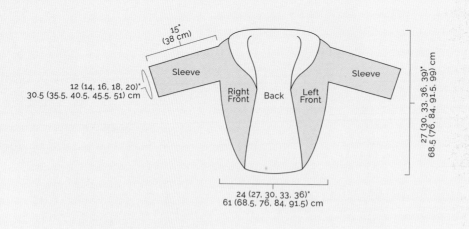

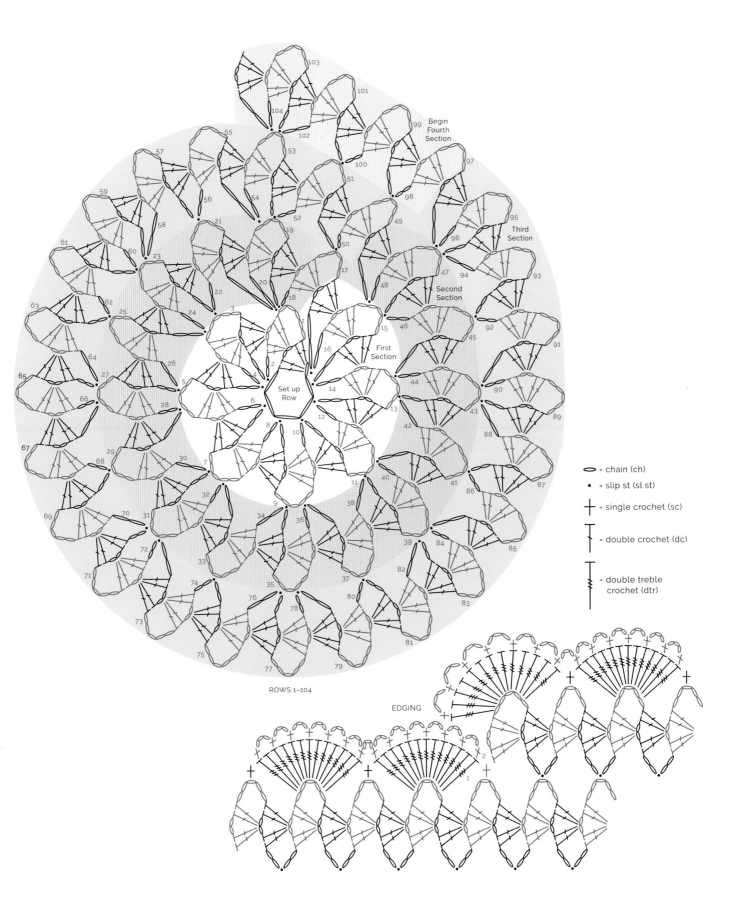

ROWS 1–104

EDGING

= chain (ch)

= slip st (sl st)

= single crochet (sc)

= double crochet (dc)

= double treble crochet (dtr)

Set up Row

First Section

Second Section

Third Section

Begin Fourth Section

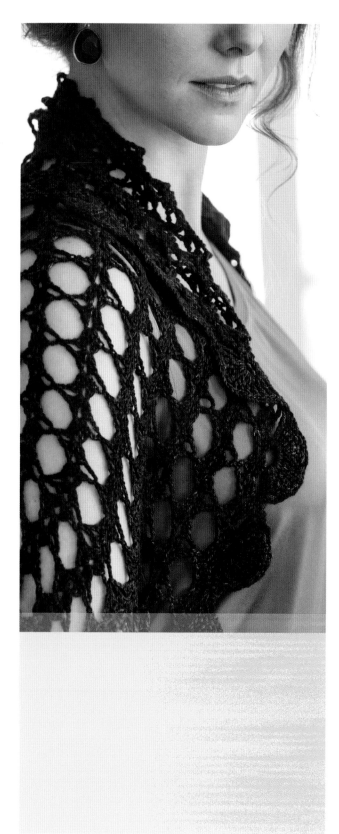

THIRD SECTION

Row 49: Rep Row 1.

Row 50: Ch 2, sl st in next ch-5 sp in preceding section, ch 2, shell in next ch-2 sp, turn.

Rows 51–54: Rep Rows 17–20 once.

Rows 55–96: Rep Rows 49–54 (7 times).

Note: Third Section of spiral complete—you should have 24 ch-5 lps around perimeter of work.

FOURTH SECTION

Rows 97–100: Rep Rows 17 and 18 (twice).

Rows 101–104: Rep Rows 17–20 once.

Rows 105–160: Rep Rows 97–104 (7 times).

Note: Fourth Section of spiral complete—you should have 40 ch-5 lps around perimeter of work.

FOURTH SECTION

Rows 161–166: Rep Rows 17 and 18 (3 times).

Rows 167–170: Rep Rows 17–20 once.

Rows 171–240: Rep Rows 161–170 (7 times).

Note: Fourth Section of spiral complete—you should have 40 ch-5 lps around perimeter of work.

FIFTH SECTION

Rows 241–248: Rep Rows 17 and 18 (4 times).

Rows 249–252: Rep Rows 17–20 once.

Rows 253–336: Rep Rows 241–252 (7 times).

Note: Fifth Section of spiral complete—you should have 48 ch-5 lps around perimeter of work.

SIXTH SECTION

Rows 337–346: Rep Rows 17 and 18 (5 times).

Rows 347–350: Rep Rows 17–20 once.

Rows 351–448: Rep Rows 337–350 (7 times).

Note: Sixth Section of spiral complete—you should have 56 ch-5 lps around perimeter of work.

SEVENTH SECTION

Rows 449–460: Rep Rows 17 and 18 (6 times).

Rows 461–464: Rep Rows 17–20 once.

Rows 465–576: Rep Rows 449–464 (7 times).

Note: Seventh Section of spiral complete—you should have 64 ch-5 lps around perimeter of work.

EIGHTH SECTION

Rows 577–590: Rep Rows 17 and 18 (7 times).

Rows 591–594: Rep Rows 17–20 once.

Rows 595–720: Rep Rows 577–594 (7 times).

Note: Eighth Section of spiral complete—you should have 72 ch-5 lps around perimeter of work.

NINTH SECTION

Rows 721–737: Rep Rows 17 and 18 (8 times).

Rows 738–741: Rep Rows 17–20 once.

Rows 742–880: Rep Rows 721–741 (7 times).

Note: Ninth Section of spiral complete—you should have 80 ch-5 lps around perimeter of work.

Sizes M, L, XL, and 2X only
TENTH SECTION

Rows 881–898: Rep Rows 17 and 18 (9 times).

Rows 899–902: Rep Rows 17–20 once.

Rows 903–1056: Rep Rows 881–902 (7 times).

Note: Tenth Section of spiral complete—you should have 88 ch-5 lps around perimeter of work.

Sizes L, XL, and 2X only
ELEVENTH SECTION

Rows 1057–1076: Rep Rows 17 and 18 (10 times).

Rows 1077–1080: Rep Rows 17–20 once.

Rows 1081–1248: Rep Rows 1057–1080 (7 times).

Note: Eleventh Section of spiral complete—you should have 96 ch-5 lps around perimeter of work.

Sizes XL and 2X only
TWELFTH SECTION

Rows 1249–1270: Rep Rows 17 and 18 (11 times).

Rows 1271–1274: Rep Rows 17–20 once.

Rows 1275–1456: Rep Rows 1249–1274 (7 times).

Note: Twelfth Section of spiral complete—you should have 104 ch-5 lps around perimeter of work.

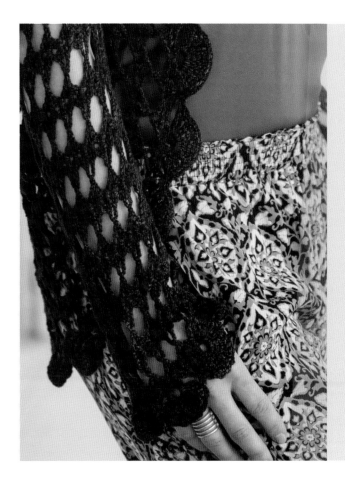

Size 2X only
THIRTEENTH SECTION

Rows 1457–1480: Rep Rows 17 and 18 (12 times).

Rows 1481–1484: Rep Rows 17–20 once.

Rows 1485–1680: Rep Rows 1457–1484 (7 times).

Note: Thirteenth Section of spiral complete—you should have 112 ch-5 lps around perimeter of work.

All Sizes
NEXT SECTION

Joining round to create body and armhole openings:

*Rep Rows 17 and 18 (29 [31, 33, 35, 37] times), skip next 11 (13, 15, 17, 19) ch-5 lps in last section of spirals; rep from * once—58 (62, 66, 70, 74) ch-5 lps plus 2 armhole openings. Place a marker at end of last rnd.

Rep Rows 17 and 18 (work even) until 3 more sections are complete from marker.

Edging

Rnd 1: *Work 13 dtr in next ch-5 sp, sc in next ch-5 sp; rep from * around, sl st to top of first dtr at beg of round to join.

Rnd 2: *Ch 3, sc in next st, rep from * around. Fasten off.

Sleeve *(make 2)*

FIRST SECTION

Note: Sleeves are worked in a spiral without increases.

Row 1: Ch 3 (counts as working ch and ch-2 of ch-5 join), sl st in any ch-5 lp on edge of sleeve opening, ch 2, shell in first ch of beg ch-3, turn.

Row 2: Ch 5, shell in next ch-2 sp, turn.

Row 3: Ch 2, sl st in next ch-5 sp on edge of sleeve opening, ch 2, shell in next ch-2 sp, turn.

Rows 4–21 (23, 25, 27, 29): Rep Rnds 2 and 3 (9 [10, 11, 12, 13] times) around perimeter of sleeve opening.

Row 22 (24, 26, 28, 30): Rep Rnd 2.

Row 23 (25, 27, 29, 31): Ch 2, sl st in next ch-2 sp on inside edge of Tenth Section of sweater, ch 2, shell in next ch-2 sp, turn.

Row 24 (26, 28, 30, 32): Rep Rnd 2.

Note: First Section of spiral complete—you should have 12 (14, 16, 18, 20) ch-5 lps around perimeter of Sleeve.

SECOND SECTION

Row 1: Ch 2, sl st in next ch-5 sp of previous section, ch 2, shell in next ch-2 sp, turn.

Row 2: Ch 5, shell in next ch-2 sp, turn.

Rows 3–24 (26, 28, 30, 32): Rep Rows 1 and 2 of Second Section (11 [12, 13, 14, 15] times).

Rep Section 2 until Sleeve measures 14" (35.5 cm) from beg.

Edging

Rnd 1: *Work 13 dtr in next ch-5 sp, sc in next ch-5 sp; rep from * around, sl st to top of first dtr at beg of rnd to join.

Rnd 2: *Ch 3, sc in next st; rep from * around. Fasten off.

Finishing

Weave in ends. Wash, block to finished measurements, and let dry.

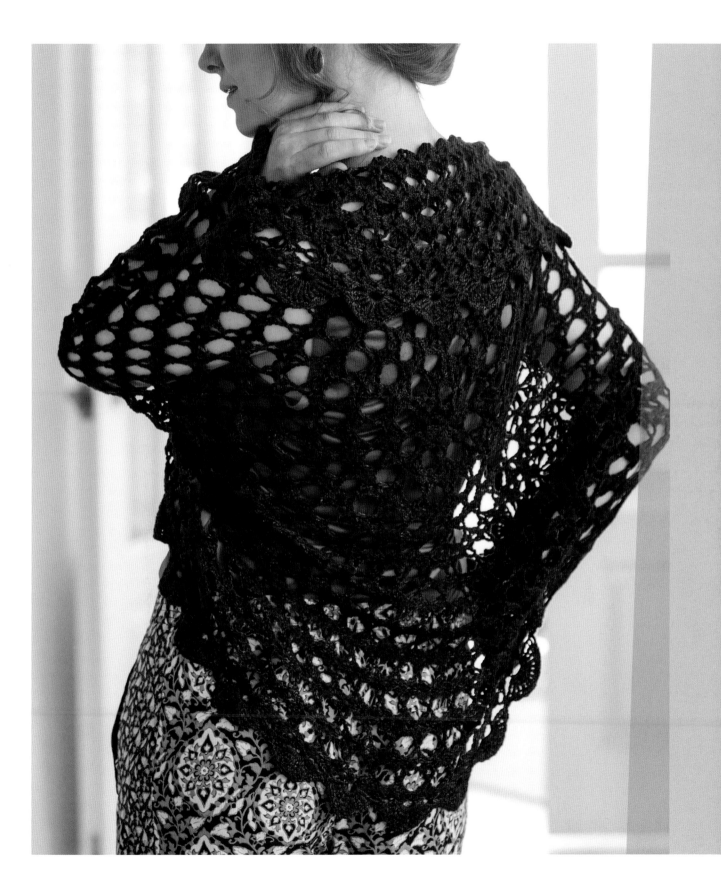

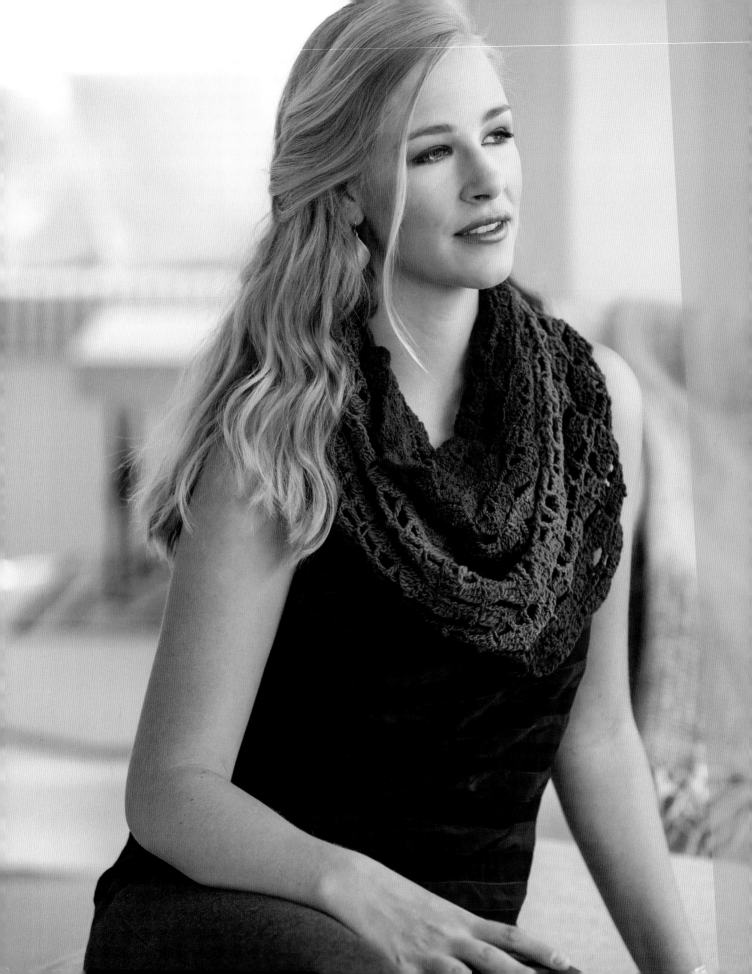

YARN

Sport weight (#2 Fine).

SHOWN HERE: Freia Fine Handpaints Ombre Sport (100% wool; 217 yd [200 ml]/2.66 oz [75 g]): Tijuana Teal, 2 skeins.

HOOKS

D/3 (3.25 mm), G/6 (4 mm), and H/8 (5 mm) or sizes needed to obtain gauges.

NOTIONS

Yarn needle; stitch marker.

GAUGE

With largest hook, one rep = 2½" (6.5 cm) wide; 4 rows in pattern = 3" (7.5 cm), blocked. With smallest hook, one rep = 2" (5 cm) wide; 4 rows in pcattern = 2" (5 cm), blocked.

FINISHED SIZE

Directions are given for size S. Changes for M, L, XL, and 2X are in parentheses.

FINISHED SIZES: 24 (26, 28, 30, 32)" (61 [66, 71, 76, 81.5] cm) in circumference at top, 36 (39, 42, 45, 48)" (91.5 [99, 106.5, 114.5, 122] cm) around bottom edge, 18" (45.5 cm) deep.

Naida Medallion
COWL

Begun with the largest sized hook and worked in the first round of the spiral to fit comfortably around your shoulders with ease, this easy-to-custom-fit cowl is shaped upward through the yoke by reducing the size of the hook. This shrinks the gauge and therefore tightens the stitches. You can also wear this piece as a capelet, and the tighter gauge will give you a fitted yoke over the shoulders.

Using an ombre dyed yarn is a fun way to add bold color interest to a design. Each ball is worked from the opposite end so the ombre color changes only once. Wear it up around your neck, with folds of fabric, for a bold, pretty cowl that easily lies flat under a coat. Or pull it down over your shoulders for a capelet to wear as the focal accessory to a more casual weekend outfit.

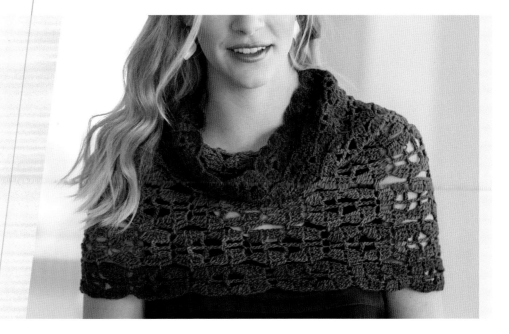

STITCH GUIDE

Treble crochet 2 together (tr2tog): *Yo (twice), insert hook into next st, yo, draw yarn through st, [yo, draw yarn through 2 lps on hook]; rep from * once, yo, draw yarn through 3 lps on hook.

Treble crochet 3 together (tr3tog): *Yo (twice), insert hook into next st, yo, draw yarn through st, [yo, draw yarn through 2 lps on hook]; rep from * twice, yo, draw yarn through 4 lps on hook.

NOTE

- Due to the scalloped edge of this strip of fabric, it is important to make sure you begin the joins on the right rows so it fits offset. Meaning, the curved-out scalloped edge of one strip nestles neatly into the curved-in scallop of the adjacent strip edge.

First Circle

Starting at bottom edge, with largest hook, ch 7.

Row 1: 2 tr in 5th ch from hook, ch 2, tr in next ch, ch 2, 3 tr in last ch, turn.

Row 2: Ch 4 (counts as tr here and throughout), tr2tog over next 2 sts, ch 5, skip next ch-2 sp, dc in next tr, ch 5, sk next ch-2 sp, tr3tog over last 3 sts, turn.

Row 3: Ch 4, 2 tr in first st, ch 2, skip next ch-5 sp, dc in next dc, ch 2, skip next ch-5 sp, 3 tr in last st, turn.

Row 4: Ch 4, tr2tog over next 2 sts, sk next ch-2 sp, tr in next dc, sk next ch-2 sp, tr3tog over last 3 sts, turn.

Row 5: Ch 4, 2 tr in first st, ch 2, dc in next tr, ch 2, 3 tr in last st, turn.

Rows 6–44 (48, 52, 56, 60): Rep Rows 2–5 (9 [10, 11, 12, 13] times); Rep Rows 2–4 (once). There are 11 (12, 13, 14, 15) repeats in each circle.

Second Circle

BEGIN SPIRAL

Row 1: Ch 4, sl st in first ch at base of Row 1, 2 tr in first st in previous row, ch 2, dc in next tr, ch 2, 3 tr in last st, turn. Place a marker at end of Row 1 and move marker up when starting each new circle.

Row 2: Ch 4, tr2tog over next 2 sts, ch 5, skip next ch-2 sp, dc in next tr, ch 5, sk next ch-2 sp, tr3tog over last 3 sts, turn.

Row 3: Ch 4, sk next row on previous circle, sl st in next ch-4 turning ch of next row, 2 tr in first st, ch 2, skip next ch-5 sp, dc in next dc, ch 2, skip next ch-5 sp, 3 tr in last st, turn.

Row 4: Ch 4, tr2tog over next 2 sts, sk next ch-2 sp, tr in next dc, sk next ch-2 sp, tr3tog over last 3 sts, turn.

Row 5: Ch 4, sk next row on previous circle, sl st in next ch-4 turning ch of next row, 2 tr in first st in previous row, ch 2, dc in next tr, ch 2, 3 tr in last st, turn.

Rep Rows 2–5, joining at every other row of previous circle for pattern. Work until 4 circles are completed. Change to medium size hook and work in pattern for 2 more circles. Then change to smallest hook and work in pattern for 2 more circles. At end of last circle, rep Row 2 once, sl st in next row-end st of previous circle. Fasten off.

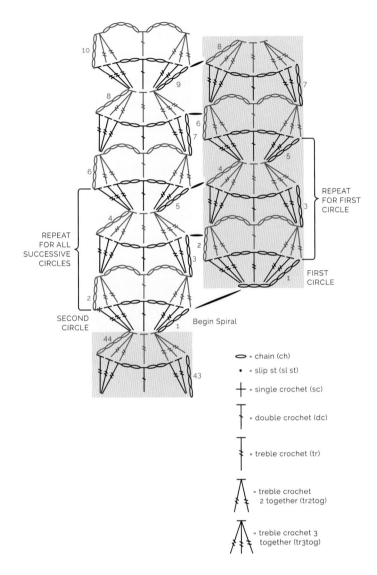

REPEAT FOR ALL SUCCESSIVE CIRCLES

REPEAT FOR FIRST CIRCLE

SECOND CIRCLE

FIRST CIRCLE

Begin Spiral

⬯ = chain (ch)

• = slip st (sl st)

✛ = single crochet (sc)

✝ = double crochet (dc)

✢ = treble crochet (tr)

⋀ = treble crochet 2 together (tr2tog)

⋀ = treble crochet 3 together (tr3tog)

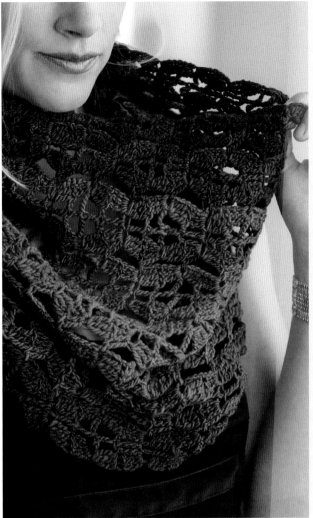

Finishing

Weave in ends. Wash, block to finished measurements, and let dry.

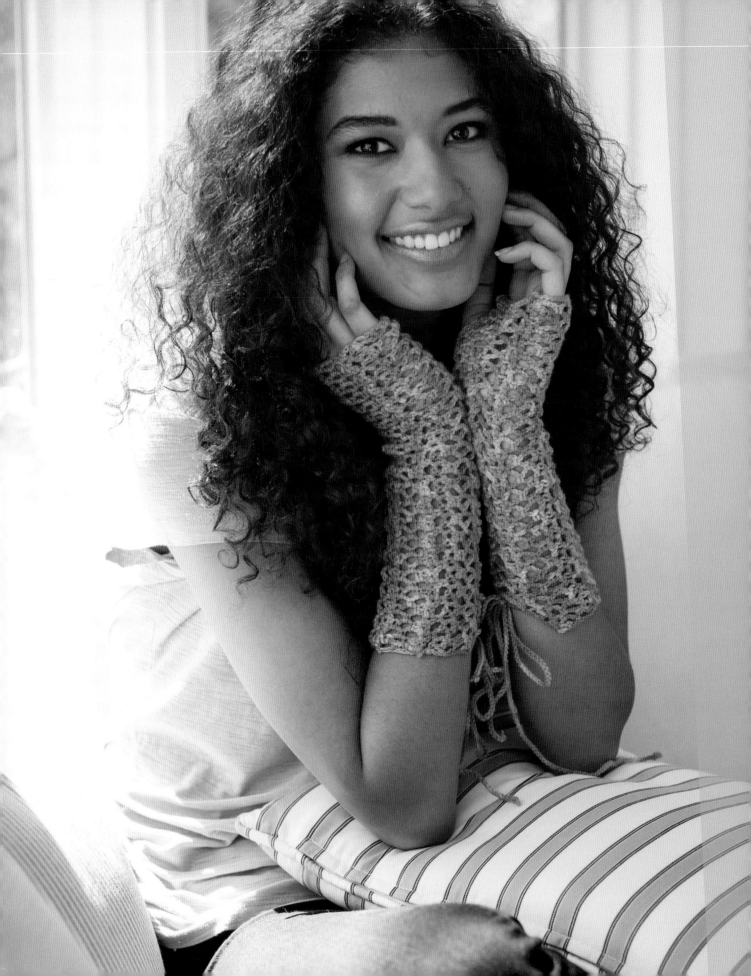

YARN

Sport weight (#2 Fine).

SHOWN HERE: Drew Emborsky Inappropriate Gemstones (90% extrafine superwash merino/10% nylon; 440 yd [403 m]/4 oz [113 g]): Citrine (November), 1 skein.

HOOK

C3 (2.75 mm) or size needed to obtain gauge.

NOTIONS

Yarn needle

GAUGE

Each strip = 2" (5 cm) wide; 9 rows = 3" (7.5 cm), blocked.

Corset-Laced
GAUNTLETS

Bruges lace strips are so much fun to join as you go. These bright and cheerful gauntlets can be whipped up in no time, and the instant gratification of watching the strips come to life with each additional join is terrific. The shaping is accomplished with corset tied (or shoelace tied) chains that are simply adjusted for width as you tie them. Easy, quick, and supercute, these would make wonderful gifts! Also, if you want longer gauntlets, simply crochet the strips longer.

FINISHED SIZE

15" (38 cm) long × 7" (18 cm) in circumference (wider when laces are widened).

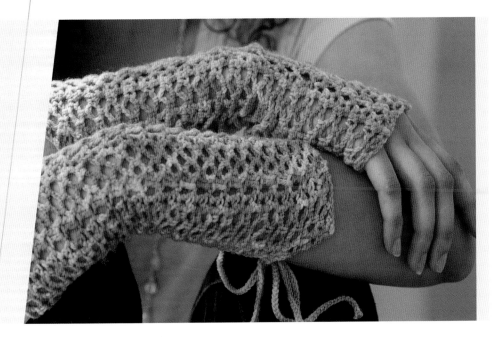

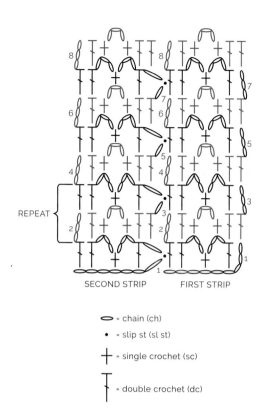

REPEAT

SECOND STRIP FIRST STRIP

⬭ = chain (ch)

• = slip st (sl st)

+ = single crochet (sc)

† = double crochet (dc)

First Strip

Row 1: Ch 9, dc in 4th ch from hook, ch 3, sk next ch, sc in next ch, ch 3, skip next ch, dc in each of last 2 ch, turn.

Row 2: Ch 3 (counts as dc here and throughout), dc in next st, sc in next ch-3 sp, ch 3, sc in next ch-3 sp, dc in each of last 2 sts, turn.

Row 3: Ch 3, dc in next st, ch 3, sc in next ch-3 sp, ch 3, dc in ea of last 2 sts, turn.

Rows 4–44: Rep Rows 2 and 3 (20 times); rep Row 2. Fasten off.

Make 4 more strips, joining to previous strip as follows:

Second and Successive Strips

Row 1: Ch 7, sl st in side of last dc on first row of previous strip, ch 1, turn, sk last 2 ch, dc in next ch, ch 3, skip next ch, sc in next ch, ch 3, skip next ch, dc in each of last 2 ch, turn.

Row 2: Ch 3, dc in next st, sc in next ch-3 sp, ch 3, sc in next ch-3 sp, dc in next dc, dc in next ch, turn.

Row 3: Ch 1, sk next row-end st on previous strip, sl st in side of next row-end dc on previous strip, ch 1 (ch 1, sl st, ch counts as dc), turn, dc in next st, sc in next ch-3 sp, ch 3, sc in next ch-3 sp, dc in each of last 2 sts, turn.

Rows 4–44: Rep Rows 2 and 3 (20 times); rep Row 2. Fasten off.

Laces (make 2)

Ch 350. Fasten off.

Weave in ends. Wash, block to finished measurements, and let dry.

Using the row-end sts, weave the laces back and forth through the side edges of the gauntlet, like you are lacing a new pair of shoes.

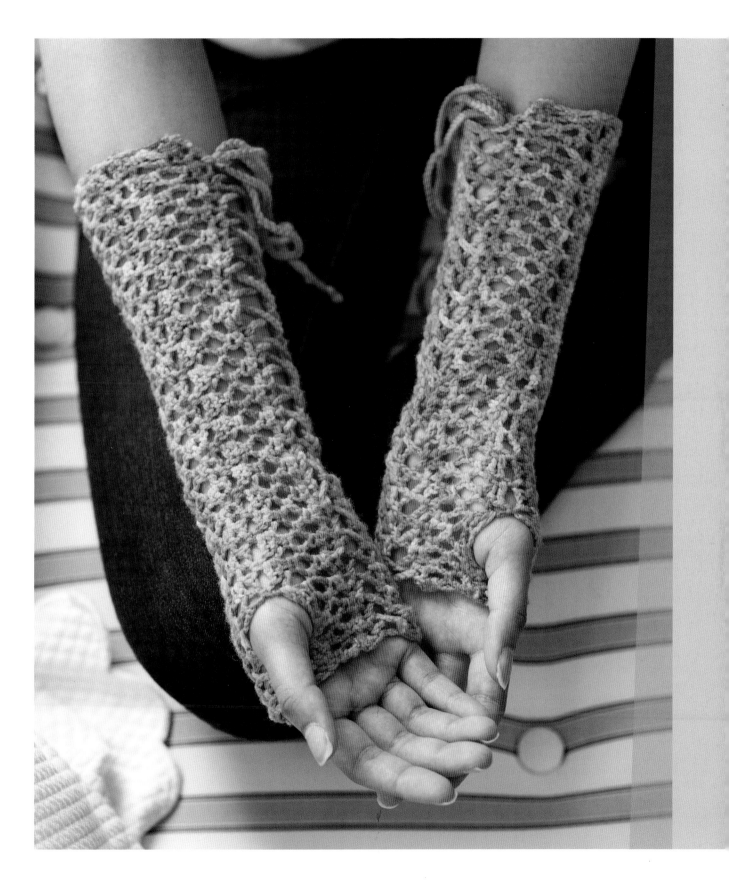

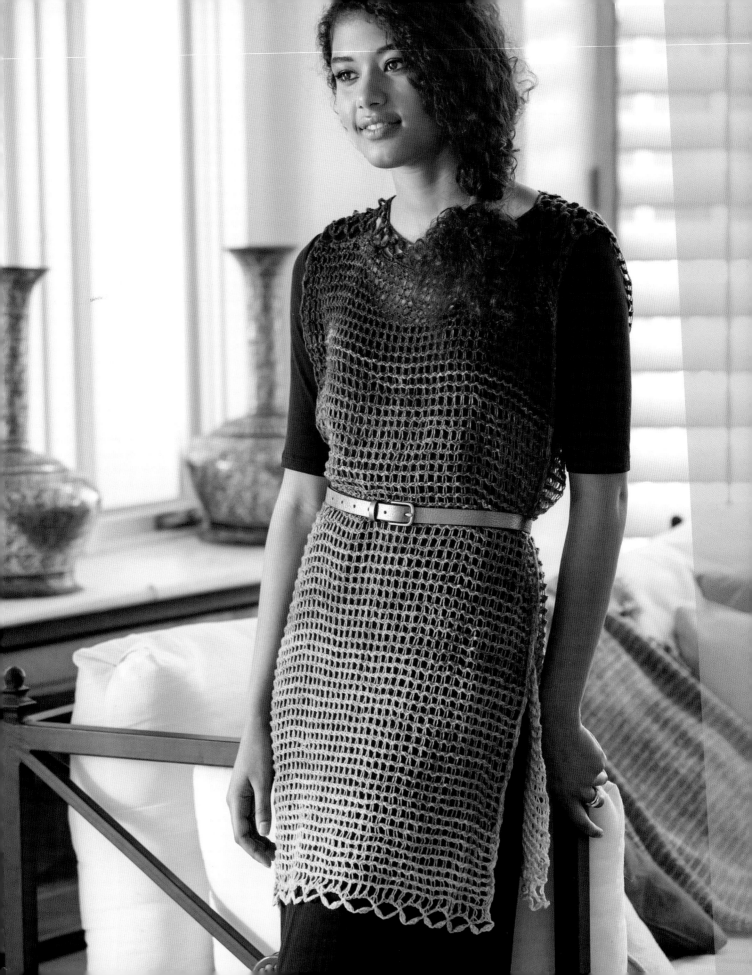

Flora Ombre
CONVERTIBLE WRAP

I love the superlong urban scarves I see wrapped multiple times around women's necks when I travel to big cities. But I wanted the long scarf/wrap to have options for wearing multiple ways, so I added a sleeve opening down the center of the wrap.

You can wear this loosely on one shoulder and shawl-pinned on the opposite shoulder or wrapped around the other shoulder for a secure capelet/poncho/wrap. Or draped over your shoulders for a dramatic evening wrap, with fabric in loose folds at the crook of your elbows. Or folded in half, both ends loosely looped through the fold, and then the doubled piece pulled over your head. There is ample yardage to drape the fabric to be a two-fold capelet, one wrapped around your neck and the second widened and worn around your arms. The ombre effect of the yarn is really amplified with this styling.

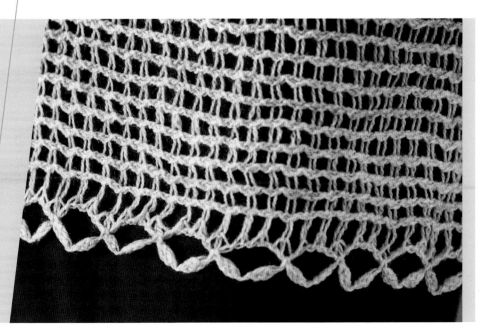

STITCH GUIDE

2-dc cluster: [Yo, insert hook in next st, yo, draw yarn through st, yo, draw yarn through 2 lps on hook] twice in same st, yo, draw yarn through 3 lps on hook.

Tunisian Crochet

The main body of wrap is worked in Tunisian crochet. Each row of Tunisian crochet is worked in 2 parts, with RS facing at all times. The forward (Fwd) pass is worked to pick up lps across row. The return pass (Rtn) returns back across row, working off lps.

Tunisian simple stitch (Tss): Fwd: Lp on hook counts as first st, sk first vertical bar, insert hook under next vertical bar, yo, draw yarn through st; rep from * as required. Standard Rtn: Yo, draw yarn through 1 lp on hook, *yo, draw through 2 lps on hook; rep from * across—1 lp rem and counts as first st of next row.

NOTE

• First Half of wrap begins at center and is worked out toward end. Second Half is worked from same foundation chain and worked out toward other end. With the ombre dyed yarn, make sure both sides begin with the same section of color and work out toward end in same color. For this wrap and colorway, we begin with charcoal gray at centers.

First Half

With standard crochet hook, ch 100.

Row 1 (RS): 2-dc cluster in 4th ch from hook, ch 4, 2-dc cluster in 4th ch from hook, sk next 5 ch, sl st in next ch, *[ch 4, 2-dc cluster in 4th ch from hook] twice, sk next 5 ch, sl st in next ch; rep from * across, turn—32 petals.

Row 2: Ch 10, 2-dc cluster in 4th ch from hook, sl st in sp bet next 2 petals, *[ch 4, 2-dc cluster in 4th ch from hook] twice, sl st in sp bet next 2 petals; rep from * across, ch 4, 2-dc cluster in 4th ch from hook, trtr in ch at base of first cluster in Row 1, turn—32 petals.

Row 3: *Ch 5, sk next 2 petals, sl st in sp bet next 2 petals rep from * across, ch 5, sl st in ch at base of last cluster in Row 2, turn—16 ch-5 sps.

Row 4: Ch 1, 6 sc in each ch-5 sp across, turn—96 sc.

Row 5: Change to Tunisian crochet hook. Fwd: Lp on hook counts as first st of row, sk first sc, *insert hook in next sc, yo and pull up a lp; rep from * across—96 lps on hook. Rtn: Yo, draw through 1 lp on hook, *yo, draw through 2 lps on hook; rep from * across—1 lp rem and counts as first st of next row.

Row 6: Sk first vertical bar, insert hook in next vertical bar, yo, pull up a loop, *yo, Tss in next vertical bar; rep from * across—96 loops on hook. Rtn: Work Standard Rtn.

Row 7: Sk first vertical bar, insert hook in next vertical bar, yo, pull up a loop, *yo, insert hook in next vertical bar, yo, pull up a loop; rep from * across—96 lps on hook. Rtn: Work Standard Rtn.

Rows 8–59: Rep Row 7.

Row 60: Change to standard crochet hook, *[Ch 4, 2-dc cluster in 4th ch from hook] twice, sk next 2 vertical bars, sl st in next vertical bar; rep from * across—32 petals. Fasten off.

Second Half

Note: Make sure to begin with the same section of color with the 2nd ball of yarn so the ombre effect works as a mirror, like in the sample garment. With WS facing, working across opposite side of foundation ch, join yarn with sl st in ch at base of first cluster in Row 1 of First Half of the wrap.

Set-up row (WS): Ch 1, sc in same st, *4 sc in next ch-4 sp, sc in next ch at base of sl st; rep from * 3 times, ch 47, sk next 8 reps (or 47 ch sts), sc in next ch at base of sl st, 4 sc in next ch-4 sp, sc in next ch at base of sl st; rep from * across, turn—89 sts.

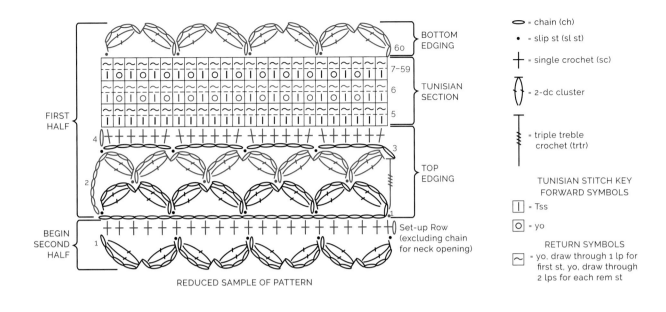

BOTTOM EDGING — 60

TUNISIAN SECTION — 7-59, 6, 5

FIRST HALF

TOP EDGING — 4, 3, 2, 1

BEGIN SECOND HALF — 1

Set-up Row (excluding chain for neck opening)

REDUCED SAMPLE OF PATTERN

⬭ = chain (ch)

• = slip st (sl st)

╅ = single crochet (sc)

◖◗ = 2-dc cluster

╪ = triple treble crochet (trtr)

TUNISIAN STITCH KEY FORWARD SYMBOLS

▯ = Tss

◻O◻ = yo

RETURN SYMBOLS

~ = yo, draw through 1 lp for first st, yo, draw through 2 lps for each rem st

Row 1 (RS): *[Ch 4, 2-dc cluster in 4th ch from hook] twice, sk next 4 sc, sl st in next sc; rep from * across 3 times*, **[Ch 4, 2-dc cluster in 4th ch from hook] twice, sk next 5 ch, sl st in next ch; rep from ** 7 times, ending with last sc in first sc of 2nd side, rep from * to * across 2nd side—32 petals.

Rows 2–60: Rep Rows 2–60 of First Half. Fasten off.

Finishing

Weave in ends. Wash, block to finished measurements, and let dry.

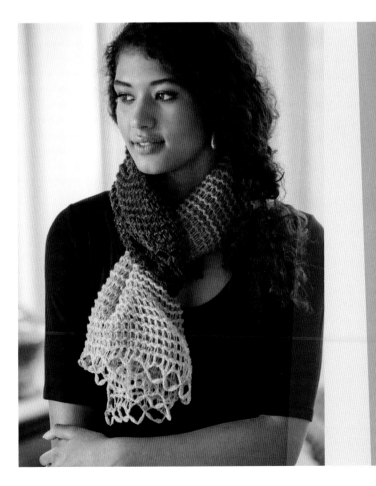

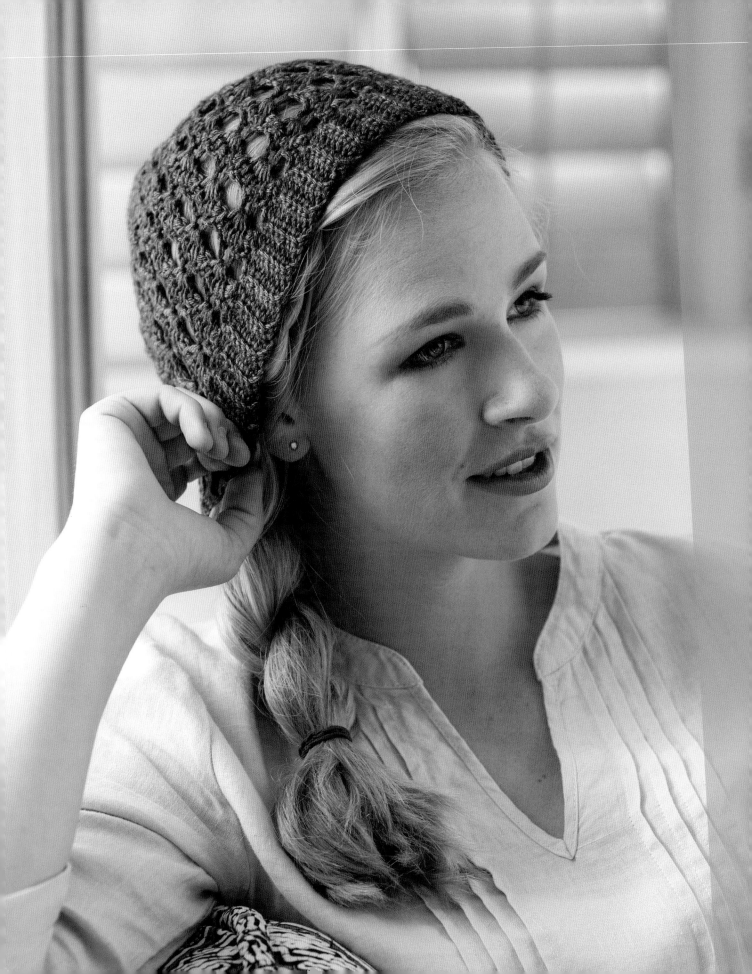

YARN

Sport weight (#2 Fine).

SHOWN HERE: Bijou Basin Ranch Lhasa Wilderness Yak/Bamboo Blend (75% Yak down/25% bamboo; 180 yd [165 m]/2 oz [56 g]): Blueberry, 1 hank.

HOOK

I/9 (5.5 mm) Tunisian crochet hook or size needed to obtain gauge.

NOTIONS

Yarn needle.

GAUGE

5 sts and 2 rows = 1" (2.5 cm) in Tunisian Lace Stitch pattern, blocked.

Alexa
LACE HAT

Short-rows are a great way of adding curved dimension to a flat fabric. By adding short-rows in this side-to-side construction hat, we are able to add the crown simultaneously to the body of this hat. It's easy to modify for other sizes, too: Simply crochet rows until the height of your fabric measures the distance around the head!

FINISHED SIZE

20" (51 cm) in circumference; 9" (23 cm) deep.

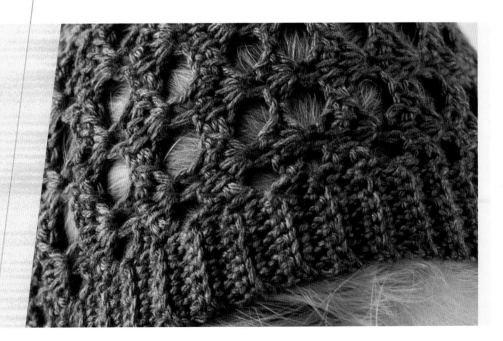

STITCH GUIDE

Tunisian Crochet

Hat is worked in Tunisian crochet. Each row of Tunisian crochet is worked in 2 parts, with RS facing at all times. The forward (Fwd) pass is worked to pick up lps across row. The return pass (Rtn) returns back across row, working off lps.

Tunisian simple stitch (Tss): Fwd: Lp on hook counts as first st, sk first vertical bar, *insert hook under next vertical bar, yo, draw yarn through st; rep from * as required. Standard Rtn: Yo, draw yarn through 1 lp on hook, *yo, draw through 2 lps on hook; rep from * across—1 lp rem and counts as first st of next row.

Tunisian double crochet (Tdc): Fwd: Lp on hook counts as first st, sk first vertical bar, *yo, insert hook under next vertical bar, yo, draw yarn through st, yo, draw yarn through 2 lps on hook; rep from * as required. Rtn: Work as indicated in row.

NOTE

- Hat is worked in short-rows, running vertically from brim to crown. Short-rows will create a narrow end for crown, and a wider end for brim.

Hat

Ch 37.

Row 1 (RS): Fwd: Insert hook in 2nd ch from hook, yo, draw up a lp, *insert hook in next ch, draw up a lp; rep from * across—37 lps on hook. Rtn: Yo, draw through 1 lp on hook, *yo, draw through 2 lps on hook; rep from * across—1 lp rem and counts as first st of next row.

Row 2: Sk first vertical bar, Tdc in each of next 31 sts—32 lps on hook. Leave last 5 sts unworked. Rtn: Yo, draw yarn through 1 lp, *ch 2, yo, draw yarn through 6 lps on hook, ch 2; rep from * 5 times, yo, draw yarn through 2 lps on hook—1 lp rem and counts as first st of next row.

Row 3: Sk first vertical bar, *[insert hook in next ch, draw up a lp] twice, insert hook in next cluster, draw up a lp, [insert hook in next ch, draw up a lp] twice; rep from * 4 times, insert hook in next ch, draw up a lp—27 lps on hook. Leave last 5 sts unworked. Rtn: Work Standard Rtn.

Row 4: Fwd: Rep Row 2—27 lps on hook. Rtn: Yo, draw yarn through 1 lp, *ch 2, yo, draw yarn through 6 lps on hook ch 2; rep from * 4 times, yo, draw yarn through 2 lps on hook—1 lp rem and counts as first st of next row.

Row 5: Sk first vertical bar, *[insert hook in next ch, draw up a lp] twice, insert hook in next cluster, draw up a lp, [insert hook in next ch, draw up a lp] twice; rep from * 3 times, insert hook in next ch, draw up a lp—22 lps on hook. Leave last 5 sts unworked. Rtn: Work Standard Rtn.

Row 6: Fwd: Rep Row 2—22 lps on hook. Rtn: Yo, draw yarn through 1 lp, *ch 2, yo, draw yarn through 6 lps on hook, ch 2; rep from * 3 times, yo, draw yarn through 2 lps on hook—1 lp rem and counts as first st of next row.

Row 7: Sk first vertical bar, *[insert hook in next ch, draw up a lp] twice, insert hook in next cluster, draw up a lp, [insert hook in next ch, draw up a lp] twice; rep from * 4 times, insert hook in next ch, draw up a lp, **working in free sts 3 rows below, insert hook in next ch, draw up a lp, insert hook in next cluster, draw up a lp, [insert hook in next ch, draw up a lp] twice, insert hook in last st, draw up a lp; rep from ** once, working in free sts 3 rows below, Tss in each of last 5 sts of Row 1—37 lps on hook. Rtn: Work Standard Rtn.

Row 8–48: Rep Rows 2–7 (6 times). Rep Rows 2–6 (once). Fasten off, leaving a long sewing length. With sewing length, sew top edge to base of Row 1, matching sts across each step of short-rows.

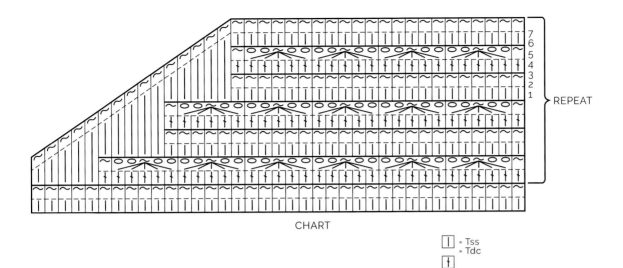

CHART

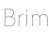 = Tss
☐ = Tdc

RETURN SYMBOLS

~ = yo, draw through 1 lp for first st, yo, draw through 2 lps for each rem st

◯ = ch 1

⟋⟍ = yo, draw through 6 lps on hook

Brim

Row 1: With RS facing, join yarn with sl st in first st to left of seam on wider edge, ch 8, sc in 2nd ch from hook and ea ch across, sk next on edge of hat, sl st in next st, turn—7 sc.

Row 2: Sk sl st, sc-tbl in ea st across, turn—7 sc.

Row 3: Ch 1, sc-tbl in ea st across—7 sc.

Row 4: Rep Row 2.

Rep Rows 3 and 4 around brim edge of hat. Fasten off, leaving a long sewing length. With sewing length, sew last row of Brim to base of Row 1.

Finishing

Weave in ends. Wash, block to finished measurements, and let dry.

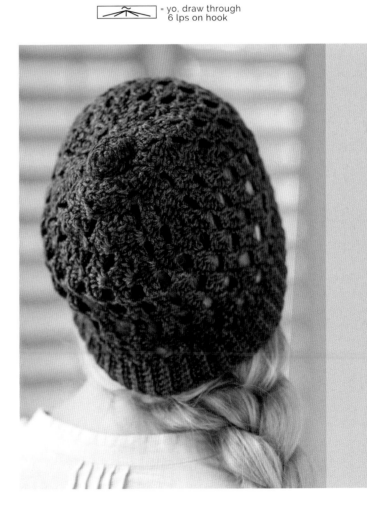

CHAPTER FIVE *Motifs*

Joining motifs is a wonderful way to create crocheted lace in any form—a tunic, a wrap, a bag, an accessory. The projects in this chapter show the impressive array of what can be accomplished in taking a single thought or idea, in the form of a motif, and taking it wherever your imagination goes. As you join motifs, sit back and watch as new possibilities arise and take flight.

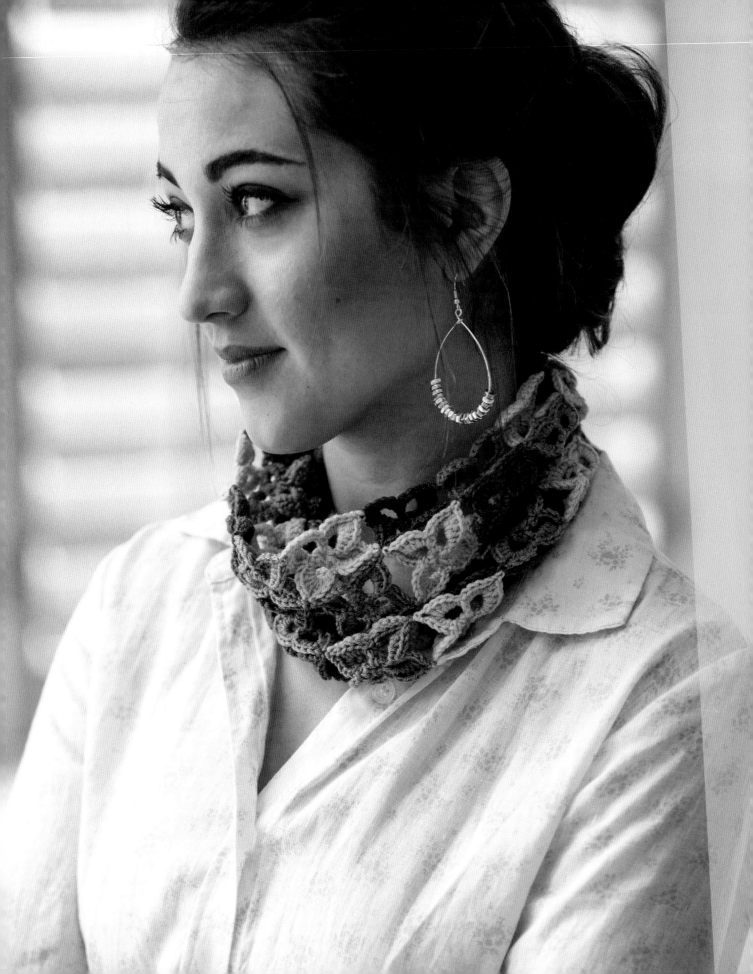

YARN

Sport weight (#2 Fine).

SHOWN HERE: Tahki Stacy Charles Filatura Di Crosa Zarina (100% extrafine merino superwash wool; 181 yd [165 m]/1.75 oz [50 g]): #1527 Light Green (A), 1 ball.

Tahki Stacy Charles Filatura Di Crosa Zarina Melange (100% extrafine merino superwash wool; 181 yd [165 m]/1.75 oz [50 g]): #1627 Medium Persian Green (B) and #1628 Dark Teal (C), 1 ball each.

HOOKS

D/3 (3.25 mm) or size needed to obtain gauge.

NOTIONS

Yarn needle.

GAUGE

With larger hook, Motif = 1½" (3.8 cm) square. With smaller hook, Motif = 1" (2.5 cm) square.

FINISHED SIZE

20" (51 cm) in circumference; 9" (23 cm) deep.

Hydrangea
COWL

These pretty little one-round motifs remind me of the tiny cluster flowers of a hydrangea. They come in all sorts of colors, ranging from green to blue, purple, pink, white, and sometimes a variety of those colors mixed together. For this simple project, spiral colorblocking adds an interesting element to the design.

The cowl doubles as a headband. On a chilly day, sweep your hair into an updo and still keep your head warm!

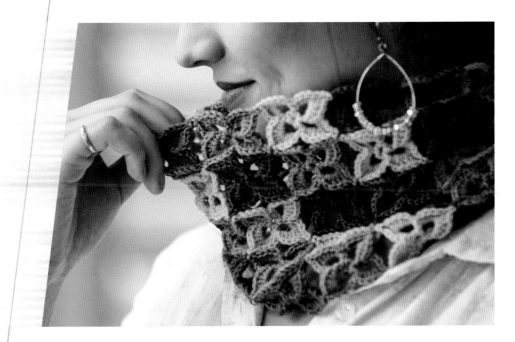

NOTE

- When joining multiple motifs into same corner space, for a more streamlined look, join in the center chain of the adjacent motif instead of just the larger chain space. For example, on a chain-3 space, join in the 2nd of the 3 chains (center chain) for each time you join.

Cowl or Headband

FIRST MOTIF

Ch 5, sl st in 5th ch from hook to form ring.

Rnd 1: Ch 1, [sc, ch 7] 4 times in ring, join with sl st in first sc—8 ch-7 sps.

Rnd 2: Sl st in next ch-7 sp, ch 1, (sc, 4 dc, ch 3, 4 dc, sc) in each ch-7 sp around, join with sl st in first sc—4 petals. Fasten off.

SECOND AND SUCCESSIVE MOTIFS
(joining on one side)

Work same as First Motif through Rnd 1.

Rnd 2: Sl st in next ch-7 sp, ch 1, (sc, 4 dc, ch 1, sl st in ch-3 sp of previous motif, ch 1, 4 dc, sc) in each of next 2 ch-7 sps, (sc, 4 dc, ch 3, 4 dc, sc) in each of last 2 ch-7 sps around, join with sl st in first sc—4 petals. Fasten off.

SUCCESSIVE MOTIFS
(joining on two sides)

Work same as First Motif through Rnd 1.

Rnd 2: Sl st in next ch-7 sp, ch 1, (sc, 4 dc, ch 1, sl st in ch-3 sp of previous motif, ch 1, 4 dc, sc) in each of next 3 ch-7 sps, (sc, 4 dc, ch 3, 4 dc, sc) in last ch-7 sp around, join with sl st in first sc—4 petals. Fasten off.

SUCCESSIVE MOTIFS
(joining on three sides)

Work same as First Motif through Rnd 1.

Rnd 2: Sl st in next ch-7 sp, ch 1, (sc, 4 dc, ch 1, sl st in ch-3 sp of previous motif, ch 1, 4 dc, sc) in each ch-7 sp around, join with sl st in first sc—4 petals. Fasten off.

JOIN

A	B	C	A	B	C	A	B	C	A	B	C
C	A	B	C	A	B	C	A	B	C	A	B
B	C	A	B	C	A	B	C	A	B	C	A
A	B	C	A	B	C	A	B	C	A	B	C
C	A	B	C	A	B	C	A	B	C	A	B

COWL ASSEMBLY DIAGRAM

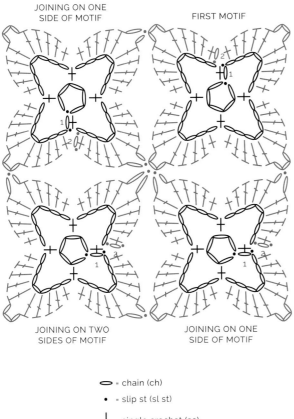

JOINING ON ONE SIDE OF MOTIF

FIRST MOTIF

JOINING ON TWO SIDES OF MOTIF

JOINING ON ONE SIDE OF MOTIF

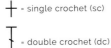

⬯ = chain (ch)

• = slip st (sl st)

+ = single crochet (sc)

† = double crochet (dc)

Finishing

With larger hook, make 60 motifs and join in a tube 12 motifs around and 5 motifs deep following Assembly Diagram for color placement.

With sewing length, sew last row to foundation ch at base of Row 1. Alternatively, with RS facing, working through double thickness, sc in each st across, or with WS facing, working through double thickness, sl st in each st across.

Note: Crocheting the seam will take quite a bit more yarn than sewing the seam.

Weave in ends. Wash, block to finished measurements, and let dry.

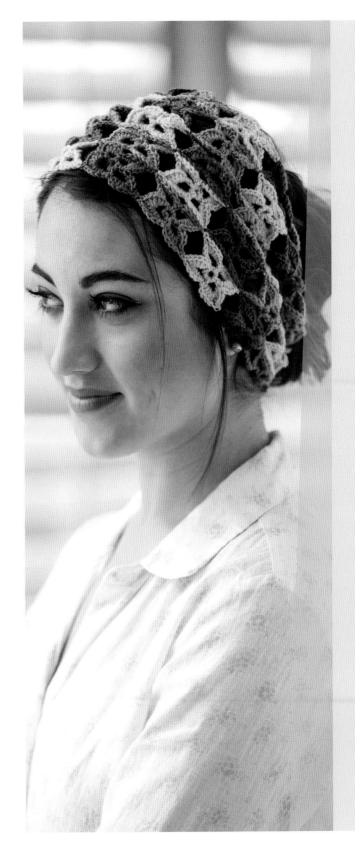

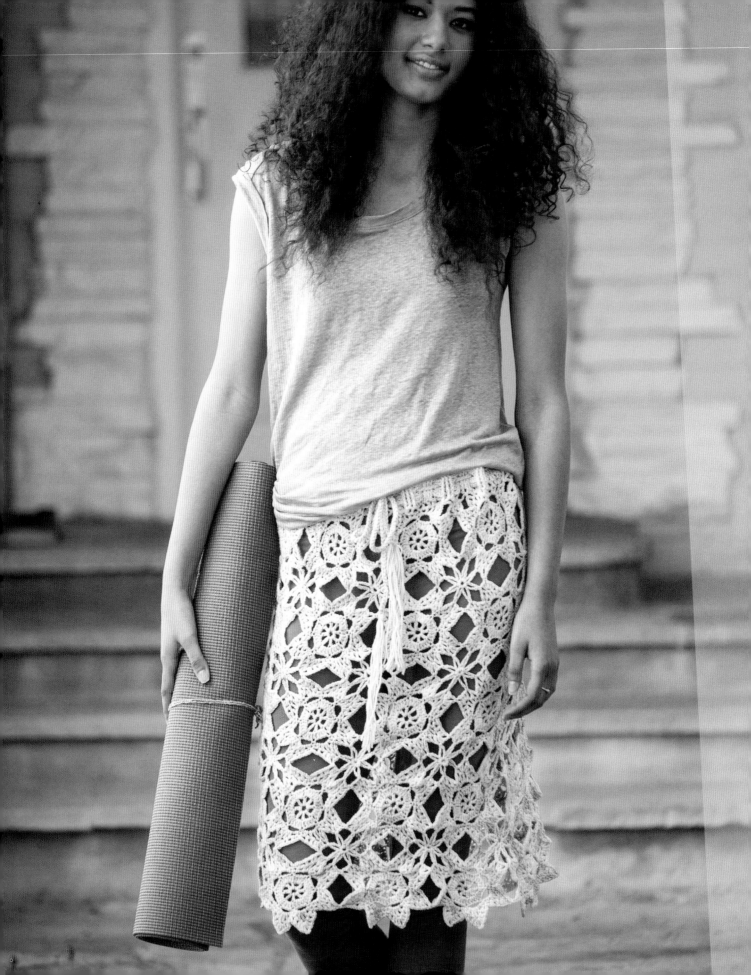

YARN

Sport weight (#2 Fine).

SHOWN HERE: Drew Emborsky Inappropriate (90% extrafine superwash merino wool/10% nylon; 440 yd [402 m]/4 oz [114 g]): Moonwalk, 3 (3, 3, 3, 4) skeins.

HOOKS

F/5 (3.5 mm) (for waistband) and G/6 (4 mm) or sizes needed to obtain gauge.

NOTIONS

Yarn needle.

GAUGE

Motif A = 4½" (11.5 cm) square, blocked.

FINISHED SIZE

Directions are given for size S. Changes for M, L, XL, and 2X are in parentheses.

FINISHED HIPS: 38¼ (42½, 46¾, 51, 55¼)" (97 [108, 118.5, 129.5, 139.5] cm) hip circumference, with 2¼ (2½, 2¾, 3, 3¼)" (5.5 [6.5, 7, 7.5, 8.5] cm) ease.

HEM CIRCUMFERENCE: 42 (46, 51, 56, 60)" (106.5 [117, 129.5, 142, 152.5] cm).

Note: Hem circumference is wider because the large motifs are not tamed with smaller motifs to give the fabric structure. The scalloped edge of the open motifs blocks wider, thus the wider hem.

FINISHED LENGTH: 23½" (59.5 cm).

Moonlight Stroll
SKIRT

Inspired by Moroccan tile work, the tandem motifs in this skirt (large and small) work together beautifully. The octagonal motifs are joined on four sides so there is a negative space between the motifs, begging for a smaller motif to fill the space.

Knit and crochet skirts look best when worn low between the hips and natural waistline (below the belly button). You will need an underlayer for the skirt, either a stretchy fitted skirt or a slip. Play around with tonal and contrast colors. But shy away from busy, loud prints because the lace patterning of the skirt counts as a print.

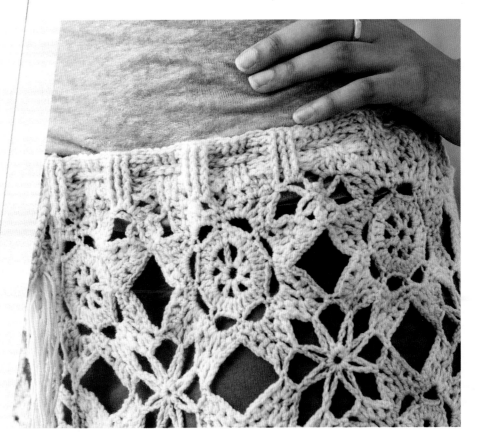

STITCH GUIDE

Front post double crochet (FPdc): Yo, insert hook from front to back to front again around the post of next st, yo, draw yarn through st, [yo, draw yarn through 2 lps on hook] twice.

Back post double crochet (BPdc): Yo, insert hook from back to front to back again around the post of next st, yo, draw yarn through st, [yo, draw yarn through 2 lps on hook] twice.

Skirt

Note: All sizes are 5 motifs tall but 9 (10, 11, 12, 13) motifs wide before joining.

FIRST MOTIF A

Ch 5, sl st in 5th ch from hook to form ring.

Rnd 1: Ch 5 (counts as dc, ch 2 here and throughout), [dc, ch 2] 7 times in ring, join with sl st in 3rd ch of beg ch-5— 8 ch-2 sps.

Rnd 2: Ch 3 (counts as dc here and throughout), *3 dc in next ch-2 sp, dc in next dc; rep from * around, join with sl st to top of beg ch-3—32 dc.

Rnd 3: Ch 1, sc in first st, ch 5, skip next 3 sts, *sc in next st, ch 5, skip next 3 sts; rep from * around, join with sl st to top of beg ch-3—8 ch-7 sps.

Rnd 4: Ch 1, sc in first st, (hdc, ch 1, dc, ch 1, tr, ch 1, dc, ch 1, hdc) in next ch-5 sp**, sc in next sc; rep from * around, ending last rep at **, join with sl st in first sc—8 petals.

Rnd 5: Ch 1, sc in first st, *ch 2, dc in next ch-1 sp, ch 1, dc in next ch-1 sp, ch 1, (2 dc, ch 3, 2 dc) in next tr, (ch 1, dc) in each of next 2 ch-1 sps, ch 2**, sc in next sc; rep from * around, ending last rep at **, join with sl st in first sc— 8 petals.

Make 44 (49, 54, 59, 64) more Motifs joining each to previous Motif(s) on one, two, or three sides while completing last rnd, following Assembly Diagram for placement.

SECOND AND SUCCESSIVE MOTIF A
(joining on one side)
Work same as First Motif A through Rnd 4.

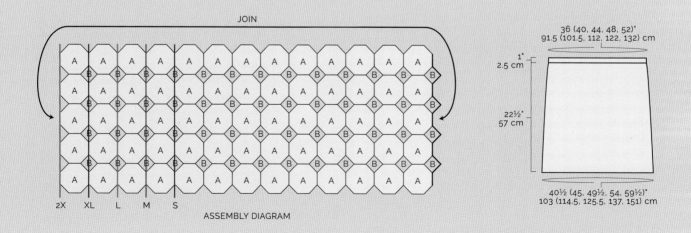

JOIN

2X XL L M S

ASSEMBLY DIAGRAM

36 (40, 44, 48, 52)"
91.5 (101.5, 112, 122, 132) cm

1"
2.5 cm

22½"
57 cm

40½ (45, 49½, 54, 59½)"
103 (114.5, 125.5, 137, 151) cm

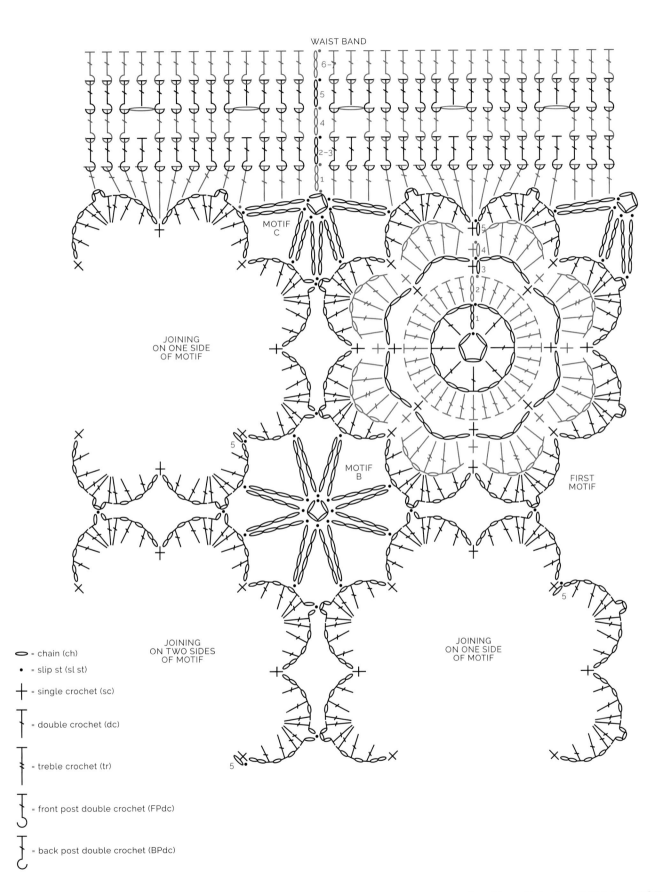

WAIST BAND

MOTIF C

JOINING
ON ONE SIDE
OF MOTIF

MOTIF B

FIRST MOTIF

JOINING
ON TWO SIDES
OF MOTIF

JOINING
ON ONE SIDE
OF MOTIF

⬯ = chain (ch)

• = slip st (sl st)

+ = single crochet (sc)

↑ = double crochet (dc)

↑ = treble crochet (tr)

↑ = front post double crochet (FPdc)

↑ = back post double crochet (BPdc)

Rnd 5: Ch 1, sc in first st, *ch 2, dc in next ch-1 sp, ch 1, dc in next ch-1 sp, ch 1, (2 dc, ch 1, sl st in ch-3 sp of previous Motif, 2 dc) in next tr, (ch 1, dc) in each of next 2 ch-1 sps, ch 2, sc in next sc; rep from * once, **ch 2, dc in next ch-1 sp, ch 1, dc in next ch-1 sp, ch 1, (2 dc, ch 3, 2 dc) in next tr, (ch 1, dc) in each of next 2 ch-1 sps, ch 2***, sc in next sc; rep from ** around, ending last rep at ***, join with sl st in first sc—2 joined petals, 6 unjoined petals.

SUCCESSIVE MOTIF A
(joining on two sides)

Work same as First Motif A through Rnd 4.

Rnd 5: Ch 1, sc in first st, *ch 2, dc in next ch-1 sp, ch 1, dc in next ch-1 sp, ch 1, (2 dc, ch 1, sl st in ch-3 sp of previous Motif, 2 dc) in next tr, (ch 1, dc) in each of next 2 ch-1 sps, ch 2, sc in next sc*; rep from * to * once in same motif, rep from * to * twice in next motif, **ch 2, dc in next ch-1 sp, ch 1, dc in next ch-1 sp, ch 1, (2 dc, ch 3, 2 dc) in next tr, (ch 1, dc) in each of next 2 ch-1 sps, ch 2***, sc in next sc; rep from ** around, ending last rep at ***, join with sl st in first sc—4 joined petals, 4 unjoined petals.

SUCCESSIVE MOTIF A
(joining on three sides)

Work same as First Motif A through Rnd 4.

Rnd 5: Ch 1, sc in first st, *ch 2, dc in next ch-1 sp, ch 1, dc in next ch-1 sp, ch 1, (2 dc, ch 1, sl st in ch-3 sp of previous motif, 2 dc) in next tr, (ch 1, dc) in each of next 2 ch-1 sps, ch 2, sc in next sc*; rep from * to * once in same motif, rep from * to * twice in next motif, rep from * to * twice in next motif, ch 2, dc in next ch-1 sp, ch 1, dc in next ch-1 sp, ch 1, (2 dc, ch 3, 2 dc) in next tr, (ch 1, dc) in each of next 2 ch-1 sps, ch 2, join with sl st in first sc—6 joined petals, 2 unjoined petals.

MOTIF B
(worked in spaces between 4 large motifs, joining in 8 places, 2 ch-3 sps on each of the 4 Motifs A)

Ch 4, sl st in 4th ch from hook to form a ring.

Rnd 1: *Ch 4, sl st in ch-1 sp after joined ch-3 sp on next one Motif A, ch 4, sl st in ring, ch 4, sk next 4 ch-sps on same Motif A, sl st in next ch-1 sp, ch 4, sl st in ring; rep from * 3 times, joining to next 3 Motifs A, join with sl st to first ch at beg of rnd. Fasten off.

MOTIF C
(worked along top edge between 2 Motifs A, joining in 4 places, and creating a flat, straight edge along what will become the waistband edge)

Note: This motif is worked in a row, not a rnd.

Ch 4, sl st in 4th ch from hook to form a ring.

Row 1: *Ch 4, sl st in first ch-1 sp to the left of ch-3 sp on next adjacent Motif A, ch 4, sl st in ring, ch 4, sk next 4 ch-sps on same Motif A, sl st in next ch-1 sp, ch 4, sl st in ring*, ch 4, sl st in junction bet Motifs A, ch 4, sl st in ring, rep from * to * once on next Motif A. Fasten off.

Waistband

Rnd 1: With smaller hook, join with sl st in center ring of any Motif C on top edge of skirt, ch 3, work 17 dc evenly spaced across to center of next Motif C, *work 18 dc evenly spaced across to center of next Motif C; rep from * around—162 (180, 198, 216, 234) dc.

Rnd 2: Ch 3 (counts as FPdc), FPdc around the post of ea of next 2 sts, *BPdc around the post of ea of next 3 sts**, FPdc around the post of ea of next 3 sts; rep from * around, ending last rep at **, join with sl st in top of beg ch-3—162 (180, 198, 216, 234) post st.

Rnd 3: Rep Rnd 2.

Rnd 4: Ch 3, FPdc around the post of ea of next 2 sts, *BPdc around the post of next st, ch 1, sk next st, BPdc around the post of next st**, FPdc around the post of ea of next 3 sts; rep from * around, ending last rep at **, join with sl st in top of beg ch-3—27 (30, 33, 36, 39, 42) ch-1 sps.

Rnd 5: Ch 3, FPdc around the post of ea of next 2 sts, *BPdc around the post of next st, dc in next st, BPdc around the post of next st**, FPdc around the post of ea of next 3 sts; rep from * around, ending last rep at **, join with sl st in top of beg ch-3—162 (180, 198, 216, 234) sts.

Rnds 6 and 7: Rep Rnd 2. Fasten off.

Tie: With 2 strands of yarn held together as one, make a ch that is double your waist measurement. Fasten off. Weave Ties through ch-1 spaces in Rnd 4 of Waistband. Fringe (make 2): Cut seven 14" (35.5 cm) lengths of yarn for each Fringe. Fold bundle of 7 strands in half, insert hook in end of Tie, draw folded end of Fringe through end of Tie, yo with cut strands of Fringe, draw through folded end of Fringe. Pull on Fringe to tighten. Trim ends even.

Finishing

Weave in ends. Wash, block to finished measurements, and let dry.

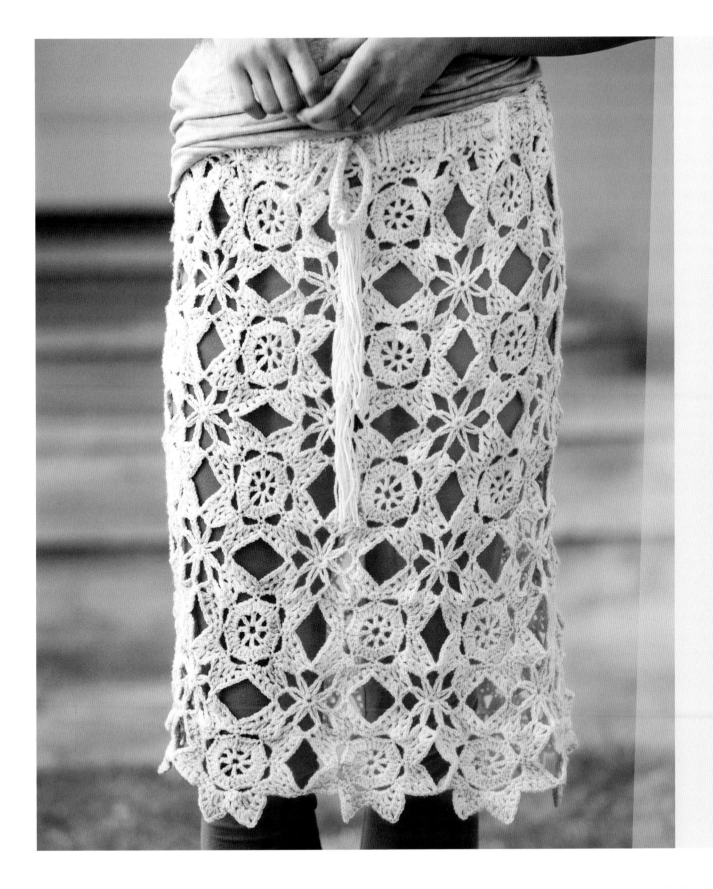

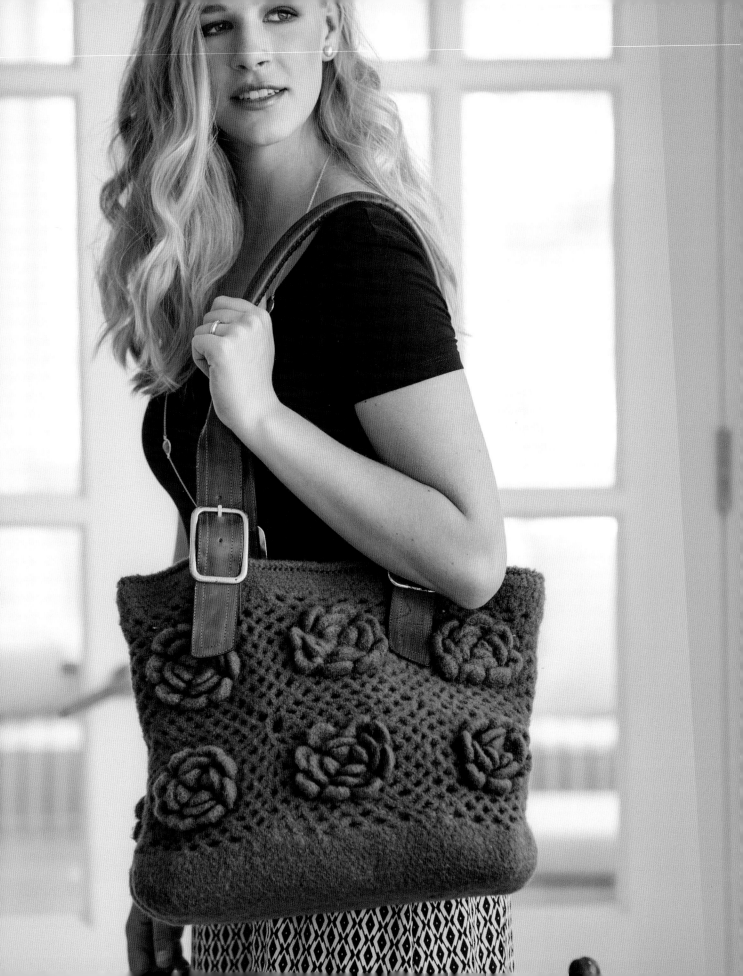

YARN

Worsted weight (#4 Medium).

SHOWN HERE: Cascade 220 (100% Peruvian Highland Wool; 220 yd [210 m]/3.5 oz [100 g]): #8339 Marine, 4 skeins.

HOOK

I/9 (6 mm) or size needed to obtain gauge.

NOTIONS

A few yds of scrap, nonfelting, contrast yarn (I used cotton tan yarn); Grayson E large buckle leather handles, distributed by Muench Yarns.

GAUGE

MOTIF - TK" (TK cm) square, before felting.

MOTIF - 5" (12.5 cm) square, after felting.

Felted Flower
BAG

I love following designer handbag trends. Laser-cut leather is really hot right now. Notice how the felted lace fabric resembles laser cuts. And the flower is worked as part of the motif, so there is absolutely no sewing of these beautifully embellished flowers either.

This is a great sized tote bag for everyday use, with ample space for toting along your smaller crafting project, too. Unless you are an excellent seamstress and wish to sew your own lining, you can purchase great purse organizer inserts online that double as a lining.

FINISHED SIZE

15" (38 cm) wide × 13" (33 cm) deep, excluding strap.

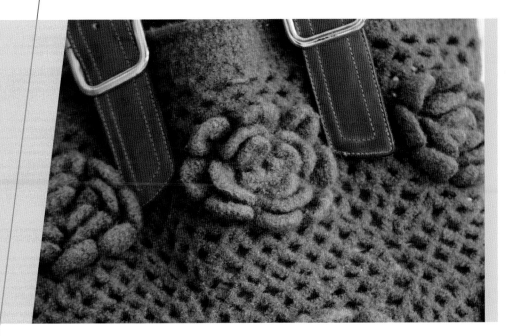

STITCH GUIDE

Double crochet 5 together (dc5tog): [Yo, insert hook in next st, yo, draw yarn through st, yo, draw yarn through 2 lps on hook] 5 times, yo, draw yarn through 6 lps on hook.

4-dc cluster: [Yo, insert hook in next st, yo, draw yarn through sp, yo, draw yarn through 2 lps on hook] twice in same sp, [yo, insert hook in next sp, yo, draw yarn through st, yo, draw yarn through 2 lps on hook] twice in next sp, yo, draw yarn through 5 lps on hook.

JOIN

ASSEMBLY DIAGRAM

Bag

FIRST MOTIF
(no joining)

Ch 4, sl st in 4th ch from hook to form ring.

Rnd 1 (RS): *Ch 3, (3 tr, ch 3, sl st) in ring; rep from * 3 times—4 petals.

Rnd 2: *Ch 5, working behind petal, sl st in next sl st; rep from * around—4 ch-5 sps.

Rnd 3: *(Sl st, ch 3, 6 tr, ch 3, sl st) in each ch-5 sp around—4 petals.

Rnd 4: *Ch 5, working behind petal, sk next 3 tr, sl st in ch-5 sp in Rnd 2, ch 5, sk remainder of same petal, sl st in next sl st; rep from * around—8 ch-5 sps.

Rnd 5: *(Sl st, ch 3, 6 tr, ch 3, sl st) in each ch-5 sp around—8 petals.

Rnd 6: *Ch 5, working behind petal, sk next 3 tr, sl st in ch-5 sp in Rnd 4, ch 5, sk remainder of same petal, sl st in next sl st; rep from * around—16 ch-5 sps.

Rnd 7: Ch 1, sc in first sp, *(ch 5, sc) in each of next 3 ch-5 sps, ch 5**, (sc, ch 5, sc) in next ch-5 sp; rep from * around, ending last rep at **, sc in beg ch-sp, ch 2, dc in first sc instead of last ch-5 sp—20 ch-5 sps.

Rnd 8: Ch 1, sc in first sp, *(ch 5, sc) in each of next 4 ch-5 sps, ch 5**, (sc, ch 5, sc) in next ch-5 sp; rep from * around, ending last rep at **, sc in beg ch-sp, ch 2, dc in first sc instead of last ch-5 sp—24 ch-5 sps.

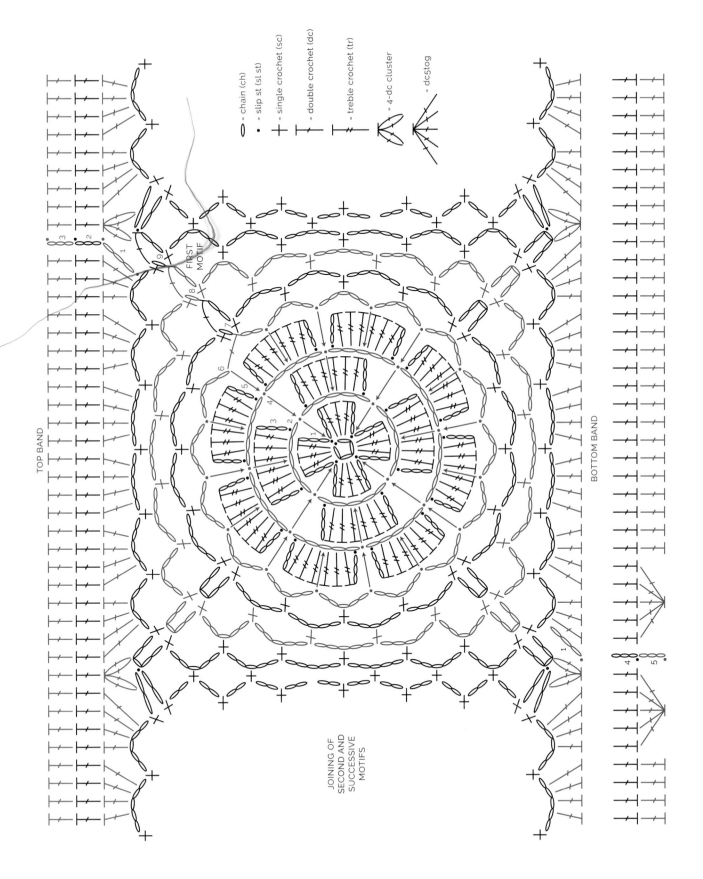

= chain (ch)

= slip st (sl st)

= single crochet (sc)

= double crochet (dc)

= treble crochet (tr)

= 4-dc cluster

= dc5tog

TOP BAND

BOTTOM BAND

FIRST MOTIF

JOINING OF SECOND AND SUCCESSIVE MOTIFS

Rnd 9: Ch 1, sc in first sp, *(ch 5, sc) in each of next 5 ch-5 sps, ch 5**, (sc, ch 5, sc) in next ch-5 sp; rep from * around, ending last rep at **, sc in beg ch-sp, ch 2, dc in first sc instead of last ch-5 sp—28 ch-5 sps. Fasten off.

Make 11 more motifs in a tube, 6 motifs around and 2 motifs deep, joining each to previous motif(s) while completing last rnd, joining to one, two, or three sides as required.

SECOND AND SUCCESSIVE MOTIFS
(joined on one side)

Work same as First Motif through Rnd 8.

Rnd 9: Ch 1, sc in first sp, (ch 5, sc) in each of next 5 ch-5 sps, ch 5, (sc, ch 2, sl st in corner ch-5 sp of previous motif, ch 2, sc) in next ch-5 sp, ch 2, sc in next corresponding ch-5 sp of previous motif, ch 2, sc in next ch-5 sp of current motif] 6 times, ch 2, sl st in next corner ch-5 sp, ch 2, sc in same corner ch-5 sp of current motif, *(ch 5, sc) in each of next 5 ch-5 sps, ch 5**, (sc, ch 5, sc) in next ch-5 sp; rep from * around, ending last rep at **, sc in beg ch-sp, ch 2, dc in first sc instead of last ch-5 sp. Fasten off.

SUCCESSIVE MOTIFS
(joined on two opposite sides)

Work same as First Motif through Rnd 8.

Rnd 9: Ch 1, sc in first sp, (ch 5, sc) in each of next 5 ch-5 sps, ch 5, *(sc, ch 2, sl st in corner ch-5 sp of previous motif, ch 2, sc) in next ch-5 sp, ch 2, sc in next corresponding ch-5 sp of previous motif, ch 2, sc in next ch-5 sp of current motif] 6 times, ch 2, sl st in next corner ch-5 sp, ch 2, sc in same corner ch-5 sp of current motif*, (ch 5, sc) in each of next 5 ch-5 sps, ch 5; rep from * to * once joining to First Motif, ch 2, sl st in next corner ch-5 sp of First Motif, ch 2, join with sl st in first sc.

SUCCESSIVE MOTIFS
(joined on two adjacent sides)

Work same as First Motif through Rnd 8.

Rnd 9: Ch 1, sc in first sp, (ch 5, sc) in each of next 5 ch-5 sps, ch 5, (sc, ch 2, sl st in corner ch-5 sp of previous motif, ch 2, sc) in next ch-5 sp, *ch 2, sc in next corresponding ch-5 sp of previous motif, ch 2, sc in next ch-5 sp of current motif] 6 times, ch 2, sl st in next corner ch-5 sp, ch 2, sc in same corner ch-5 sp of current motif; rep from * once, **(ch 5, sc) in each of next 5 ch-5 sps, ch 5***, (sc, ch 5, sc) in next ch-5 sp; rep from * around, ending last rep at **, sc in beg ch-sp, ch 2, dc in first sc instead of last ch-5 sp.

SUCCESSIVE MOTIF
(joined on three adjacent sides)

Work same as First Motif through Rnd 8.

Rnd 9: Ch 1, sc in first sp, (ch 5, sc) in each of next 5 ch-5 sps, ch 5, (sc, ch 2, sl st in corner ch-5 sp of previous motif, ch 2, sc) in next ch-5 sp, *ch 2, sc in next corresponding ch-5 sp of previous motif, ch 2, sc in next ch-5 sp of current motif] 6 times, ch 2, sl st in next corner ch-5 sp, ch 2, sc in same corner ch-5 sp of current motif; rep from * twice, (ch 5, sc) in each of next 5 ch-5 sps, ch 5, sc in beg ch-sp, ch 2, dc in first sc instead of last ch-5 sp.

Top Band

Rnd 1: With RS facing, join yarn with sl st in any corner join on top edge of tube, *work 4-dc cluster over corner join, placing 2 points of cluster in each side of corner join (see diagram); rep from * around, join with sl st to top of beg ch-3 sp—150 sts.

Rnds 2 and 3: Ch 3, work dc in ea st around, join with sl st to top of beg ch-3 sp.

Rnd 4: Sl st in ea st around, join with sl st in first sl st. Fasten off.

Bottom Band and Base

Rnd 1: With RS facing, join yarn in first ch-5 sp to the left of any junction bet motifs on bottom edge of tube, ch 3, 3 dc in same sp, 4 dc in each ch-5 sp to next junction bet motifs, *work 4dc-cluster over corner join, placing 2 points of cluster in each side of corner join (see diagram); rep from * around, join with sl st to top of beg ch-3 sp—150 sts.

Rnds 2–4: Ch 3, work dc in ea st around, join with sl st to top of beg ch-3 sp.

Rnd 5: Ch 3, dc5tog over next 5 sts, dc in ea of next 64 sts, dc5tog over next 5 sts, dc in next st, dc5tog over next 5 sts, dc in ea of next 64 sts, dc5tog over last 5 sts, join with sl st to top of beg ch-3 sp—134 sts.

Rnd 6: Ch 3, dc5tog over next 5 sts, dc in ea of next 56 sts, dc5tog over next 5 sts, dc in next st, dc5tog over next 5 sts, dc in ea of next 56 sts, dc5tog over last 5 sts, join with sl st to top of beg ch-3 sp—118 sts.

Rnd 7: Ch 3, dc5tog over next 5 sts, dc in ea of next 48 sts, dc5tog over next 5 sts, dc in next st, dc5tog over next 5 sts, dc in ea of next 48 sts, dc5tog over last 5 sts, join with sl st to top of beg ch-3 sp—102 sts.

Rnd 8: Ch 3, dc5tog over next 5 sts, dc in ea of next 40 sts, dc5tog over next 5 sts, dc in next st, dc5tog over next 5 sts, dc in ea of next 40 sts, dc5tog over last 5 sts, join with sl st to top of beg ch-3 sp—86 sts.

Rnd 9: Ch 3, dc5tog over next 5 sts, dc in ea of next 32 sts, dc5tog over next 5 sts, dc in next st, dc5tog over next 5 sts, dc in ea of next 32 sts, dc5tog over last 5 sts, join with sl st to top of beg ch-3 sp—70 sts.

Turn bag inside out. Flatten bag. With WS facing, working through double thickness, sl st across bottom of the bag. Fasten off. Weave in ends.

Finishing

Using scrap cotton yarn, sl st around top opening of bag, then sl st both thicknesses together. This prevents the top from felting unevenly and also prevents it from felting together in the process. Once the bag is dry, you can unravel it back out. If you have any problems, you can always use a seam ripper or sharp scissors to remove the sl st row.

Felting

Placing bag in the washing machine set for hot water, with soap (I used Wrapture), and low water setting, start the wash. If you have a top loader, you can check on it often. Otherwise, you may be unable to stop the process if you think it goes too far. Some people like to stop the process prematurely. I let the wash cycle complete and didn't remove it early.

Find a box or form that closely fits the shape of your bag. I used a 9" (23 cm) × 14" (35.5 cm) box. Invert the bag over the box to let dry overnight.

Sew handles to each side of bag.

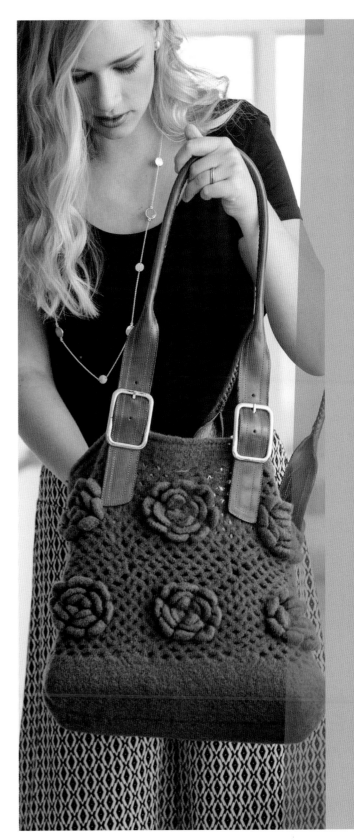

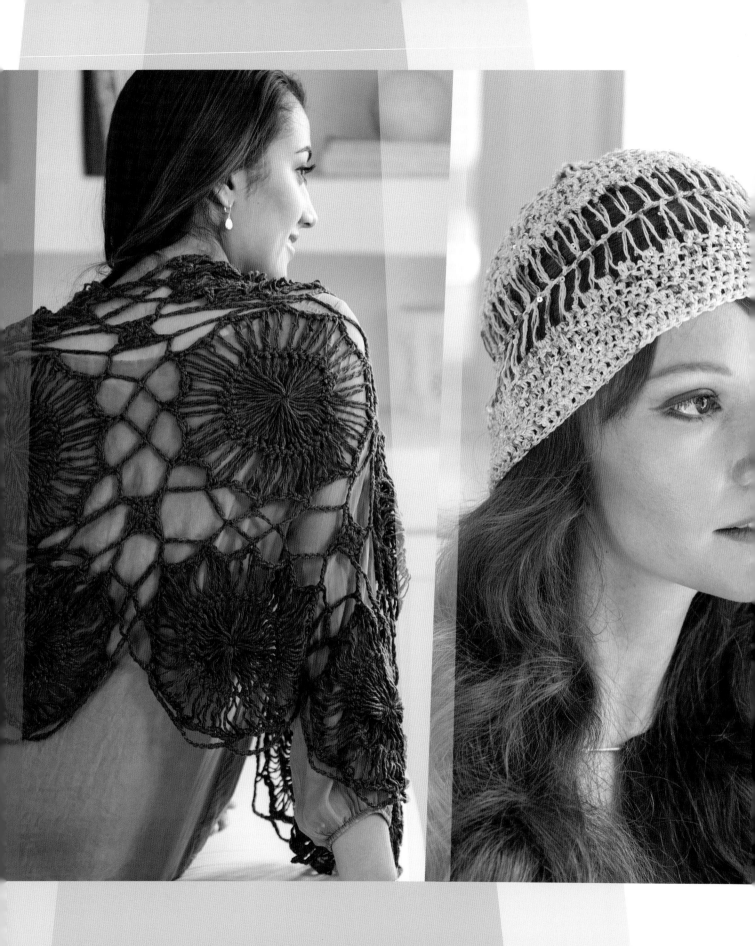

Broomstick
& Hairpin

Traditionally, both of these techniques are crocheted in flat fabric. For a little excitement, I turned both into motifs for this collection. The broomstick lace motifs are adorable as a scalloped border along the edge of a lace shawl. And the hairpin lace strips are wrapped around themselves for a simple but dramatically different look: from strips to medallions!

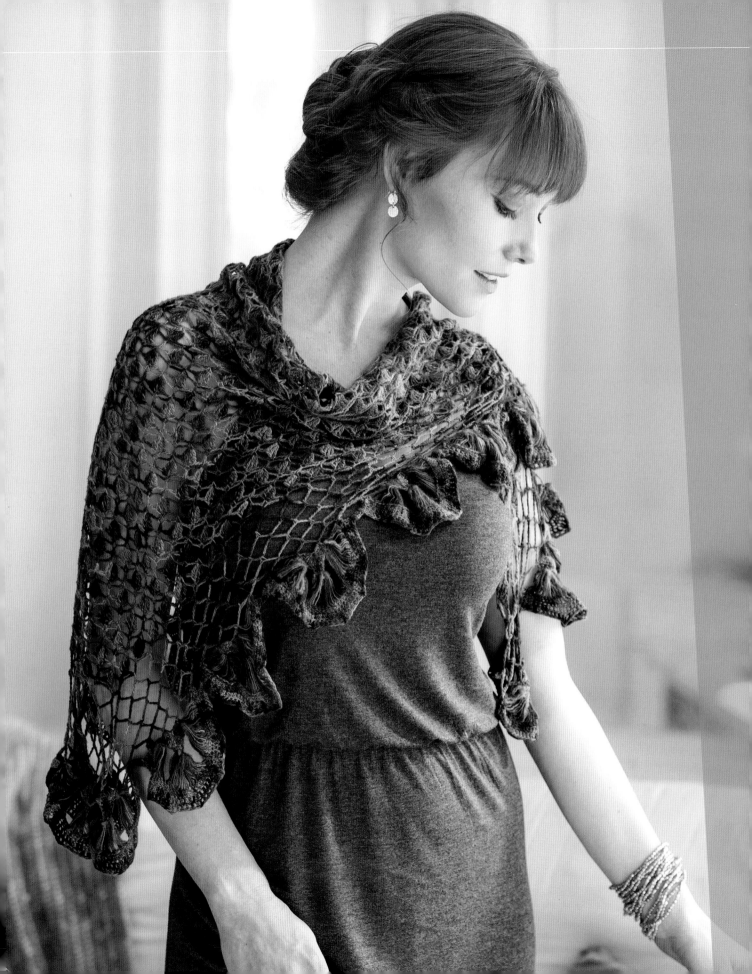

YARN

Lace weight (#1 Super Fine).

SHOWN HERE: Malabrigo Lace (100% baby merino wool; 470 yd [430 m]/ 1.75 oz [50 g]): #203 Verdes, 2 skeins.

HOOKS

C/2 (2.75 mm) and G/6 (4 mm) or sizes needed to obtain gauges.

US 50 (25 mm) knitting needle

NOTIONS

Yarn needle; stitch markers.

GAUGE

With smaller hook, Motif = 4½" (11.5 cm) wide × 2½" (6.5 cm) tall, blocked. With larger hook, 3 pattern reps and 7 rows in Lace Stitch pattern = 4" (10 cm), blocked.

FINISHED SIZE

55" (139.5 cm) wide × 27" (68.5 cm) deep.

Bleeding Heart
SHAWL

This delicate laceweight yarn has added structure and textural interest with the blending of large-scale broomstick lace and motifs for a beautifully scalloped border to this otherwise simple crochet lace shawl. The motifs are crocheted separately and joined to the bottom-up-construction shawl with the addition of a simple mesh border/panel for an easy, sew-free joining.

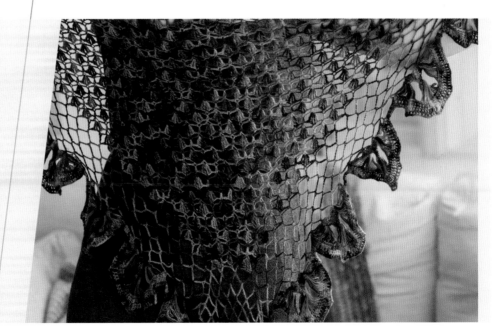

STITCH GUIDE

Double crochet 15 together (dc15tog):
[Yo, insert hook in next st, yo, draw yarn through st, yo, draw yarn through 2 lps on hook] 15 times, yo, draw yarn through 16 lps on hook.

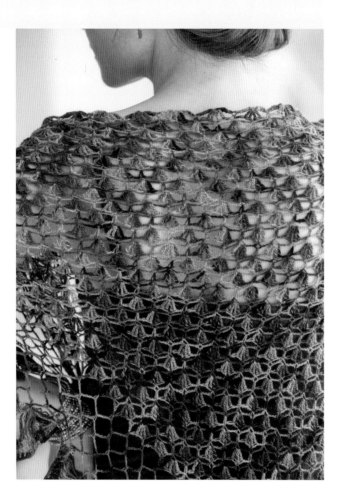

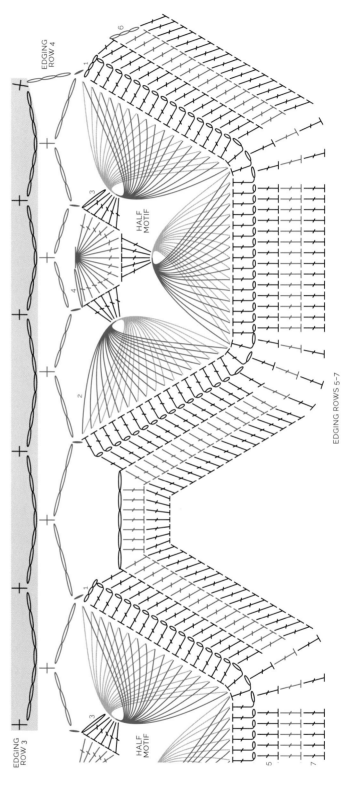

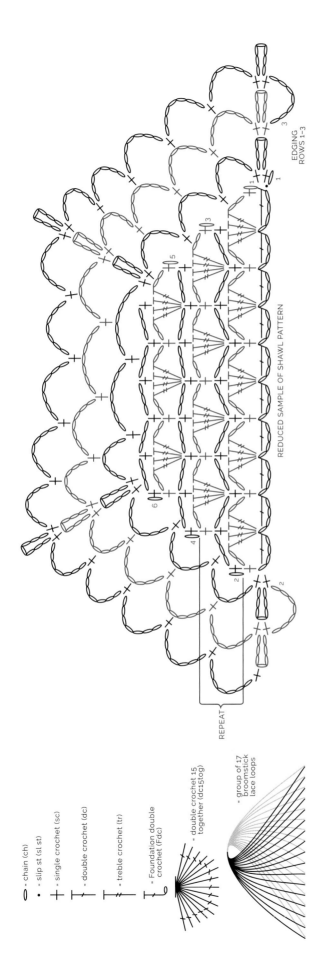

REDUCED SAMPLE OF SHAWL PATTERN

EDGING ROWS 1–3

REPEAT

= chain (ch)

= slip st (sl st)

= single crochet (sc)

= double crochet (dc)

= treble crochet (tr)

= Foundation double crochet (Fdc)

= double crochet 15 together (dc15tog)

= group of 17 broomstick lace loops

Half Motif *(make 17)*

Row 1: With smaller hook, work 51 Fdc, do not turn.

Row 2: Draw up lp on hook and place it on knitting needle (broomstick), insert hook in next st to right, draw up a lp and place it on needle; rep from * across—51 lps on needle.

Row 3: Insert hook in first 17 lps, yo, draw yarn though lps, ch 1 (does not count as a st), work 5 dc in first 17 lps, 5 dc in next 17 lps, 5 dc in last 17 lps, turn—15 dc.

Row 4: Ch 1 (does not count as a st), dc15tog over next 15 dc. Fasten off.

Shawl

Set-up row: With larger hook, *ch 4, dc in 4th ch from hook; rep from * 65 times—66 dc.

Row 1 (RS): Ch 1, sc in top of last st worked, *ch 2, 4 tr in base of next st, ch 2, sc in base of next st; rep from * across—33 shells.

Row 2: Ch 1, sc in first sc, *ch 3, skip next 2 tr, sc in sp before next tr**, ch 3, skip next 2 tr, sc in next sc; rep from * across, ending last rep at **, turn, leaving rem sts un-worked—65 ch-3 sps.

Row 3: Ch 1, sc in same st, ch 2, 4 tr in next sc, ch 2, sc in next sc; rep from * across—32 shells.

Rows 4–61: Rep Rows 2 and 3 (29 times)—3 shells at end of last row. Fasten off. Place stitch marker at beg and end of last row.

Edging

Note: Edging is worked along lower "V" edge of shawl, with ch-7 mesh and inc's at each end of row and on either side of midpoint corner (4 inc's per row).

Row 1: With RS facing and larger hook, join yarn with sl st in top left-hand corner of shawl, ch 7, sc in same sp (inc made), *ch 7, skip next ch-sp, sc in next ch-sp*; rep from * to * to stitch marker, ch 7, sc in same sp (inc made); rep from * to * across to next marker, ch 7, (sc, ch 7, sc) in next ch-2 sp (inc made); rep from * to * across to next corner, ch 7, sc in same sp (inc made), turn—68 ch-7 sps. Move markers to the inc ch-7 sps on either side of center.

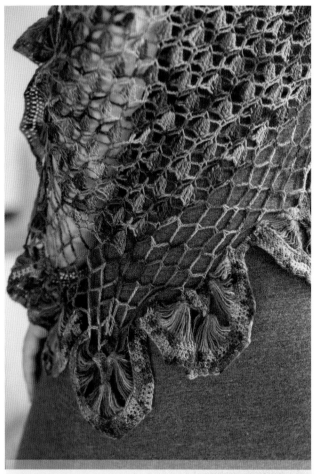

Row 2: Ch 7, (sc, ch 7, sc) in next ch-7 sp (inc made), *[ch 7, skip next ch-2 sp, sc in next ch-2 sp across to next marked sp, ch 7, sc in same sp (inc made); rep from * twice, ending in top right-hand corner, turn—72 ch-7 sps. Move markers to the inc ch-7 sps on either side of center.

Row 3: Ch 7, (sc, ch 7, sc) in next ch-7 sp (inc made), *[ch 7, skip next ch-2 sp, sc in next ch-2 sp across to next marked sp**, ch 7, sc in same sp (inc made); rep from * across, ending last rep at ** with sc in top right-hand corner, turn—75 ch-7 sps.

Note: Each motif is joined along the flat edge in 4 places (see diagram or photo for placement). Join motifs to next row of edging as follows.

Row 4: Ch 3, sl st to corner of first motif, *ch 3, sc in next ch-7 sp of Edging, ch 3, sk next row of motif, sl st to top of next row-end dc, ch 3, sc in next ch-7 sp of Edging, ch 3, sk next row of motif, sk next row of motif, sl st top of next row-end dc**, ch 3, sc in next ch-7 sp of Edging, ch 3, sl st top of next row-end dc of next motif, ch 3, sc in next ch-7 sp of Edging; rep from * across entire edge of shawl, joining 19 motifs, ending last rep at **, dc in last ch-7 sp, turn. Work now progresses in rows across outer edge of motifs. Change to smaller hook.

Row 5: With smaller hook, working along the curved edge of each motif in one continuous row, Ch 3 (counts as dc here and throughout), dc in base of ea of next 51 sts across bottom edge of first motif, *ch 5, dc in base of ea of next 51 sts across bottom edge of next motif; rep from * across next 18 motifs, turn.

Row 6: Ch 3, dc in ea of next 50 sts, *7 dc in next ch-5 sp, dc in ea of next 51 sts; rep from * across, ending with dc in top of turning ch.

Finishing

Weave in ends. Wash, block to finished measurements, and let dry.

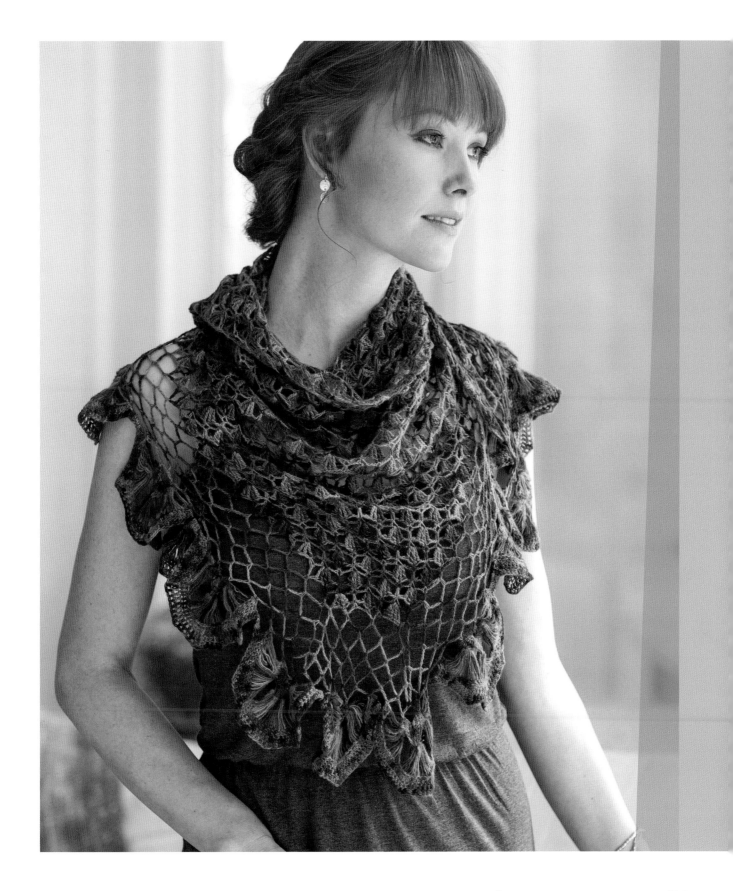

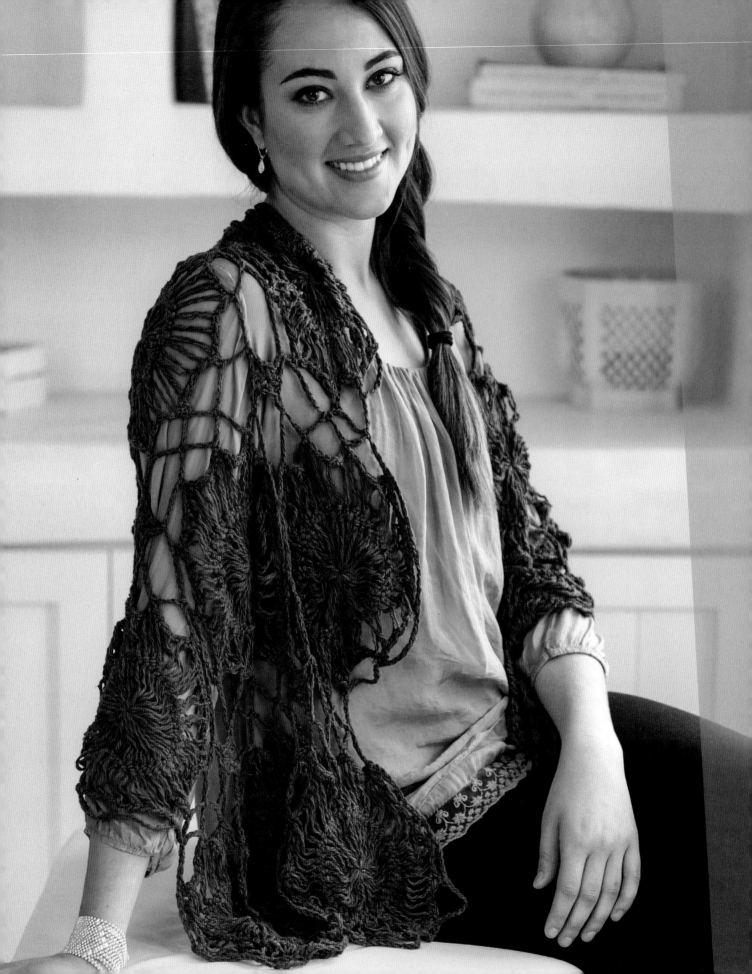

YARN

Aran weight (#4 Medium).

SHOWN HERE: Be Sweet Bambino (hand-dyed 70% organic cotton/30% bamboo; 100 yd (92 m)/1.75 oz (50 g)): #844 Aubergine, 5 balls.

HOOK

G/7 (4.5 mm) or size needed to obtain gauge.

Hairpin Lace Loom set at 4" (10 cm) wide.

NOTIONS

Yarn needle.

GAUGE

One Large Motif = 9" (23 cm) in circumference, blocked.

Passion Flower
WRAP

Hairpin lace is traditionally worked in strips and then joined linearly in a variety of ways. Taking small strips and turning them into a circle is a great and fast way to add delicate lace to your motif repertoire! Cinching one length of loops of the strip and crocheting into the other side's loops creates a beautiful, circular medallion motif. In this gorgeous purple color, it strikingly resembles a passionflower!

The large motifs are joined to each other as you go, and are stabilized with smaller interior motifs that also join as you go. However, I chose to omit the stabilizing smaller motifs along the perimeter because the deep scallops are great for styling, for wrists and neck placement.

FINISHED SIZE

55" (139.5 cm) wide × 27" (68.5 cm) deep.

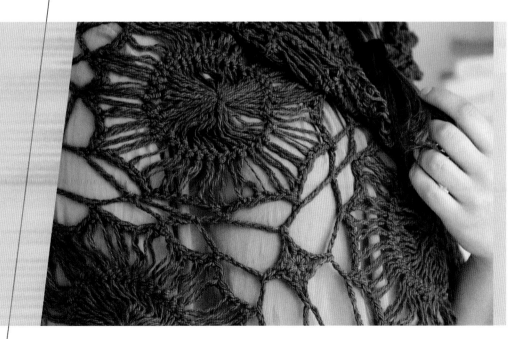

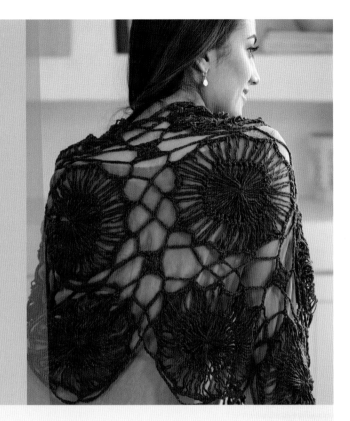

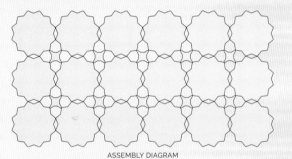

ASSEMBLY DIAGRAM

First Large Motif *(no joins)*

Set hairpin lace loom to 4" (10 cm) wide. Tie a piece of yarn to top and bottom of hairpin lace loom's horizontal bars on either side before beginning, making ties loose so they can be untied easily. Following direction on hairpin lace loom package, make a hairpin lace strip that has 42 lps each side. Fasten off. There should be a strand of yarn running inside 42 lps on one side of strip. Loosely tie strand of yarn before sliding strip off of loom. Gathering 42 lps on side of strip together, tie ends of strand tightly around lps. This will be the center of the motif.

MOTIF EDGING

Rnd 1: Join yarn with sl st in first lp on outer edge of strip, ch 1, 2 sc in same lp, 2 sc in ea lp around, join with sl st in first sc—84 sc.

Rnd 2: Ch 1, sc in first st, ch 9, sk next 6 sts**, sc in next st; rep from * around, ending last rep at **, join with sl st in first sc—12 ch-7 lps.

Make and join 26 more motifs in a rectangle 3 deep × 9 wide, joining ea to previous motif(s) on one or two sides while completing last rnd as follows:

Second and Successive Large Motifs *(joined on one side)*

Work same as First Motif through Rnd 1.

Rnd 2: Ch 1, sc in first st, [ch 4, sl st in ch-9 sp on previous motif, ch 4, sk next 6 sts, sc in next st] twice in same previous motif, *ch 9, sk next 6 sts, sc in next st; rep from * around, join with sl st in first sc.

Successive Large Motifs *(joined on two sides)*

Work same as First Motif through Rnd 1.

Rnd 2: Ch 1, sc in first st, [ch 4, sl st in ch-9 sp on previous motif, ch 4, sk next 6 sts, sc in next st] twice in same previous motif, [ch 4, sl st in ch-9 sp on next adjacent motif, ch 4, sk next 6 sts, sc in next st] twice in same motif, *ch 9, sk next 6 sts, sc in next st; rep from * around, join with sl st in first sc.

Interior Motif

(make and join 10 motifs in ea opening between four Large Motifs)

Ch 4 (first 3 ch counts as dc), 2 dc in 4th ch from hook, ch 2, sl st in free ch-9 sp on inside opening of one Large Motif, ch 2, *3 dc in same ch, ch 2, sl st in free ch-9 sp on inside opening of next Large Motif, ch 2; rep from * 3 times, join with sl st in top of beg ch-3.

Finishing

Weave in ends. Wash, block to finished measurements, and let dry.

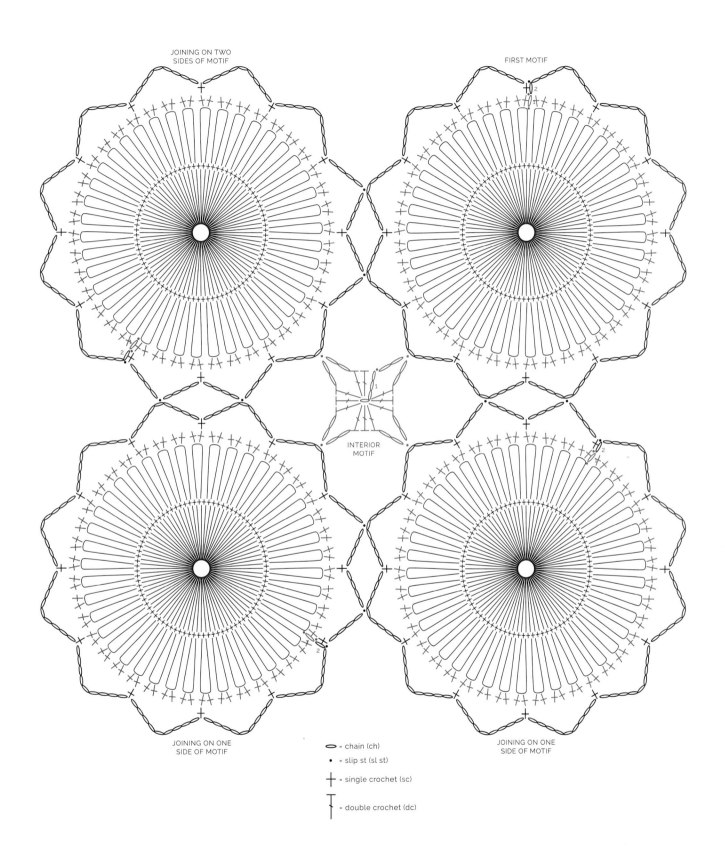

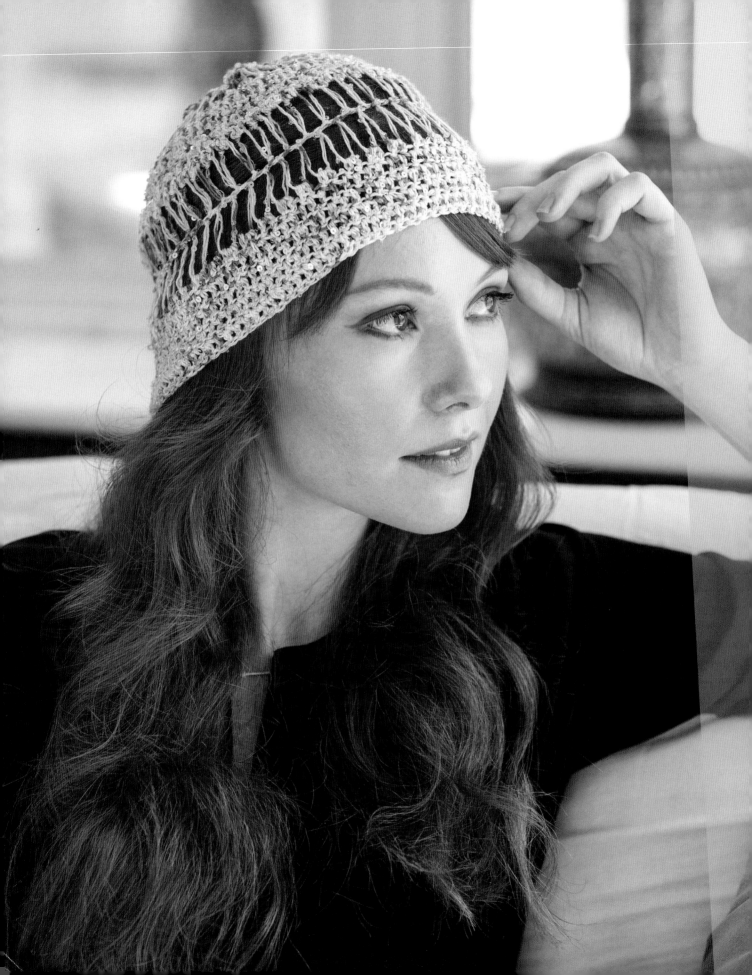

YARN

DK weight (#3 Light).

SHOWN HERE: Art Yarns Beaded Silk and Sequins Light (100% silk, with glass beads and sequins (110 yd [100 m]/1.75 oz [50 g]): 1 hank.

HOOK

B/2 (2.75 mm) crochet hook or size needed to obtain gauge.

Hairpin Lace Loom set to 3" (7.5 cm) wide.

NOTIONS

Yarn needle.

GAUGE

20 sts = 4" (10 cm) in dc.

FINISHED SIZE

20" (51 cm) in circumference.

Hairpin Lace
HAT

My favorite hats "in the wild" are ones with a little bling. When people-watching, I am always drawn toward people wearing hats with beads or sequins. In an effort to push the envelope and see what I could do with one skein of sequin and beaded silk yarn, I decided to challenge myself with hairpin lace. Creating strips of fabric in the traditional way, I then manipulated one strip into a medallion (perfect for a hat's crown) and joined strips into tubes to create the remainder of the hat. As long as you set the loom to the radius of the crown, you will have a hat that fits!

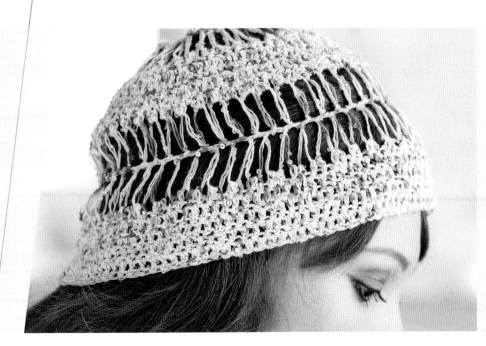

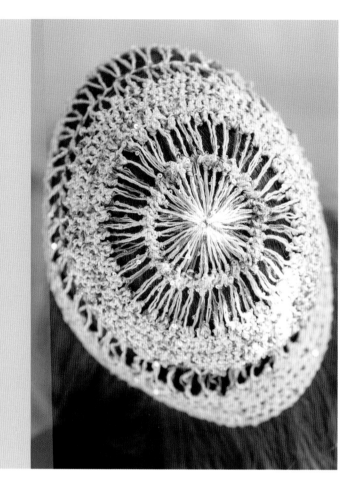

Outer Edging

Rnd 1: Join yarn with a sl st in first loop on outer edge of Crown, ch 3 (counts as dc here and throughout), dc in same lp, 2 dc in each lp around, join with a sl st in top of beg ch-3—80 dc.

Rnd 2: Ch 3, dc in same st, dc in each of next 3 sts, *2 dc in next st, dc in each of next 3 sts; rep from * around, join with a sl st in top of beg ch-3—100 dc. Fasten off.

Sides

Set hairpin lace loom to 3" (7.5 cm) wide. Following directions on hairpin lace loom package, make a hairpin lace strip that has 50 lps on each side, working 1 sc in the left-hand lp on each turn of the loom. Fasten off, leaving a sewing length. Being careful not to twist strip, sew ends of strip together in center to form a tube.

Outer Edging (Brim)

Rnd 1: Join yarn with a sl st in first loop on outer edge of Crown, ch 3 (counts as dc here and throughout), dc in same lp, 2 dc in each lp around, join with a sl st in top of beg ch-3—100 dc.

Rnd 2: Ch 3, dc in each st around, join with a sl st in top of beg ch-3—100 dc.

Rnds 3–5: Rep Rnd 2. Fasten off.

Inner Edging

Rnd 1: Working in lps on the opposite side of Sides Strip, join yarn with sl st in first lp, ch 3, dc in same loop, 2 dc in each lp around, join with a sl st in top of beg ch-3—100 dc.

Rnd 2: Ch 3, dc in each st around, join with a sl st in top of beg ch-3—100 dc.

Rnd 3 (joining rnd): Holding Crown (circular motif) and Inner Edging of Sides together with WS facing, working through double thickness, very loosely sl st in each st around, join with sl st in first sl st. Fasten off.

Note: Due to the nature of the beaded thread in this yarn, I suggest untwisting the strands and cutting the beaded thread off before weaving in ends.

Handwash, block to finished measurements, and let dry.

Crown

Set hairpin lace loom to 3" (7.5 cm) wide. Tie a piece of yarn to top and bottom of hairpin lace loom's horizontal bars on either side before beginning, making ties loose so they can be untied easily. Following directions on hairpin lace loom package, make a hairpin lace strip that has 40 lps on each side, working 2 sc in the left-hand lp on each turn of the loom. Fasten off, leaving a sewing length. There should be a strand of yarn running inside 40 lps on one side of strip. Loosely tie strand of yarn before sliding strip off of loom. Gathering 40 lps on side of strip together, tie ends of strand tightly around lps. This will be the center of the Crown. Being careful not to twist strip, sew ends of strip together in center to form a tube.

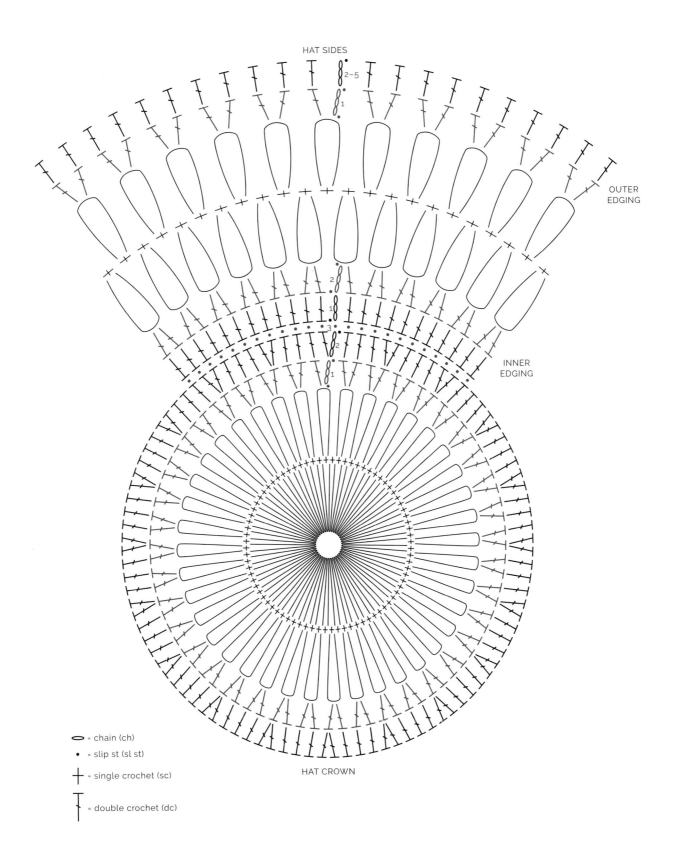

HAT SIDES

2-5

1

OUTER
EDGING

2

1

3

2

1

INNER
EDGING

⬭ = chain (ch)

• = slip st (sl st)

+ = single crochet (sc)

† = double crochet (dc)

HAT CROWN

abbreviations

beg	begin; begins; beginning
bet	between
ch(s)	chain(s)
cm	centimeter(s)
cont	continue(s); continuing
dc	double crochet
dc2tog	double crochet 2 stitches together
dc3tog	double crochet 3 stitches together
dc-tbl	double crochet through back loops long
dec	decrease(s); decreasing; decreased
dtr	double treble (triple)
est	established
foll	follows; following
g	gram(s)
hdc	half double crochet
inc	increase(s); increasing; increased
lp(s)	loop(s)
MC	main color
m	marker
mm	millimeter(s)
p	picot
patt	pattern(s)
pm	place marker
rem	remain(s); remaining
rep	repeat; repeating
rev sc	reverse single crochet
rnd(s)	round(s)
RS	right side
sc	single crochet
sc-tbl	single crochet through back loop only
sk	skip
sl	slip
sl st	slip(ped) stitch
sp(s)	space(s)
st(s)	stitch(es)
tch	turning chain
tog	together
tr	treble crochet
tr tr	triple treble crochet
TSS	Tunisian simple stitch
WS	wrong side
*	repeat starting point
WS	wrong side
yd	yard(s)
yo	yarn over
()	alternate measurements and/or instructions

Techniques

TSS (TUNISIAN SIMPLE STITCH)

Tunisian simple stitch (Tss): Fwd: Lp on hook counts as first st, sk first vertical bar, *insert hook under next vertical bar, yo, draw yarn through st; rep from * as required. Standard Rtn: Yo, draw yarn through 1 lp on hook, *yo, draw through 2 lps on hook; rep from * across—1 lp rem and counts as first st of next row.

Beg X Stitch: Ch 4 (counts as first leg of beg X st), skip 3 sts, tr in next st, ch 7 (counts as next leg of X st and ch 3), tr in top of first 2 legs of X st.

X Stitch: Yo 4 times, insert hook in next st, (yo, pull through 2 loops) twice, skip 3 sts, yo twice, insert hook in next st, (yo, pull through 2 loops) 4 times, ch 3, yo twice, insert hook in top of first 2 legs of X st, (yo, pull through 2 loops) 3 times.

Beg Increase X Stitch: Ch 4 (counts as first leg of beg X st), tr in same st, ch 7 (counts as next leg of X st and ch 3), tr in top of first 2 legs of X st.

Increase X Stitch: Yo 4 times, insert hook in same st, (yo pull through 2 loops) twice, yo twice, insert hook in next st, (yo, pull through 2 loops) 4 times, ch 3, yo twice, insert hook in top of first 2 legs of X st, (yo, pull through 2 loops) 3 times.

FPDC (FRONT POST DOUBLE CROCHET)

Yarn over hook, insert hook from front to back to front again around post of stitch indicated, yarn over hook and pull up a loop (3 loops on hook), [yarn over hook and draw through 2 loops on hook] twice—1 fpdc made.

BPDC (BACK POST DOUBLE CROCHET)

Yarn over hook, insert hook from back to front, to back again around the post of stitch, yarn over hook, draw yarn through stitch, [yarn over hook, draw yarn through 2 loops on hook] twice.

FSC (FOUNDATION SINGLE CROCHET)

Ch 2 **(Figure 1)**, insert hook in 2nd ch from hook **(Figure 2)**, yarn over hook and draw up a loop (2 loops on hook), yarn over hook, draw yarn through first loop on hook **(Figure 3)**, yarn over hook and draw through 2 loops on hook **(Figure 4)**—1 fsc made **(Figure 5)**.

*Insert hook under 2 loops of ch made at base of previous stitch **(Figure 6)**, yarn over hook and draw up a loop (2 loops on hook), yarn over hook and draw through first loop on hook, yarn over hook and draw through 2 loops on hook **(Figure 7)**. Repeat from * for length of foundation.

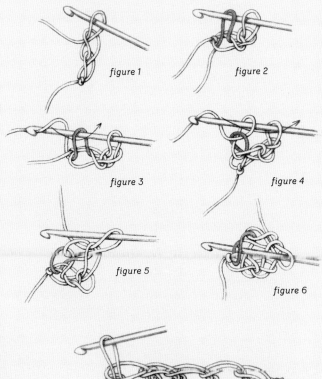

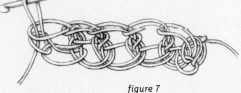

figure 7

FDC (FOUNDATION DOUBLE CROCHET)

Chain 3. Yarn over, insert hook in 3rd chain from hook, yarn over and pull up loop (3 loops on hook), yarn over and draw through 1 loop (1 chain made), [yarn over and draw through 2 loops] 2 times **(Figure 1)**— foundation double crochet. Yarn over, insert hook under 2 loops of chain at bottom of stitch just made, yarn over and pull up loop (3 loops on hook) **(Figure 2)**, yarn over and draw through 1 loop (1 chain made), [yarn over and draw through 2 loops] 2 times **(Figure 3)**. *Yarn over, insert hook under 2 loops of chain at bottom of stitch just made **(Figure 4)**, yarn over and pull up loop (3 loops on hook), yarn over and draw through 1 loop (1 chain made), [yarn over and draw through 2 loops] 2 times. Repeat from * as needed **(Figure 5)**.

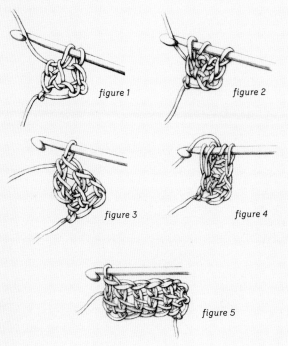

Sources for Yarns

Alchemy Yarns
PO Box 1080
Sebastopol, CA 95473
(707) 823-3276
alchemyyarns.com
Silken Straw

Art Yarns
70 Westmoreland Ave.
White Plains, NY 10606
(914) 428-0333
artyarns.com
Beaded Silk and Sequins Light

Be Sweet Products
7 Locust Ave.
Mill Valley, CA 94941
(415) 388-9696
besweetproducts.com
Bambino

Bijou Basin Ranch
PO Box 154
Elbert, CO 80106
(303) 601-7544
bijoubasinranch.com
Lhasa Wilderness

Blue Sky Alpacas
PO Box 88
Cedar, MN 55011
(763) 753-5815
blueskyalpacas.com
metalico

Cascade Yarns
cascadeyarns.com
Cascade 220, Forest Hills

Drew Emborsky Yarns
drewemborsky.com
Inappropriate

Eucalan
eucalan.com
Wrapture all natural, no-rinse delicate wash

The Fibre Company
2000 Manor Rd.
Conshohocken, PA 19428
(484) 368-3666
thefibreco.com
Meadow, Road to China Light

Freia Fine Handpaints Yarn
6023 Christie Ave.
Emeryville, CA 94608
(800) 595-KNIT (5648)
freiafibers.com
Ombre Lace, Ombre Sport

Lantern Moon
7911 NE 33rd Dr., Ste. 140
Portland, OR 97211
(800) 530-4170
lanternmoon.com
Rosewood crochet hooks, Tulip Tunisian interchangeable hooks

Malabrigo Yarns
malabrigoyarn.com
Silky Merino, Lace

Muench Yarns
1323 Scott St.
Petaluma, CA 94954
(800) 733-9276
muenchyarns.com
Grayson E large buckle leather handles

SweetGeorgia Yarns
110-408 East Kent Ave. S.
Vancouver, BC V5X 2X7 Canada
(604) 569-6811
sweetgeorgiayarns.com

Tahki Stacy Charles
70-60 83rd St., Bldg. 12
Glendale, NY 11385
(718) 326-4433
tahkistacycharles.com
S. Charles Collezione: Crystal, Luna, Stella
Filatura Di Crosa: Nirvana, Superior, Zarina
Tahki Yarns: Aria

Trendsetter Yarns
16745 Saticoy St., #101
Van Nuys, CA 91406
(800) 446-2425
trendsetteryarns.com
Lotus Mimi

acknowledgments

Thank you so much to the amazingly talented people I have the pleasure of working with at Interweave. Karen Manthey has been technically editing my books for years, and I appreciate her attention to detail so much. Allison Korleski is a force of nature and has an uncanny and incredible understanding of our industry. Erica Smith was a delight to work with, and I hope we get to work together for many years to come. Joe Hancock has been doing the photography for my books for years, and I am so grateful to have his beautiful talent grace the pages here once again. Thank you to my friends and family for motivating me, one way or another, to try to be better at everything I do.

index